DUTCH
LANDSCAPES

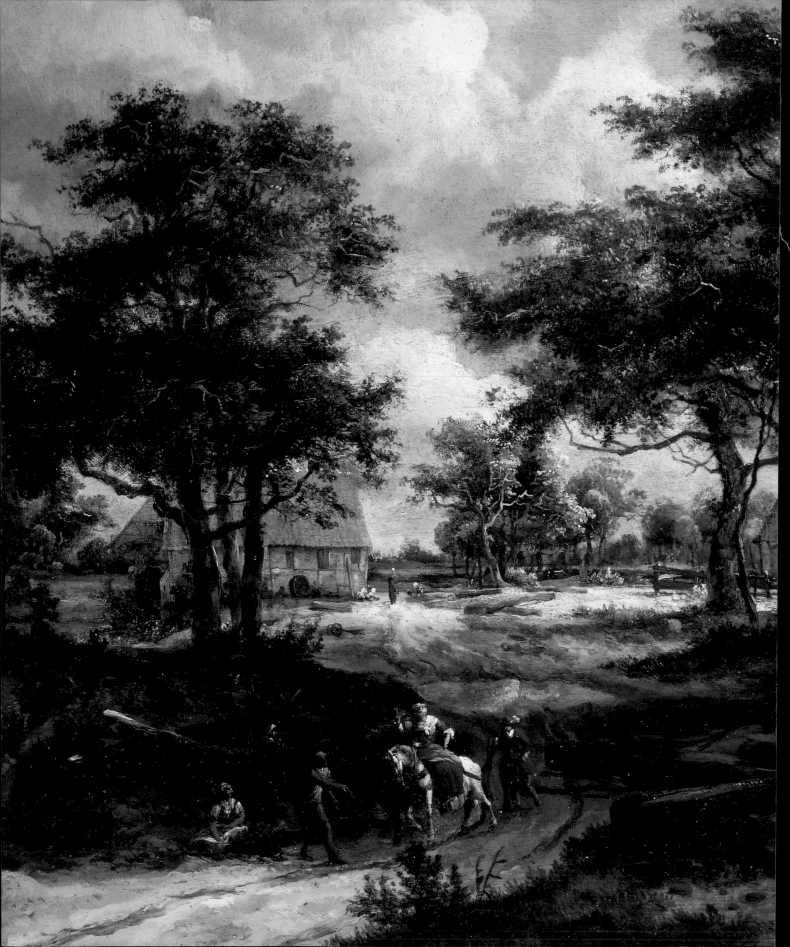

DUTCH
LANDSCAPES

Desmond Shawe-Taylor
with contributions by Jennifer Scott

Royal Collection Publications

Published by Royal Collection Enterprises Ltd
St James's Palace, London SW1A 1JR

in association with

Scala Publishers Ltd
Northburgh House
10 Northburgh Street
London EC1V OAT

For a complete catalogue of Royal Collection publications, please write to the address at top,
or visit our website at www.royalcollection.org.uk

SKU: 012361

ISBN: 978 1 905686 25 4

British Library Cataloguing-in-Publication data: A catalogue record of this book is available
from the British Library

Typeset in Plantin
Designed by Hoop Design, hoopdesign.co.uk
Map (page 36) by Isambard Thomas
Copy editor: Sarah Kane
Project manager, Scala: Oliver Craske

Printed in Italy by Conti Tipocolor
10 9 8 7 6 5 4 3 2 1

Cover: Jan van der Heyden, *A Country House on the Vliet near Delft* (no. 18, detail)
Pages 2–3: Meyndert Hobbema, *Wooded Landscape with Travellers and Beggars on a Road*
(no. 19, detail)
Page 32: Paulus Potter, *The Young Thief* (no. 9, detail)
Page 88: Willem van de Velde the Younger, *A Calm* (no. 23, detail)
Page 124: Johannes Lingelbach, *Figures before a Locanda* (no. 34, detail)
Page 152: Aelbert Cuyp, *An Evening Landscape with Figures and Sheep* (no. 42, detail)
Pages 168–169: Nicolaes Berchem, *Italian Landscape with Figures and Animals* (no. 32, detail)

Contents

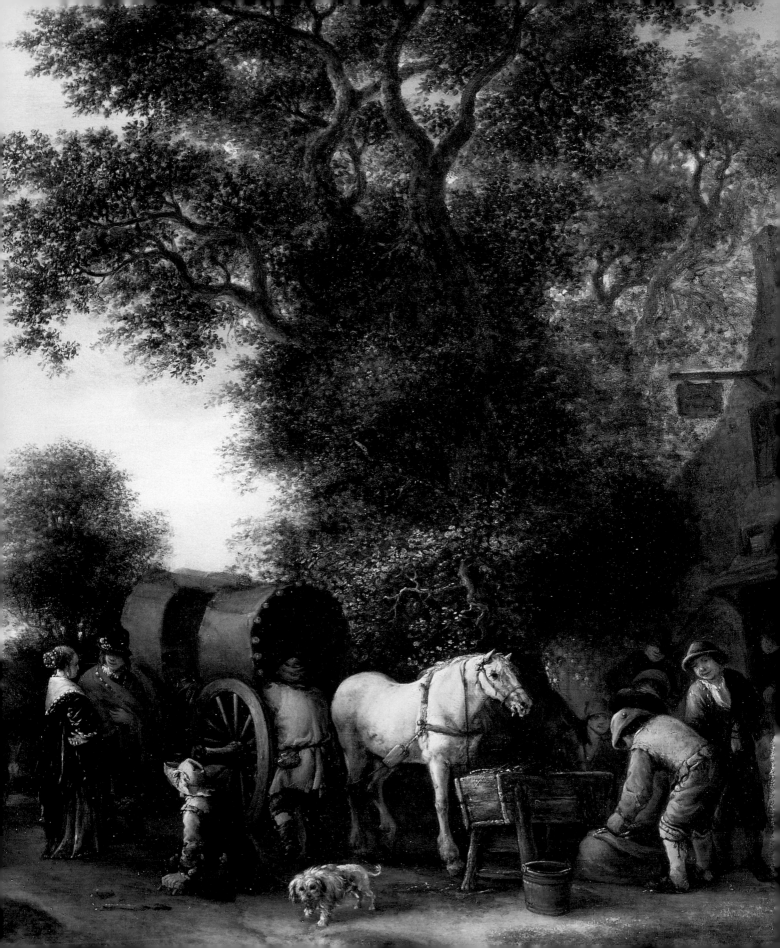

'Ten Thousand Graphic Details'
READING DUTCH LANDSCAPES

When a painting is cleaned, the task of the conservator is first to remove the accretions of the past – the layers of varnish which have become yellow with dirt and discolouration and the areas which have been repainted by previous restorers. Having revealed all that survives of the original paint layer, the conservator then retouches any lost or damaged area in order to try to make it look as it did when it first left the artist's studio. The transformation wrought by cleaning is often so dramatic that it is easy to forget that the previous overpainting was an act of well-intentioned deception rather than deliberate disfigurement. Then as now the conservator was seeking to find the original work.

The understanding of painting can require a similar process. Over the years the habitual way of thinking about the art of a particular period can start to obscure and discolour the works themselves; sometimes sincerely held ideas can overlay the truth with plausible anachronisms. The process of intellectual restoration is as fraught with difficulties as that of real restoration; the 'original experience of a work' can seem as elusive a concept as the 'original appearance of a work'.

When considering the landscapes in this book, the virtual varnishing and retouching can for convenience be divided into two campaigns: that applied by the taste of Georgian England which led to the acquisition and display of the works by George IV; and that applied subsequently which led to their display in the exhibition that this book accompanies. The last-on-first-off rule means that we should deal with the second first. The idea of a representative exhibition of the story of Dutch

Isaac van Ostade,
Travellers outside an Inn (no. 2, detail)

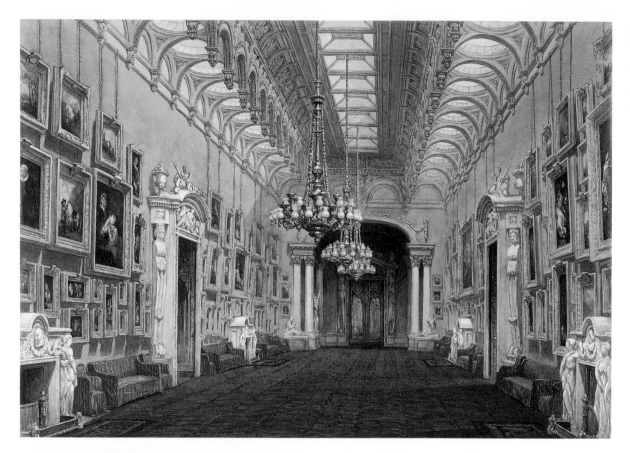

Fig. 1
Douglas Morison,
*The Picture Gallery,
Buckingham Palace,*
1843, watercolour
(Royal Collection,
RCIN 919916)

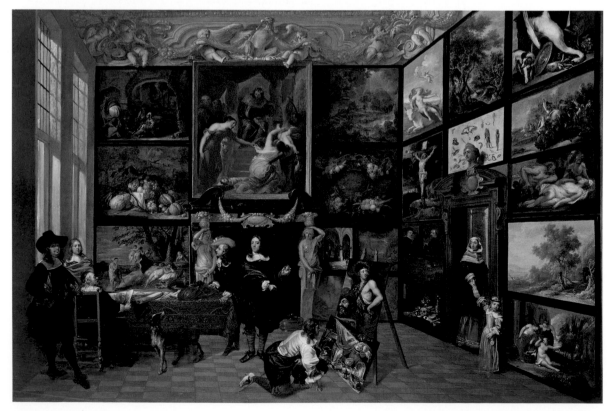

Fig. 2
Jacob de Formentrou,
Cabinet of Pictures,
1659, oil on canvas
(Royal Collection,
RCIN 404084)

painting is an invention of the last two hundred years. The arrangement of paintings in the show within the Queen's Galleries of Edinburgh and London is inevitably influenced by the displays within the National Galleries in Edinburgh and London, which 'take a position' on the relative importance of the various artists. The judgment made in 2010 may be significantly at odds with that made in 1810 or in 1610. For example, the most important episode in the story of Dutch landscape as understood today is the invention of the 'tonal' style by Esaias van de Velde (1587–1630), Jan van Goyen (1596–1656) and Salomon van Ruysdael (no. 22). This is an issue that needs to be described at some length in a catalogue written today (see pp. 48 and 104), but one which would have left George IV cold. This is why the tonal school is represented on the walls by a single untypical exhibit (no. 22) collected at a later date from the bulk of the exhibition; the works from George IV's collection which come nearest to the style (nos 2 and 7) are given low valuations in his inventories.[1] Major national museums also need to explain the relationship between seventeenth-century Dutch and mainstream European painting; it is usually the Dutch rooms which are presented as the odd men out by comparison, for example, with religious and mythological painting from Italy, rather than the other way round. Cultures generally do not think of themselves as odd men out.

The idea of a picture gallery, designed for no other purpose than that of displaying a large number of paintings, is at least two hundred years old; most of the works in this exhibition hung in the Picture Gallery at Buckingham Palace, a handful can be recognised in the view of 1843 (fig. 1).[2] By this date almost all these paintings would have been sent to the exhibitions organised by the British Institution; over 30 of the exhibits here were on show at the institute's galleries in Pall Mall in 1826 and substantially the same selection again the following year.[3] There was talk during these years of the King donating them along with many other Dutch pictures to the recently formed National Gallery.[4]

From what we know of the arrangement of galleries in the early nineteenth century (as in fig. 1), it is difficult to discern a didactic logic, but they certainly offered a chance to compare an astonishingly rich variety of works. The original artists can never have expected their work to be appreciated in this context. In the Southern Netherlands during the seventeenth century there are images of richly hung collector's cabinets, showing the work of local Flemish artists, as in the case of Formentrou's painting of 1659 (fig. 2), or more prestigious Italian pictures, as in the case of the famous depictions of the collection of the Archduke Leopold William in Brussels by David Teniers the Younger.[5] North of the border in the Dutch Republic there were no princely collections of this importance and international scope. The nearest thing to a ruling family – that of the House of Orange, the hereditary Stadholders – had a significant group of Flemish and Dutch pictures, but nothing to compare with the more comprehensive collections of other European monarchs.[6] Dutch picture dealers may have crowded their walls as in fig. 2 (though we have no

record of this), but their clients certainly did not. The landscapes seen hanging on the walls of seventeenth-century Dutch interiors are isolated or thinly arranged. Four landscapes (possibly two pairs) hang over a gilded-leather wall covering in van Bassen's imaginary palace interior of *c*.1634 (fig. 3) in simple ebonised frames. Single landscapes hang at eye level on white plaster walls in the more modest interiors of Metsu's famous pair of genre paintings of *c*.1664–6 (figs 4 and 5).[7] The gentleman writes in front of an Italianate landscape within a gilded auricular frame; his letter is read in front of a stormy grey seascape in an ebonised frame and covered with a curtain to keep off the dust.

In the second half of the seventeenth century some of the most lavish Amsterdam townhouses contained decorative schemes, presumably fitting into the panelling of a reception room, involving landscapes of a much more ambitious scale. In the mid-1660s the Italianate landscapist Adam Pynacker (*c*.1620–1673), produced such a series for no. 548 Herengracht, Amsterdam, the home of the East India Company Director, Cornelis Backer (1633–1681); the poet Pieter Verhoek (1633–1702) described how 'all the walls of the hall are painted with artful parks and green woods', adding that Pynacker's brush 'thus surpasses tapestries', reminding us of where this idea of wrap-around decoration came from.[8] Most of Melchior de Hondecoeter's work (fig. 6) was similarly conceived to decorate townhouse rooms in series of five or six canvases, with imagery designed to remind the owner of his country estates.[9] An interior of this type, with marble Corinthian pilasters and 'fitted'

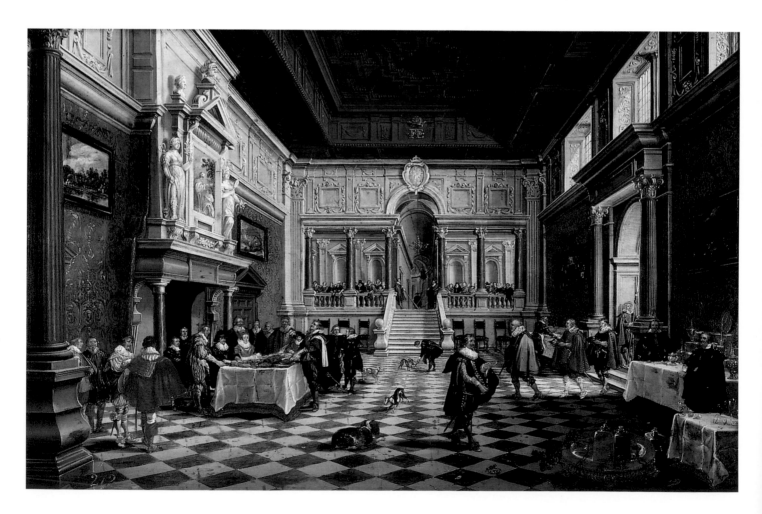

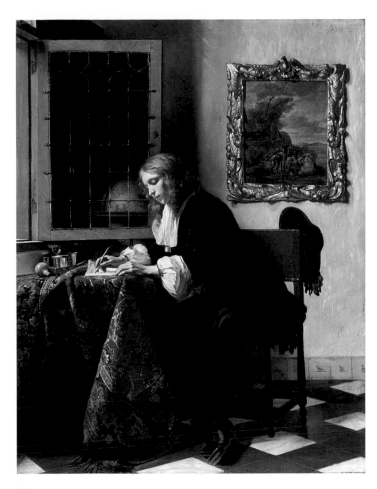

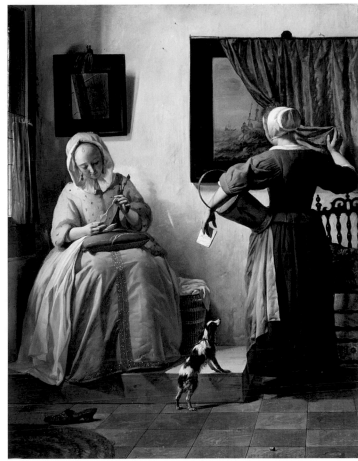

Fig. 4
Gabriel Metsu,
Man Writing a Letter,
*c.*1664–6, oil on panel
(National Gallery of
Ireland)

Fig. 5
Gabriel Metsu,
*Woman Reading a
Letter*, *c.*1664–6, oil
on panel (National
Gallery of Ireland)

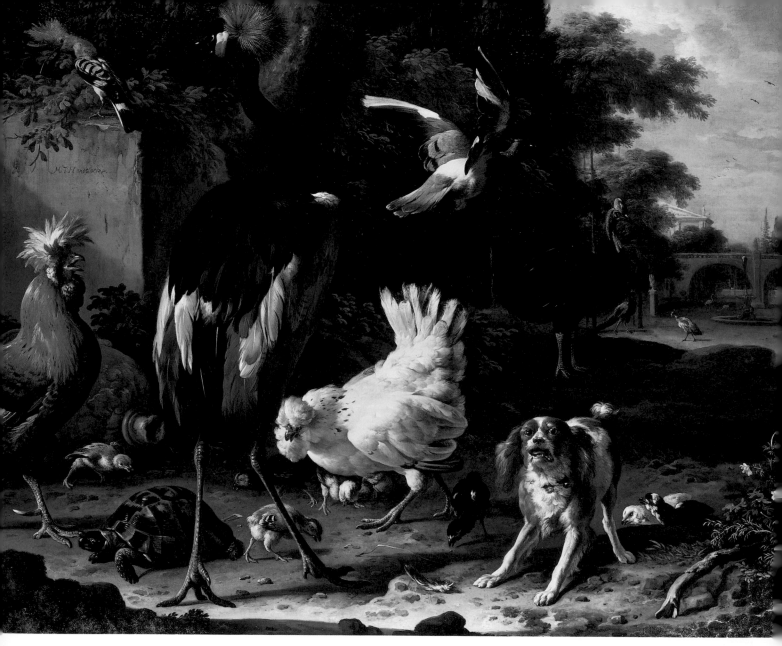

Fig. 6
Melchior de
Hondecoeter, *Birds
and a Spaniel in a
Garden*, *c.*1680, oil
on canvas (Royal
Collection, RCIN
405354)

'TEN THOUSAND GRAPHIC DETAILS': READING DUTCH LANDSCAPES

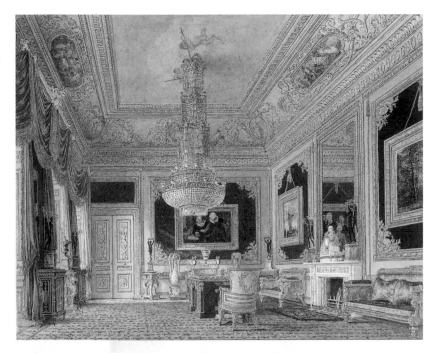

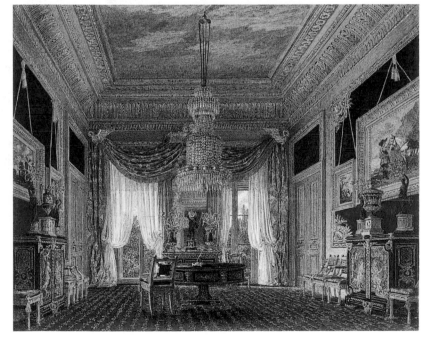

landscapes, can be seen in Pieter de Hooch's *Jacott-Hoppesack Family* of *c*.1670 (Amsterdams Historisch Museum). Rather less distinguished landscape painters than de Hondecoeter came to England, especially after the Restoration in 1660, to provide similar interior decoration: a set of classical landscapes by the Dutch artist Hendrick Danckerts (1630–1679) of 1675–7 must originally have provided overdoors for Hampton Court or Windsor Castle.[10] The vestige of this decorative system, whereby an entire interior is made up of large panels fitting together, can still be seen at Carlton House, the home of the Prince Regent, in 1816–18 (figs 7 and 8). By this date, however, the panels, surrounded by gilded frames, contain blue velvet or mirror glass; the only landscapes here are individual examples, in recently made gilded frames, hung over the velvet. These works were originally intended for interiors like those seen in figs 3–5. They are not the second-rank Dutch landscapes, commissioned by the Stuarts during the seventeenth century, but an entirely fresh batch acquired in the decade before their appearance on his walls. To give a more precise account of this extraordinary spending spree: 34 of the 42 paintings in this exhibition were acquired by George IV between 1809 and 1820, 21 of them from a single sale, that of Sir Francis Baring in 1814.

There are historical and economic reasons for both these collectors' interest in Dutch art. Sir Francis Baring's banking business owed much of its success to a partnership with Hope and Sons of Amsterdam; when the French invaded Holland in 1794 the Hope office relocated to London.

TOP:
Fig. 7
Charles Wild, *Carlton House: The Blue Velvet Room*, 1816, watercolour with touches of bodycolour and gum arabic over pencil (Royal Collection, RCIN 922184)

ABOVE:
Fig. 8
Charles Wild, *Carlton House: The Blue Velvet Closet*, 1818, watercolour and bodycolour with gum arabic over pencil (Royal Collection, RCIN 922185)

During this time (1796–1803) Baring tried unsuccessfully to merge the two enterprises as an Anglo-Dutch banking and trading powerhouse with 'one foot in England, the other in Holland'.[11] The Prince of Wales (the future George IV) might also have been especially aware of the Netherlands during the same period. The British army was fighting there after 1799 under the command of his brother, the Duke of York. In 1814 the Prince Regent (as he then was) began negotiations for his daughter Charlotte (1796–1817) to marry William VII, Prince of Orange (1792–1849, subsequently William II, King of the Netherlands), who was serving as aide-de-camp to the Duke of Wellington and who fought with somewhat reckless distinction at the Battle of Waterloo. In seeking this match the Prince Regent was following an established precedent: in 1641 Charles I's daughter Mary (1631–1660) married William II of Orange (1626–1650); in 1677 the daughter of James, Duke of York (the future James II), Mary (1662–1694) married her first cousin William III of Orange (1650–1672), the couple subsequently ruled Britain; George II's daughter Anne (1709–1759) married William IV (1711–1751) in 1734. William VII must have been very put out when Princess Charlotte refused him in favour of Prince Leopold of Saxe-Coburg-Saalfeld (1790–1865).

However suggestive this shared history and common destiny may seem, George IV's interest in Dutch landscape probably reflected recent French taste, and complemented rather than contrasted with his love of French furniture and Sèvres porcelain.[12] Images of late eighteenth-century French interiors, like the 1791 portrait of Baron de Besenval in his Salon de Compagnie by Henri-Pierre Danloux (1753–1809; fig. 9), show the same combination of modern French furnishing and old Dutch and Flemish masters, seen in Wild's views of Carlton House.[13] The French Revolution (and the French invasion of the Netherlands) brought onto the London art market many significant French holdings of Dutch paintings, for example at the sale in 1792 of this part of the collection of Louis Philippe II, duc d'Orléans (1747–1793) and that in 1795 of the collection of Charles de Calonne (1734–1802), from which Sir Francis Baring, George IV and many other like-minded British collectors profited.[14]

Regency admiration for Dutch art was a highly developed, refined and 'professionalised' taste: there was an agreed canon of names; much available expertise in determining authorship, condition and quality; and a considerable network of dealers and collectors endorsing each other's purchases. The canon had remained substantially the same throughout the eighteenth century and included the names strongly represented in this exhibition: Philips Wouwermans, Paulus Potter, Adriaen and Willem van de Velde, Jan Both and to a lesser extent Jan van der Heyden, Nicolaes Berchem, Karel du Jardin and Cornelis van Poelenburgh. The taste for Jacob van Ruisdael, Meyndert Hobbema and Aelbert Cuyp was of slightly more recent date but well established by 1800.[15] All these artists were admired as 'fine' painters, with a meticulous finish and astonishing detail. This taste is reflected in the notes made in

the inventory of the pictures at Carlton House in 1819 (quoted below in the relevant catalogue entries) which reveal the author's concern that the work in question should be a good example of the right master in their 'finest manner' or 'best time', and that it should be 'in the highest preservation'; it is sometimes mentioned that it comes from a famous collection, and often that it is finished with great 'accuracy', 'care' or 'delicacy and freedom of pencilling'.[16] When all these things are in place the valuations are impressive, in comparison with other old masters (Wouwermans's *Hayfields*, no. 5, was valued at 800 guineas along with Rembrandt's *Agatha Bas* (Royal Collection, RCIN 405352)) and in absolute terms (Potter's small-scale farmyard scene, no. 9, was valued at 2,000 guineas, a seven-figure sum in today's money).[17]

When in 1876 Eugène Fromentin (1820–1876) called his account of Netherlandish painters *Les Maîtres d'autrefois* he was making it clear that he was referring to this canon:

I am giving the title of *The Masters of Past Time* to these pages, in the exact sense in which I would speak of the 'Masters' in the Grand or Familiar styles of French Literature, if I were speaking of Pascal, Bossuet, de la Bruyère, Voltaire and Diderot – with this difference that in France there are schools where the respect for and study of these masters of style are still practised, whilst I am hardly aware of any school where the respectful study of the always admirable masters of Flanders and Holland is at the present moment encouraged.[18]

If the Dutch masters were so avidly collected, why were they not 'respectfully studied'? The answer was that their prices were high but their subjects low. For Horace Walpole (1717–1797) the Dutch were the 'drudging Mimics of Nature's most uncomely coarsenesses'.[19] The fact that Dutch and Flemish artists painted this coarseness with such a fine technique made the matter worse: in a letter of 1779 Walpole lamented that they 'thought a man vomiting a good joke; and would not have grudged a week on finishing a belch, if mere labour and patience could have compassed it'.[20] Queen Victoria evidently agreed when she visited the Picture Gallery at Buckingham Palace (fig. 1) in 1839 and talked with Lord Melbourne of the pictures 'of their being all Dutch, which we agreed was a low style; our preferring the Italian masters'.[21] Even in their lifetimes there was concern expressed at Dutch artists' fondness for supplying more information about country life than seemed strictly necessary (see fig. 10). A Potter farmhouse scene of 1649 (now in the Hermitage, St Petersburg) was said to show 'much too base a subject' for the Stadholder's widow, Amalia van

Fig. 10
Paulus Potter, *Two Sportsmen outside an Inn* (no. 10, detail)

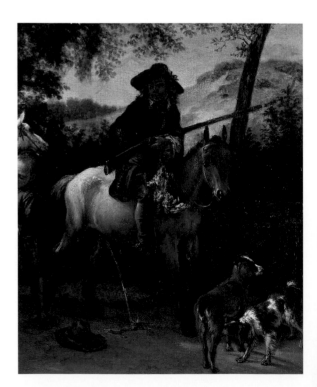

Fig. 11
J.M.W. Turner, *Calm*,
etching, aquatint and
mezzotint, 1812, *Liber
Studiorum*, No. 44
(British Museum)

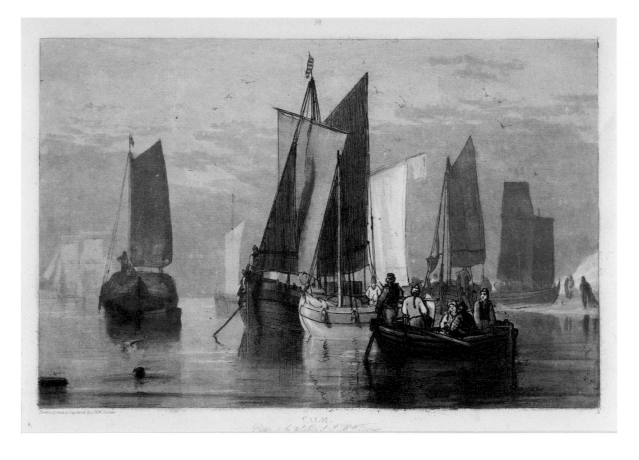

Solms (1602–1675), 'to view daily'.[22] Dutch artists were attacked for their squalid subject matter by Italian writers (see below, pp. 129–30), but also by fellow-countrymen, such as Jan de Bisschop (1628–1671), who wished to correct their mistaken belief that 'things which are hideous in life are sweet and pleasant when depicted in art'.[23]

In spite of these lapses Dutch painters *were* studied by artists in Regency England, as many comparisons within this catalogue suggest (see, for example, nos 2, 8 and 18); but only as a model for the lower genres of painting. The *Liber Studiorum* by J. M. W. Turner (1775–1851) of 1807–18 makes this classification explicit by labelling the prints with an 'M' for 'Marine', 'P' for 'Pastoral' and 'EP' probably meaning 'Elevated Pastoral'.[24] These scenes are all of Turner's own invention but they contain explicit tributes to different landscape traditions. So, for example, a 'Calm' very like those of Willem van de Velde the Younger (fig. 11, compare nos 23 and 24) is labelled 'M'; an idealised Italian scene is in the manner of Claude (fig. 12, compare fig. 74) and earns an 'EP'; a farmyard scene somewhat in the

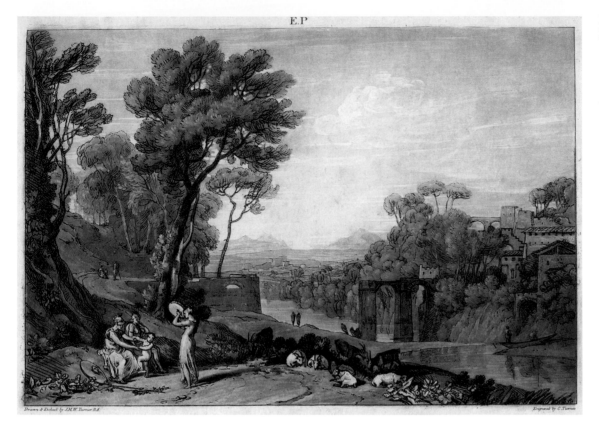

Fig. 12
J.M.W. Turner and
Charles Turner,
*Woman and
Tambourine*, etching
and mezzotint, *c.*1807,
Liber Studiorum, No. 3
(British Museum)

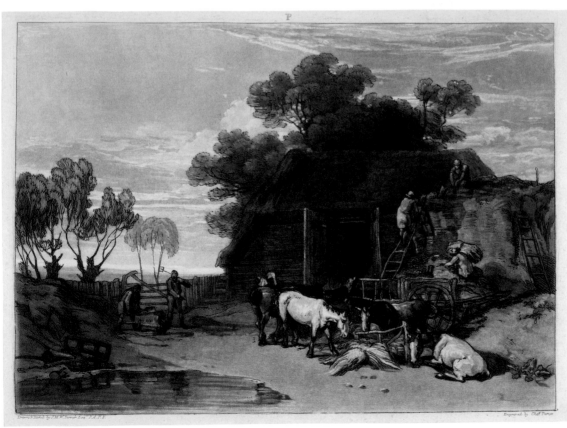

Fig. 13
J.M.W. Turner and
Charles Turner, *The
Straw Yard*, etching,
mezzotint and dry-
point, 1808, *Liber
Studiorum*, No. 7
(British Museum)

manner of Paulus Potter (fig. 13, compare no. 9) is merely 'Pastoral'. This would seem to be 'too base a subject' for daily viewing, but Turner suggests that the Dutch style has its place, albeit lowly, in the story of art.

The two-tier system of landscape was first introduced to England in *The Principles of Painting* of 1743 (a translation of Roger de Piles's *Cours de peinture par principes* of 1708) which states: 'Among the many different styles of landskip, I shall confine my self to two; *the heroick*, and *the pastoral* or *rural*; for all other styles are but mixtures of these.'[25] It is clear to Joshua Reynolds (1723–1792) who belongs in which camp:

The same local principles which characterize the Dutch school extend even to their landscape painters; … Their pieces in this way are, I think, always a representation of an individual spot, and each in its kind a very faithful but very confined portrait.

Claude Lorrain, on the contrary, was convinced, that taking nature as he found it seldom produced beauty. His pictures are a composition of the various draughts which he had previously made from various beautiful scenes and prospects. … That the practice of Claude Lorrain, in respect to his choice, is to be adopted by Landschape Painters, in opposition to that of the Flemish and Dutch schools, there can be no doubt, as its truth is founded upon the same principle as that by which the Historical Painter acquires perfect form.[26]

It is not so much squalor as banality – the literal, matter-of-fact record of specific things and places – which condemns the Dutch to the second rank of painting. This is what Horace Walpole calls being 'minute, circumstantial and laborious like the Dutch Painters'.[27] The Dutch, for Reynolds, employ some 'inferior dexterity, some extra-ordinary mechanical power' to 'exhibit all the minute particularities of a nation differing in several respects from the rest of mankind'.[28] In his view Holland was a *school* for artists and Italy a *university*: 'Painters should go to the Dutch school to learn the art of painting, as they would go to a grammar-school to learn languages. They must go to Italy to learn the higher branches of knowledge.'[29] Part of Reynolds's difficulty with Dutch art is its resistance to analysis, as he admits with disarming frankness in his *Journey to Flanders and Holland* of 1781:

One would wish to be able to convey to the reader some idea of that excellence, the sight of which has afforded so much pleasure: but as their merit often consists in the truth of representation alone, whatever praise they deserve, whatever pleasure they give when under the eye, they make but a poor figure in description.[30]

If one sought works which in Reynolds's *Discourses* do make a 'rich figure in description' it might be the tapestry cartoons by Raphael (1483–1520) where *artistry* is more easily distilled from *representation*, where one can admire a figure style derived from the antique or a composition

arranged as if on a stage. It is easy to see that Claude could be described in this way: the Roman arch in no. 30 might derive from one 'of the various draughts which he had previously made from various beautiful scenes and prospects', but it has been smartened up and its place in the painting is contrived and arranged by the artist. Potter's farmyards (no. 9) don't look arranged; nor does Turner's (fig. 13). 'That excellence' in Dutch landscape, 'the sight of which afforded so much pleasure' to Reynolds and Turner, was lost on John Ruskin (1819–1900):

> A Dutch picture is, in fact, merely a Florentine table [made in *pietra dura*] more finely touched … and perhaps the fairest view one can take of a Dutch painter, is that he is a respectable tradesman furnishing well-made articles in oil paint: but when we begin to examine the design of these articles, we may see immediately that it is his inbred vulgarity, and not the chance of fortune, which has made him a tradesman and kept him one.[31]

What about the original audience for the landscapes in this exhibition? Who were they and what would they have made of Reynolds or Ruskin? As a working hypothesis we could begin by imagining that the room next door to the ones depicted in Metsu's pair of interiors (figs 4 and 5) contained paintings from this exhibition. Most of them are certainly of the right date to hang here: 14 were painted in the same decade (the 1660s) and 16 from the 1650s and three more in the first three years of the 1670s. Perhaps some of the eight

paintings from the 1640s and the two from 1623 might have seemed old-fashioned, but in general the paintings exhibited here belong with the Metsus within a very short time span in the middle years of the seventeenth century. Most of the paintings are roughly the right size to fit into one of the three frames seen on Metsu's walls, if we used that round the mirror to frame the smallest. Adriaen van de Velde's *Hawking Party* (no. 16) would especially suit the gentleman's gilded frame in format and style; only the Willaerts (no. 21), Both (no. 31) and some of the Cuyps (nos 39, 41 and 42) would be too large for this setting. Of course Metsu offers a home for only a handful of paintings, one or two to a room, but then the remainder could be housed in similar interiors next door and down the street.

The exact way in which this sort of person acquired this sort of painting in one Dutch city during the seventeenth century is explored from surviving documentary evidence by John Michael Montias in his brilliant 1982 study, *Artists and Artisans in Delft: A Socio-Economic Study of the Seventeenth Century*. Montias's conclusion is that Dutch artists were indeed 'respectable tradesmen furnishing well-made articles in oil paint'; their products found their way into houses lived in by two-thirds of the population, who would have bought them for a price comparable to that of the silver inkwell or globe in fig. 4.[32] The tables of average prices compiled by Alan Chong also provide an invaluable guide in this respect: the going rate for a landscape around mid-century was in the region of 30 guilders (at a time when a tradesman might earn 500–1,500 guilders a year

Fig. 14
Philips Wouwermans,
*A Horse Fair in Front of
a Town* (no. 6, detail)

and Raphael's portrait of Baldassare Castiglione (Louvre) sold for 3,500 guilders); Paulus Potter, Cornelis van Poelenburgh, Karel du Jardin, Jan Both and Philips Wouwermans did significantly better than this; Salomon van Ruysdael and Meyndert Hobbema did rather worse.[33] Those wishing to acquire such paintings could do so from the artists' studios, at dealers' shops and at stalls in fairs (the only opportunity for artists to sell their work if they were not a member of a city's painters' guild).[34] In 1641 John Evelyn (1620–1706) recorded in his *Diary* that the 'faires are full of pictures, especially Landscips, and Drolleries, as they call those Clownish representations'.[35] The toy stall at the fair in Wouwermans's painting (fig. 14) gives some idea of what a painting stall might have looked like.

Wherever they came by them these ordinary patrons would have selected their purchases without the help (or hindrance) of professional advice, as Montias explains:

> This lively market for works of art operated with a minimum of collateral information: exhibitions were in their infancy, there was virtually no literature to guide customers' tastes – no catalogues or books about artists, no advertisements, nothing that would have helped objectively or otherwise, to establish or puff up an artist's reputation.[36]

The Dutch art market was indeed lively, but the paintings had to sell themselves. Some artists acquired reputations which clearly had been

'established or puffed up' by the machinery of endorsement discussed above in connection with George IV: by the advisors, agents, collectors and fellow artists who might form a court around an aristocrat or prince. Such artists were usually figure painters or portraitists, but Cornelis van Poelenburgh was patronised by the Roman nobility, the Medici in Florence and the family of the Stadholder in The Hague; he was visited in his studio in 1627 by Rubens who admired his 'judicious small figures in Raphael's style accompanied with charming landscapes, ruins, animals and such like'.[37] He and Willem van de Velde worked for the Stuart court in London.[38] Potter also worked for the Stadholder's court and was famous enough to be visited by the agent of Queen Christina of Sweden (1626–89) in 1652 who tried to acquire a painting for 300 francs when Potter wanted 400.[39] Cosimo III de' Medici (1642–1723) made two trips to Holland in 1667 and 1669 to visit collectors' cabinets and artists' studios and to acquire paintings, including works by Willem van de Velde the Elder and Jan van der Heyden.[40] Some artists worked themselves into a position of exclusivity through the quality of their output: the great success of Wouwermans caused

an envious Pieter van Laer (1599–1642) to demand (in vain) similarly exorbitant prices.[41] However, in none of these success stories is there an equivalent of the way elsewhere in Europe a young genius could be 'discovered', and nurtured in an environment of reliable court patronage. The advice given to young Italian artists by the biographer Giovanni Battista Passeri (c.1610–1679) would have meant nothing to a Dutchman: 'To establish one's name it is vital to start with the protection of some patron.'[42] The situation of a young Dutch artist is better conveyed by records of the Haarlem guild council arbitrating in 1643 in a dispute between the 22-year-old Isaac van Ostade (see no. 2) and the Rotterdam dealer, Leendert Volmarijn, over delivery of 13 paintings valued at 27 guilders for the batch.[43] The man in the Metsu is looking to spend two guilders on an Ostade or 50 on a Wouwermans; he is not offering protection to either.

If we attempt to view Dutch painting through the eyes of Metsu's correspondents (figs 4 and 5) we find that the discoloured varnish of subsequent criticism yields to the weakest of solvents. What will our letter-writer care that generations not yet born may come to inform him that the interesting

Fig. 15
Jan van der Heyden,
A Country House on the Vliet near Delft
(no. 18, detail)

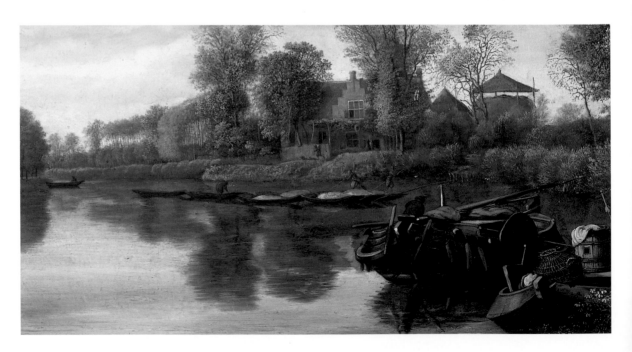

thing about his little Italianate landscape is how unlike the work of Raphael it is? Will he stay to listen while Ruskin explains to him the soul-destroying vulgarity of trade? Will his loved one appreciate that her seascape is rather too early and therefore lacks that 'silvery luminosity' one looks for in the work of whoever is its author? Will their works be seen in the context of any other painting, let alone a 'representative selection' of Dutch masters?

If we agree that they are unlikely to care about any of these things, what then would they have appreciated in their paintings? This will tell us by extension what sort of paintings they might have encouraged artists to paint by voting with their wallets. The answer must surely be that they valued resemblance to nature, both in that close detail and fine touch sought after by George IV and in the truth to the motif which they were so much better able to judge than him or us. This does not mean that they did not appreciate imaginative landscapes – like the Italianate scene hanging behind the letter writer (fig. 4) – but that they would certainly have known what was real and what fanciful and probably have expected the same level of technique in the re-creation of both. It is a commonplace that the untutored eye understands the thing it knows, namely resemblance to nature.[44] It was suggested at the time that Dutch merchants were, relatively speaking, 'untutored': a petition of the Guild of St Luke in Amsterdam of 1608 refers to 'good burghers who on the whole have little knowledge of painting'.[45] On the other hand there is also a tradition dating back to Pliny that the ability to deceive the eye is the ultimate test of a painter.[46] The century following the Amsterdam painters' submission would suggest that in the event the 'good burghers' proved to have a perfectly adequate knowledge of painting, which they enjoyed as a window onto the world without photographs to dull the excitement of representation or prejudices teaching them to despise it.

Today we find realism a complicated subject and sometimes impose that difficulty upon the seventeenth century.[47] We describe realism as 'mechanical', as if failing to appreciate that it is a discipline which admits of imaginative insight as well as patient study. This is seen in the impact of the 'camera obscura', a device which resembles a modern camera, except in providing a moving projection of the real world in real time, rather than a fixed impression. Most Dutch artists of the second half of the seventeenth century would probably have seen a camera obscura. There are vivid descriptions of the sort of large, walk-in camera obscuras created at this time, which stress the beauty as well as the potential use of the invention.[48] Anyone who has experienced the effect of a large camera obscura will attest that it is indeed beautiful: the amount of light introduced is necessarily limited, which means that the tones and colours of the world are pale, soft and loosely focused, yet at the same time this delightfully grainy image moves and illuminates the obscurity of the chamber. The distance in Jan van der Heyden's canal scene (fig. 15) has exactly this glowing softness. This is an effect which may be learned from a mechanical device but one that

serves to expand not limit the artist's vision of the world beyond. Reynolds noted in 1781 this 'creative' effect of the camera obscura in another work by Jan van der Heyden: 'Notwithstanding this picture is finished as usual very minutely, he has not forgot to preserve at the same time a great breadth of light. His pictures have very much the effect of nature, seen in a camera obscura.'[49]

A painting viewed by the sort of owner we have described, in isolation from other similar paintings, needs to be realistic; it also needs to have a *point*. This is why Metsu included these landscapes in his scenes: that in the first painting suggests the long journey which separates the writer from his loved one; the seascape in the second painting suggests what a storm of secret passion lies concealed within the breast of the young woman for those confidants permitted to look behind the curtain.[50] Clearly these paintings-within-paintings are here to support the human story, but the fact that they could be used in this way suggests that the original audience was adept at seeing meaning and narrative in every sort of painting, landscape or genre. Curiously, what subsequent writers have found difficult about Dutch art is what Fromentin refers to as the 'total absence of what we call today a *subject*'.[51]

> Note, moreover, that even in their really anecdotic or picturesque painting we cannot see the least sign of anecdote. There is no well-determined subject, no action requiring a thoughtful, expressive, or particularly significant composition; no invention, not a scene that breaks the monotony of this country or town life, which is so dull, commonplace, devoid of learning, of passion, one might say of sentiment. Drinking, smoking, dancing, kissing the maids can scarcely be called either rare or attractive incidents. Milking cows, taking them to water, loading a cart with hay – these are not remarkable scenes in an agricultural country.[52]

In some cases this description is merely inaccurate: Potter's *Young Thief* (no. 9) clearly has some 'sign of anecdote', which was recognised in George IV's time. It is probable that Fromentin and other later commentators simply missed the point of many other paintings or that it was made so indirectly that it passed underneath their radar. In some ways the most interesting subjects are the most inconsequential: we might turn Fromentin's criticisms back onto the art of his own era, the France of 1876, and observe that ballerinas in training, girls serving at bars, elderly couples drinking absinthe 'are not remarkable scenes in a fashionable capital city'. In the following discussion we have tried as far as possible to enter into the narrative of the landscapes or to expose what significance a particular motif or type of figure might have had. Meaning of this kind would have been easily grasped by a contemporary viewer, without need of special erudition; it is particularly difficult to retrieve today. To get an idea of the task one might imagine historians of popular music in the year 2300 trying to explain the meaning of Paul McCartney's *Penny Lane* with reference to the slum clearances in Liverpool in the 1960s, the glamour of fire-

engines, etc.; they might make a meal of it but the exercise would be worthwhile if it meant that the music-lover of the future could appreciate some part of that allusive meaning which was instantly grasped by the original audience. It is in this spirit that the paintings in this selection have been approached from the point of view of their subject rather than their author, exploring the geography of the motif, the moral of the story, the comedy of the situation or anything which a contemporary would have grasped without even being aware of the fact.

This image of a market-led artistic environment leaves out an important consideration: some sense of the theory of landscape painting and its history. This is something which artists would acquire with their training (specialist professions have long dynastic memories), and patrons might pick up through reading or at second hand. There was at this date a clear concept of landscape painting: Metsu's *Man Writing a Letter* (fig. 4) would never have been called a 'genre painting' at this date, but the work hanging on the wall would probably, even in the most functional inventory, have been called a 'landscape'.[53] At least since the sixteenth century landscapes had been discussed as a distinct species of painting and one in which Netherlandish artists excelled.[54] The English writer Edward Norgate (1581–1650) wrote in *c.*1650 that landscape was an art 'soe new in England' that the very name had to be borrowed from the Dutch, for 'to say truth the Art is theirs'.[55] The ancients, he added, used landscape 'but as a servant to their other peeces, to illustrate, or sett off their *Historicall* painting, by filling up the empty Corners …. But to reduce this part of painting to an absolute and intire Art … is as I conceave an Invention of these later times'.[56]

Carel van Mander (1548–1606) devotes Chapter VIII of his poem *Den grondt der edel vry schilder-const* (The Foundation of the Noble, Free Art of Painting), which is itself part of his *Schilder-boeck* (Book of Painting) of 1604, to landscape painting.[57] He seems to be thinking of 'an absolute and intire Art' rather than of 'filling up the empty Corners'. It is always difficult (or rather deceptively easy) to match a theoretical text with an actual body of paintings, but in verses 19 and 25 van Mander specifically recommends the work of Pieter Bruegel the Elder (active 1551–69); his ideas can be summarised while contemplating works in this tradition: *A Village Festival* of 1600 by Jan Brueghel the Elder (1568–1625; fig. 16) and *Summer* of *c.*1618 by Peter Paul Rubens (1577–1640; fig. 17).[58] Van Mander recommends that artists enjoy the dawn and fine weather as well as being able to paint storms, fogs and snows (verses 5 and 12–16); that they place a large object in the foreground (verse 19); that they observe the rules of perspective even if the ground isn't as clearly structured as architecture (verse 9); that the planes in the middle distances should be fused together and should undulate like the waves of the sea and move backwards like a snake (verses 20–21); that artists should merge their distances by means of hazy light, so that mountains and clouds become confused (verse 8); that skies should become lighter nearer the horizon (verse 16). When painting foliage artists should invent, because 'leaves, like hair, air and fabrics, are

Fig. 16
Jan Brueghel the
Elder, *A Village
Festival*, 1600,
oil on copper
(Royal Collection,
RCIN 405513)

Fig. 17
Sir Peter Paul Rubens,
*Summer: Peasants
Going to Market,*
*c.*1618, oil on canvas
(Royal Collection,
RCIN 401416)

spiritual things and can only be conceived and reproduced by the imagination' (verse 37). Landscapes should be adapted to some narrative or at least contain peasants doing something (verse 41). Van Mander clearly does not make much distinction between landscape painting and the depiction of everyday life (something we now call 'genre' painting). He enthusiastically paraphrases Pliny the Elder's description of the Roman painter, Ludius, who added a variety of incident to suggest that roads were slippery with mud:

> He had painted some of them walking very warily, trembling with the fear of falling down hard, while others stood, bending forward as if they were loading something heavy on the top of their heads and shoulders. Anyway, in short,

he knew how to scatter ten thousand graphic details throughout his work. Now I will leave you to invent as many (verse 47).[59]

If van Mander's descriptions seem to match a Flemish tradition of landscape (as in figs 16 and 17) this challenge to invent ten thousand graphic details (incidentally connected with slipping) was taken up most emphatically by the Dutch artist, Hendrick Avercamp (1585–1634), in a range of watercolours of wintry scenes clearly executed from life (figs 18 and 19). The paintings Avercamp produced based on such studies clearly belong to the tradition of the Brueghel dynasty, as can be seen by comparing Jan Brueghel's Flemish street fair of 1600 (fig. 16) with Avercamp's Dutch frozen-river fair of *c.*1608–9 (fig. 20). Both could be representations of the seasons and could be

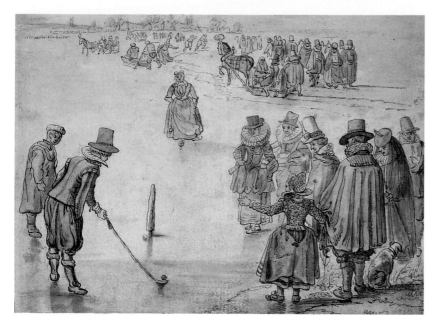

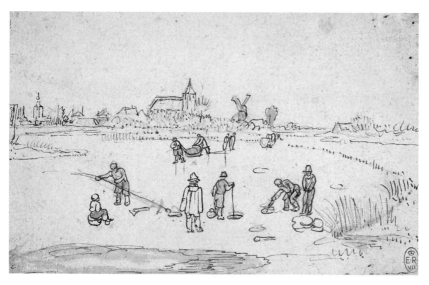

Fig. 18
Hendrick Avercamp,
*A Game of 'Kolf' on the
Ice*, c.1620, pen and
brown ink with brown
wash, watercolour, red
chalk and bodycolour
over traces of graphite
(Royal Collection,
RCIN 906470)

Fig. 19
Hendrick Avercamp,
*Fishermen on a Frozen
River*, c.1620, pen
and brown ink with
watercolour over
graphite (Royal
Collection, RCIN
906475)

referred back to a tradition of landscape painting within illuminated manuscripts. A 'Book of Hours' is a personal prayer book, with prayers and readings for every time of day and every season of the year; the calendar section, listing saint's days and religious festivals, is often illustrated by landscapes showing the labours and activities of the months. The *Très Riches Heures du duc de Berry* is the most famous example of the genre, which shows the land as part of the cosmic order of things. In *August* (fig. 21) aristocrats set out on a hunt in the foreground; behind them peasants undertake seasonal work in a landscape which fans out below the curtain wall of the landowner's castle, which itself is set below the Chariot of Apollo riding across the heavens through the appropriate Zodiac signs. The viewer, who is envisaged to be the lord of the manor, enjoys an elevated view of an ordered world as if sharing a vantage point with God and offering to Him the tribute of his land and its husbandry. The fairs of Brueghel and Avercamp have similar vantage points, a similar sense not of the labours of the month but the equally sacred festivals of the season; the church in Brueghel and the castle in Avercamp occupy the same position of spiritual supervision as the duc de Berry's chateau.

Comparing the *Très Riches Heures* with Wouwermans's *Hayfield* of the 1660s (no. 5) is revealing in a completely different way. The subject is superficially similar – hunters pass by haymakers, some of whom are bathing in the river to cool off – except that the elements which were so carefully 'layered' are now made to overlap and intermingle. This suggests that Dutch society was

less stratified: a much smaller portion of the land was owned by large aristocratic landlords than in other parts of Europe; this field may easily belong to the modest thatched farmstead on the horizon and certainly not to the hawkers.[60] More important is the suggestion that the entire scene is viewed from ground level by a spectator who seems to be on the point of walking into it along the path leading diagonally into the background. The spectator has the palpable reality and engagement of an eyewitness, but no privileged vantage point. What he, she or we see is *partial*: Walpole might call it 'circumstantial'; Reynolds would say that Wouwermans represents an 'individual spot' (one might add an individual experience of an individual spot) in what is 'a very faithful but very confined portrait'.

A very similar contrast can be demonstrated between Brueghel's *Village Festival* (fig. 16) and Isaac van Ostade's *Travellers outside an Inn* (no. 2) of 1647. Again the motif is not dissimilar: a road leading diagonally past an inn with a church in the distance and a group of peasants painted in the manner of Pieter Bruegel the Elder. In the Brueghel, groups of well-dressed city dwellers mingle with the peasants but we (that is viewers of the painting) watch from on high; in the van Ostade we feel that we are on the road, encountering not the inhabitants of a small town but a handful of figures. In part this transformation comes from the simple observation of the laws of perspective, as van Mander had recommended (see above): in a flat country church towers do appear as bumps on the

Fig. 20
Hendrick Avercamp,
A Winter Scene with Skaters near a Castle,
*c.*1608–09, oil on oak
(National Gallery, London)

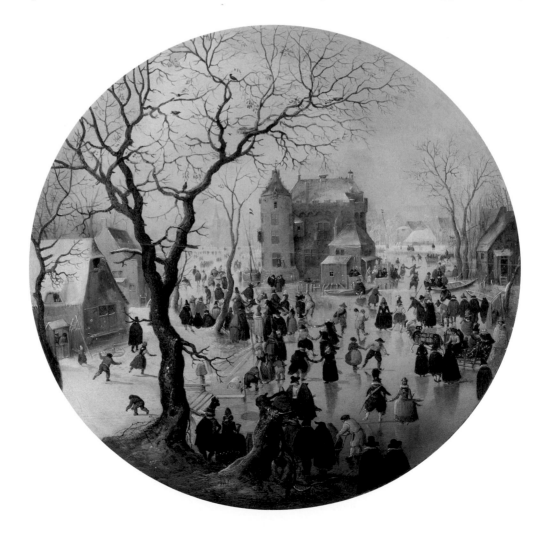

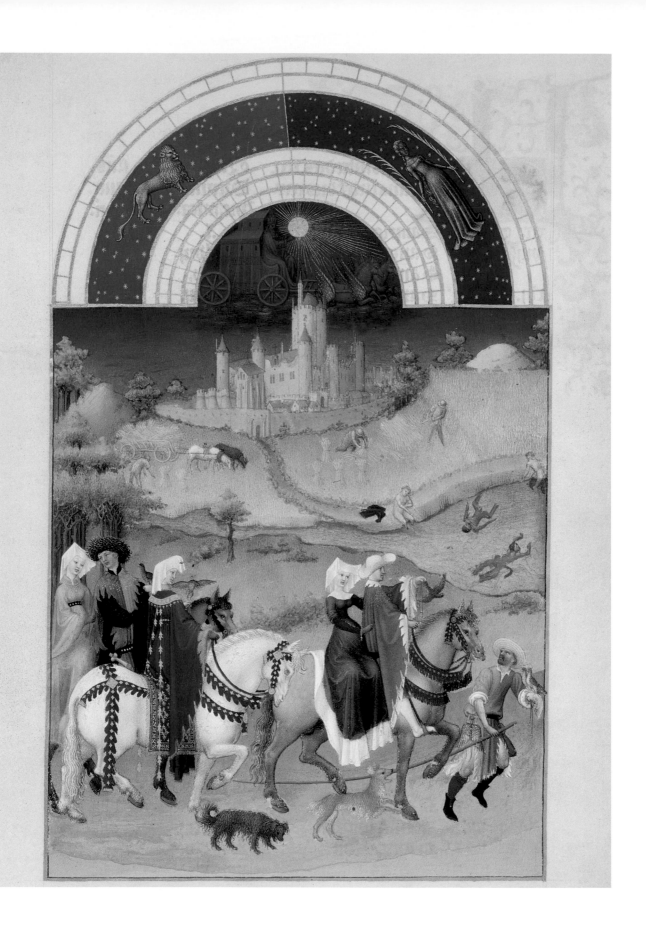

Fig. 21
Limbourg Brothers,
August from the *Très
Riches Heures du duc
de Berry*, 1412–16,
illumination on vellum
(Musée Condé,
Chantilly)

Fig. 22
David Teniers the
Younger, *Peasants
outside a Country Inn*,
*c.*1640–43, oil on panel
(Royal Collection,
RCIN 407274)

horizon even when in the middle distance. In part it derives from a fundamentally different way of relating viewer and scene – the visual equivalent of the first person narration.

This new sensibility appears to be something unique to the Northern Netherlands, as can be revealed by a comparison between a Dutch and Flemish treatment of the pub yard theme, which ultimately derived from Pieter Bruegel the Elder. David Teniers the Younger (1610–90) painted his *Peasants outside a Country Inn* (fig. 22) in Brussels in the early 1640s, less than a decade before Potter's *Two Sportsmen outside an Inn* (no. 10). It is as if Potter has taken a fragment of Teniers's stage-like composition, turning an assemblage of elements into a single encounter witnessed by a viewer who seems to be a participant in the scene.

If these aspects of landscape show a divergence from the tradition of the Flemish Renaissance, there are areas of continuity. Van Mander, for example, clearly relished the 'anti-beauty' of a tangled form of landscape, 'urging painters to notice 'irregular shaped stones', cascades tumbling 'hither and thither like a drunken man', or fir-trees 'fallen down so awkwardly you could scarcely believe it in a dream' (Chapter VIII, verse 35).

This idea that 'untidy' nature can be as suitable for painting as tidy nature becomes sufficiently entrenched for Gerard de Lairesse (1640/1–1711) to feel the need to challenge it: in his *Groot Schilderboek* of 1707 (Book VI, Chapters 15–17) he contrasts the true 'painter-like', *schilderachtig*, that is 'a landscape with perfect and straight-grown trees', with its false equivalent – 'a piece filled with misshapen trees, their branches and leaves wildly and improperly splayed from east to west'.[61] Jan van der Heyden's canal scene (no. 18) would seem to belong to this former category: a larger group of paintings selected for this book and exhibition would fit into the latter, in particular the work of Ruisdael (no. 11), Wijnants (nos 12 and 13) and Hobbema (nos 19 and 20).

One can see how the Netherlandish tradition evolved rapidly in the North during the seventeenth century with some continuity and much innovation, producing artists as varied as Hobbema and van der Heyden. It is more difficult to explain this evolution. Van Mander's ideas might have been familiar to artists and patrons in the north, but there was very little institutional structure to impose them and no collection comprehensive or accessible enough to keep the great tradition fresh in everyone's mind. The market was fragmented, domestic and 'deregulated': an unprecedented number of prosperous middle-class patrons kept an unprecedented number of innovative artists in work. With a market and an artistic culture as vibrant as this, how could the theoretical centre have been expected to impose conformity?

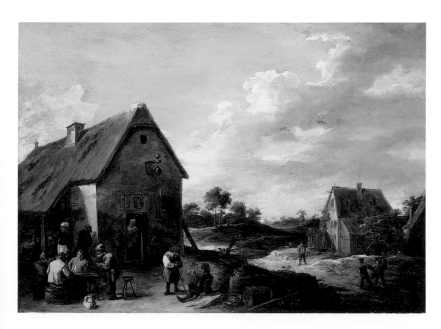

Fig. 24
The Dutch Republic
in the late seventeenth
century

This map shows the
territory and relief
of the country as it
existed in the late
seventeenth century.
Relief has been
exaggerated in order
to show the distinction
between the low land
and the dunes.

KEY:

Cities and towns

Rivers

Provincial borders

National borders

Sand banks

tow-barge (*trekschuit*) along a canal in front of an unremarkable hamlet.[12] The print is somewhat elevated by a Latin poem about the 'loosening of the bonds of winter, the bullocks returning to the fields, the blossoming trees and waves echoing to the sounds of birds singing, while carefree youth sails the boat and Cupid sends his arrows into the crowd'. The fact that the helmsman here looks as old as Nestor suggests that this poem has been cut-and-pasted from another image of spring, but this one is as arrestingly modern as the poem is hackneyed. Clearly viewed as if from the opposite bank, the gate of a country house is shown but little of the house itself; this creates that arresting 'reality of imperfect vantage point' which we see in the oblique view of the country house in no. 18.

So what sort of landscape can be visited by making these short excursions through the gates of Dutch cities (see map, fig. 24)? Firstly it should be said that Dutch artists worked in a remarkably small number of cities: apart from visits to Rome (described in chapter III), they lived in Utrecht (in the case of Willaerts, Poelenburgh and Jan Both); Dordrecht (in the case of Cuyp); The Hague and Delft (in the case of Potter); or (in the case of Molenaer, Isaac van Ostade, Philips and Jan Wouwermans, Jacob van Ruisdael, Wijnants, Willem and Adriaen van de Velde, Jan van der Heyden, Hobbema, Lingelbach and Berchem) in the Haarlem–Amsterdam corridor, these two cities being only 12 miles apart. A round trip through all the cities with significant artistic output and which accounted for a large percentage of the entire population of the

Northern Provinces – Amsterdam, Haarlem, Leiden, The Hague, Delft, Rotterdam, Dordrecht and Utrecht – requires a 130-mile walk.[13] This walk occurs mostly in the province of Holland with a brief section in that of Utrecht. This part of the Netherlands (the so-called 'maritime zone', which should include North Holland and Zeeland) was the 'newest', the most man-made and the best served with public infrastructure of any in Europe.[14] The 'creation' of this landscape occurred in the century preceding the creation of the paintings in this exhibition. The scale of the project can be gauged by the increase in population, which in the maritime zone of the Northern Netherlands grew from 350,000 to 1,000,000 between 1500 and 1660, the fastest increase occurring between 1580 and 1630.[15] This resulted in the most densely populated country in the world: the province of Holland had more than 150 souls per square kilometre by mid-century.[16]

The cities themselves were magnificent in their fabric and its maintenance: John Ray, who visited the Netherlands in the late 1660s, wrote of Dordrecht's paved streets that they were so clean 'that a man may walk them in Slippers without wetting his foot in the midst of Winter'.[17] This clean brick paving can be seen on the outskirts of Veere (no. 17). In the matter of infrastructure the Dutch looked for 'continuous improvement': in 1668 Jan van der Heyden designed a system of street lighting for Amsterdam, and in 1683 the Dutch hydraulic engineer, Cornelis Meyer (1629–1701), devised a scheme to render navigable the silted waterways of Rome.[18]

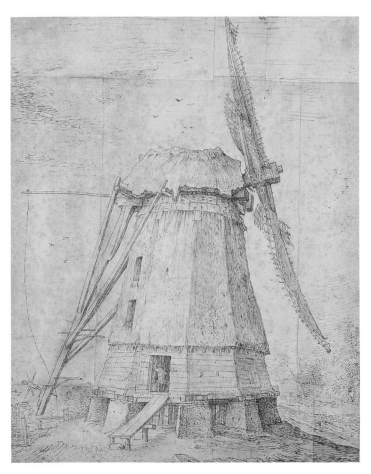

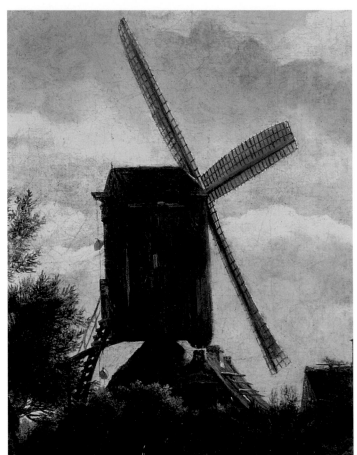

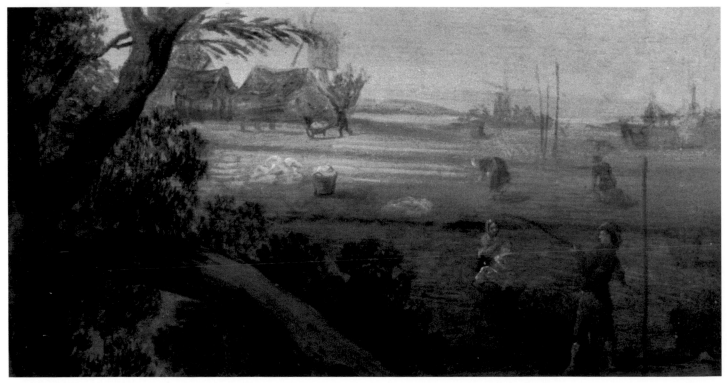

Fig. 25
Roelant Savery,
A Windmill, pen and
ink washes over
graphite, 1613–20
(Royal Collection,
RCIN 906601)

Fig. 26
Jacob van Ruisdael,
*Evening Landscape:
A Windmill by a
Stream* (no. 11, detail)

Fig 27
Jan Miense Molenaer,
Outdoor Merrymaking
(no. 1, detail)

Passenger and freight travel between cities went by water, either on navigable rivers or canals. The main route for all sea trade from the estuary zone in Zeeland (the mouths of the Scheldt, Maas, Waal and Lower Rhine; see fig. 24) was not straight out to sea, as one might have expected, but north to the Zuider Zee through the inland waterways called the *Utrechtse* and *Hollandse binnenvaarten*.[19] The navigable Vliet river was part of the *Hollandse binnenvaart* and can be seen in van der Heyden's view (no. 18). The width of vessel which could pass by this route was determined by the lock built in the fourteenth century at Gouda, on one branch of the *Hollandse binnenvaart*; this was just wide enough for a *smalschip* ('narrow-boat', see fig. 52).[20] The boat in Cuyp's famous painting (no. 39) is a *pleyt*, a vessel very like a *smalschip*, which might take its passengers from Dordrecht to Rotterdam or Delfshaven where it could then head inland up the *binnenvaart*. This inland waterway system was dramatically expanded during the seventeenth century, especially during the years 1632–65, with the creation of canals accompanied by substantial towpaths, called *trekvaarten*. Horse-drawn barges (*trekschuiten*, like the one in fig. 23) carried freight and passengers in a regular public service, slowly but reliably, between 30 cities in the Netherlands.[21] The service between Amsterdam and Haarlem ran hourly, a bell announcing the departure; in the 1660s it carried 300,000 passengers, not counting those who simply walked the distance along the well-kept towpath.[22] Away from these towpaths the road system in Holland was poor: the tracks seen in nos 2, 5, 19 and 20 would have seemed remote, rustic and primitive compared to the city approach in no. 17 and the great water-thoroughfares seen in no. 18 and fig. 23.[23]

This canal system took one through a fertile alluvial landscape, below sea level, much of it reclaimed and all protected from the sea. The expertise, energy and financial investment put into land reclamation resulted in the 'dry' area of the North Holland peninsula (the part north of the Haarlem–Amsterdam line) growing by a third between 1590 and 1650.[24] It was Dutch capital and expertise that drained the English fens in 1625–60.[25] The classic 'polder' (reclaimed field) was surrounded by a drainage ditch and dyke and a ring of windmills to pump the water continuously out of the low-lying fields. Mill design also advanced at this time: the 'post-mill' (*standaardmolen*, see no. 11, fig. 26), where the whole body of the mill rotates, was rendered somewhat old-fashioned by the invention by 1573 of the *bovenkruier* (fig. 25), where a solid structure is topped by a moveable cap and sails.[26] The characteristic geography of the polder – low, flat, rectangular fields and windmills – can be glimpsed in the background of no. 1 (fig. 27), which also includes the common sight of linen being bleached in the sun (see also no. 11). Merchants investing in land-reclaim ventures often built themselves small country houses (called *buitenplaatsen*, literally 'outside-places') around the perimeter of the reclaimed land, exactly as appears in no. 18.[27] Ludolf de Jongh's elegant scene (fig. 28) shows what such a garden might look like from inside. Such plots were

BELOW:
Fig. 28
Ludolf de Jongh,
A Formal Garden,
1676, oil on canvas
(Royal Collection,
RCIN 400596)

OPPOSITE:
Fig. 29
Jacob van Ruisdael,
*View of Egmond aan
Zee*, 1648, oil on panel
(Currier Museum of
Art, Manchester, New
Hampshire. Museum
Purchase Currier
Funds, 1950.4)

surrounded by a drainage ditch, but might also lie next to a waterway with towpath; this gives rise to the characteristic sequence of elements seen in nos 11 and 18 and perhaps in fig. 23: path (often next to a canal); ditch; stand-alone gate to the estate; garden; and finally country house itself.

In this low-lying fertile terrain the settlements often appear very densely wooded (see for example nos 1 and 11 and figs 23 and 30), especially in contrast to the fields which have ditches instead of hedgerows. The heavy planting of settlements was perhaps intended to provide shelter from the wind and much-needed timber (some recently felled trunks can be seen cut from a suburban park in no. 17 and from the village green in no. 19).[28] Wooded village greens called *brinken* still survive in Drenthe; it may be that the woodland effect in Hobbema's villages (nos 19 and 20) is a picturesque rendering of a village *brink*.[29]

The other characteristic (and dramatically contrasting) landscape of the Netherlands is the diluvial soil of the dunes, which surrounds the polders of the maritime region on both sides. A ridge of 'young dunes' runs up the western shoreline; a much larger area of dunes lies inland to the east. The most easily accessible inland dune-scape was called Het Gooi, and lay east of Amsterdam on the south shore of the Zuider Zee; beyond this (south east of the Zuider Zee on the Utrecht–Gelderland border) was De Veluwe or 'Bad-Lands' (see fig. 24).[30] Amsterdamers could reach Naarden on the edge of Het Gooi by *trekschuit* in three hours and suddenly find

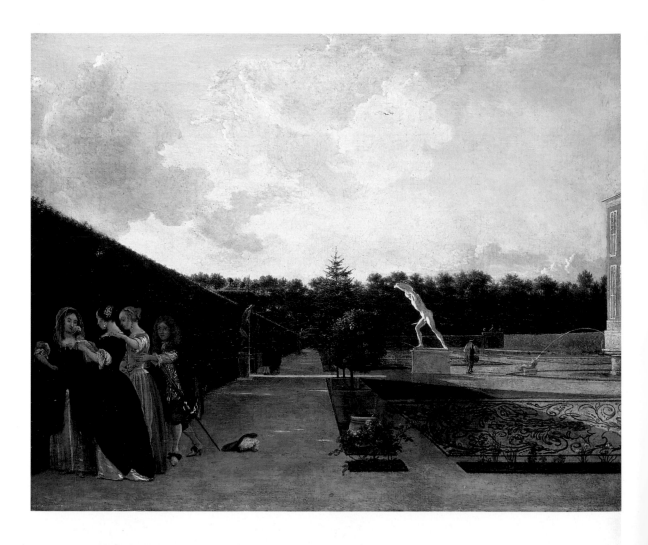

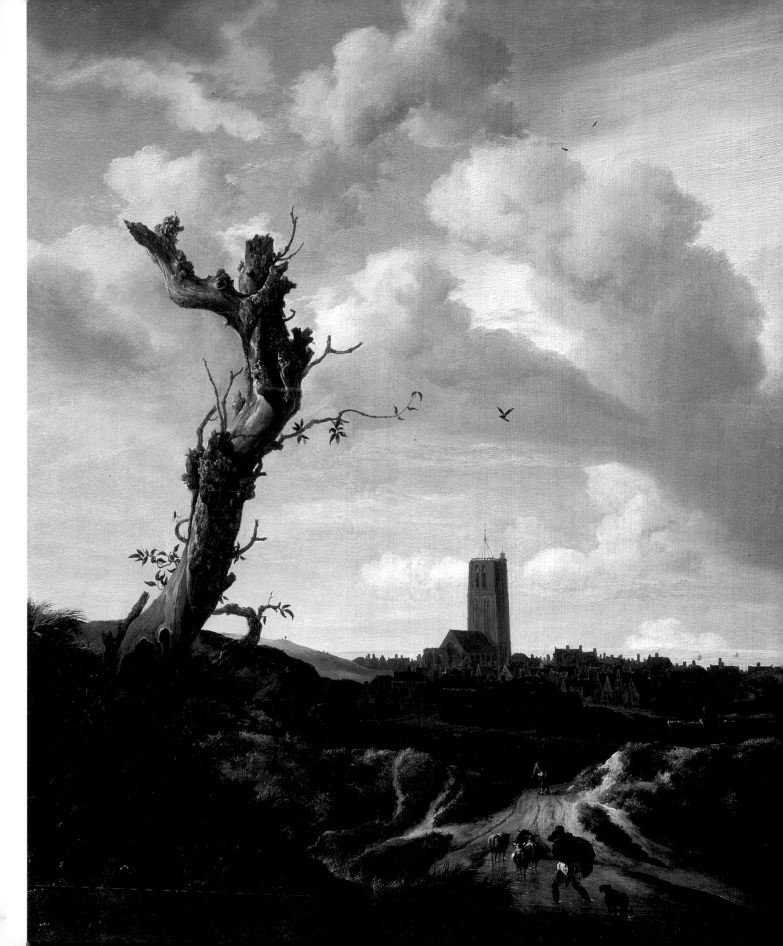

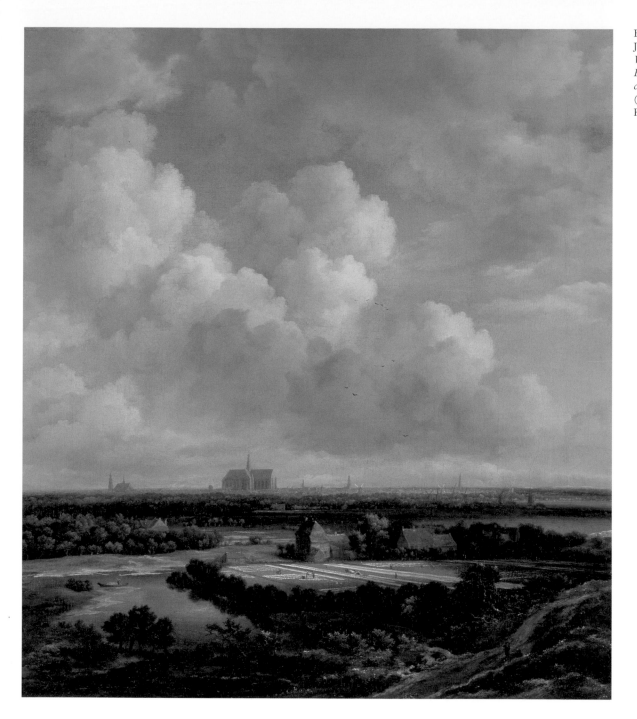

Fig. 30
Jacob van Ruisdael,
*View of Haarlem with
Bleaching Grounds*,
c.1670, oil on canvas
(Kunsthaus Zürich,
Ruzicka Foundation)

themselves on the threshold of a wilder, older, far less populated and hospitable type of landscape.[31] This contrast is described by Jan de Vries:

> The boundary line dividing the alluvial from the diluvial Netherlands consists of a change in soil type and barely perceptible change in elevation, but every man-made navigable waterway stopped abruptly when it reached that point. Away from the major rivers, on whose banks all the towns of the inland provinces were located, transport in the inland zone depended upon wagons and coaches moving slowly along crude sand roads. From the world of frequent, scheduled, horse-pulled barges one entered a world of privately arranged transport and frequently impassable roads – in a word, of unpredictability.[32]

Jacob van Ruisdael was born in Haarlem and often shows in his landscapes the dramatic contrast of the 'unpredictable' dune landscape and the flat, fertile, reclaimed land of the polder, often 'blessed' by brilliant bursts of sunshine. His view of Egmond aan Zee (fig. 29) shows the complex pattern of paths through the coastal dune ridge echoing the wild contortions of the dead tree; his famous 'Little-Haarlem-view' (*Haarlempje*; fig. 30) is taken from the same dune ridge to the north west of the city and shows the bleaching fields and polders drained by windmills. Several landscapes in this exhibition – especially nos 11 and 13 – depict this combination of precious fertile acres surrounded by inhospitable dunes.

We have seen that these landscapes seem often to be about encounters: in most of the group that follows there is a traveller with whom a middle-class city-dweller might identify, either walking, on horseback, riding in a carriage, visiting a beach or fair or hunting. This short account of the geography of the region helps to suggest what sort of encounters these travellers might expect in each terrain. In many places they are on home ground: in the views of the city-to-city thoroughfares (nos 17, 18 and 39 and fig. 23), the economic arteries of the richest country in Europe and the 'delightful places' where one might want to walk or build a *buitenplaats*. Then there are remoter towns and villages with fairs or beer-tents (nos 6 and 7) and paths leading away from the inland waterways where a journey might require a cart (nos 2 and 11). Farmsteads are usually presented as if visited by landowners, who would live in an older style of nobleman's castle, called a *riddershofstad*, like the one visible in the background of no. 9.[33] The farmyard is invariably an idyllic place peopled by idealised Arcadian characters, as in nos 1 and 15, and capable of imparting moral or patriotic instruction, as in nos 8 and 9. Amy Walsh draws attention to the relationship between such scenes and contemporary country house poems: 'As the reader of the *hofdicht* assumes the role of the visitor to the estate and vicariously enjoys the walk through the countryside, the viewer of Potter's paintings identifies with the strollers in the background.'[34]

The contrast between this hospitable world and the 'unpredictable' dune landscape, described by Professor de Vries, is as abrupt in art as in

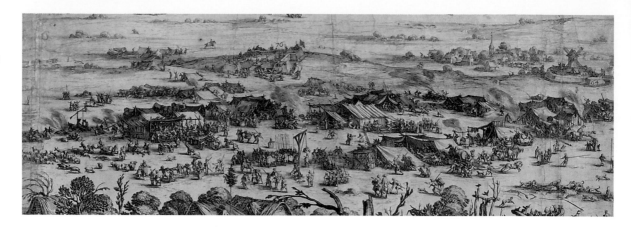

reality. The western dune ridge was a finite strip leading to the beach (no. 14), enjoyed in seventeenth-century Holland in a surprisingly modern way and painted as an impromptu fairground, rather in the spirit of a frozen river (no. 7 and fig. 20). The inland dunes on the other hand lead into the unknown; the only sort of person to undertake the journey in art is the hunter, whose expeditions take him through remoter farms (no. 5), to the 'last inn before the dunes' (no. 10) and on into the heart of the inland dunes themselves (nos 12, 13 and 16). The landscapes of Hobbema (nos 19 and 20) are more difficult to place, as they have the twisted paths of a wilderness and yet the comfortable homesteads of the fertile plain. It is probable that these are imaginative evocations of the settlements of the remoter provinces on the north and west of the Zuider Zee.

The dune landscape is home to a threatening race – soldiers and their camp-followers. These dangerous, noisy swaggerers and their pathetic dependants may have been a genuine contemporary presence (perhaps foreign mercenaries billeted in border regions). The tents set up by camp-followers to serve the soldiers, seen in nos 3 and 4, also appear on the fringes of the war zone in Jacques Callot's huge print of the Siege of Breda (fig. 31) and in the background of the anonymous depiction of William III's departure for England in 1688 (Royal Collection, RCIN 404780). The fanciful and picturesque soldiers in the paintings of Wouwermans may on the other hand be the vestige of a demonising folk memory. The subject of the threat to honest folk of the brutal soldier was an established one in Southern and Northern Netherlandish art throughout the Eighty Years' War (fig. 32). The camp scenes in nos 3 and 4 date from after the peace of 1648, but not long after. Perhaps it is comforting to laugh at soldiers acting like the lords and masters of some barren dunes once their threat to the fertile lands has receded.

Fig. 32
Sebastiaen Vrancx,
*Soldiers Attacking a
Caravan*, 1616,
oil on canvas
(Royal Collection,
RCIN 405516)

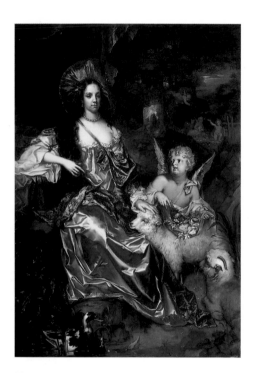

Fig. 33
Jacob Huysmans,
*Catherine of Braganza
as a Shepherdess*,
1664, oil on canvas
(Royal Collection,
RCIN 405665)

Molenaer worked in and around his native Haarlem, except for a decade (1637–48) spent in nearby Amsterdam. He belongs to a group of Haarlem painters who could loosely be termed followers of Frans Hals (*c.*1580–1666). The group included Dirck Hals (1591–1656), Willem Buytewech (who worked in Haarlem from 1612 to 1617) and Judith Leyster (1609–1660), whom Molenaer married in 1636. All these artists excelled in a form of extrovert and comic genre painting, depicting merry gatherings in low and high life. Though never life-size like Frans Hals's, many of Molenaer's figures are of a larger scale than those of most genre painters; they are carefully drawn and finished with a painterly flicker.

This scene of outdoor merriment takes place near a group of impressive farm buildings, with dovecote and tiled roofs (to be contrasted with the thatch seen in nos 2, 9 and 10). In the right background are fertile polders with windmills maintaining constant drainage and a bleaching field, of the type shown near Haarlem in the paintings of Jacob van Ruisdael (fig. 30).

The figures in this scene are more difficult to characterise: they would seem to be imaginary, but are they real peasants or city-dwellers in fancy dress? The fashion for bucolic make-believe arises in part from the Arcadian poetry of the time (see above, p. 34) and can be seen in many Dutch portraits, including Honthorst's group of the children of the King and Queen of Bohemia as followers of Diana painted in 1631 (Royal Collection, RCIN 404971). Fashionable women dressed as shepherdesses with houlettes and wide-brimmed hats were common: an example by Paulus Moreelse (1571–1638) of 1633 is in the Museum of Fine Arts, Boston; a later one of 1664 by the Flemish artist Jacob Huysmans (1633–1696) depicts Catherine of Braganza similarly attired in a rustic Never-Land attended by cupids (fig. 33). A houlette is a long staff with which a shepherd scoops up clods of earth and flings them at straying sheep. The woman seen in profile on the right of Molenaer's group wears exactly such a hat and leans a houlette over her shoulder; the slashed sleeves, feathered caps and unused shepherd's houlettes of the other merrymakers also read like stage properties. The group is engaged in courtship and in singing a rustic song to the accompaniment of pipes and a tambourine, both activities undertaken with the awkward decorousness of genteel folk trying to loosen up. As in many of Molenaer's comic scenes there is the figure of a Chorus commenting upon the action, in this case the boy with the hoop on the right, sharing with us the joke that his elders and betters are as childish as he is in their pursuit of pleasure.

I
JAN MIENSE MOLENAER (*c.*1610–1668)
Outdoor Merrymaking
Oil on panel
75.2 × 106.2cm
Signed: *Jmolenaer*
1650s
First recorded in the collection in 1852.
RCIN 405490
White 1982, no. 117

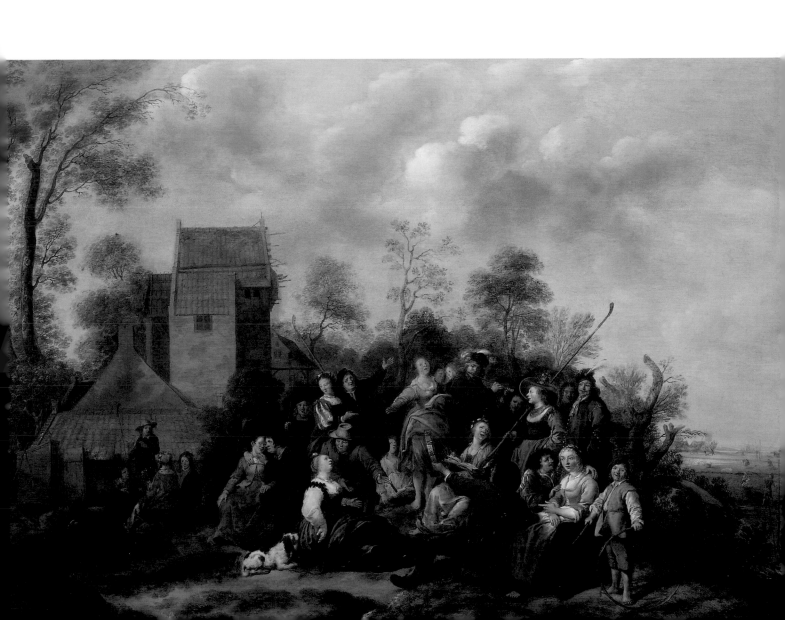

ISAAC VAN OSTADE (1621–1649)
Travellers outside an Inn
Oil on panel
83.2 × 109.5cm
Signed and dated: *Isack van Ostade/1647*
Acquired by George IV in 1814 with the Baring collection;
valued in 1819 at 100 guineas.[35]
RCIN 405216
White 1982, no. 138

Isaac van Ostade was a pupil of his much older brother, Adriaen van Ostade (1610–1685), and painted in Haarlem for a decade before his early death. His work, like that of his brother, represents a cheerful domestication of the satirical depiction of peasant life seen in Pieter Bruegel the Elder and Adriaen Brouwer (*c.*1606–1638). The way in which the landscape is composed and executed in this work demonstrates the influence of the so-called 'tonal school', a group of artists who passed through Haarlem in the 1610s and 1620s, creating a style which conveys with minimal means a dank, atmospheric distillation of a river or roadside scene: Esaias van de Velde (*c.*1590–1630, in Haarlem 1610–18) Jan van Goyen (1596–1656, in Haarlem 1615–16) and Salomon van Ruysdael (*c.*1610–1670, in Haarlem from 1623, see no. 22). Ostade's diagonal composition, his muted colour range, thin application of paint and organic confusion of buildings, trees, grass and earth, as if every part of the scene were marinated in mud, perfectly exhibits the effects of the tonal school.

The meaning of this scene is appropriately conveyed by these frugal means. The cart with the open sides is adapted for the transport of the rich (another appears in no. 14), but is not as fashionable as a coach (as seen in no. 8). The bourgeois couple (the only ones wearing bright colours or distinct blacks and whites) have taken a byroad where they stop at a down-at-heel inn, staffed by harmless drudges whose forms are submerged in the sludgy light and whose round backs resemble those of beasts of burden. A beggar shuffles on wooden blocks and hand-held pattens; beggars of all descriptions are surprisingly common within Dutch landscapes (see also nos 4, 5, 14, 17 and 19).

The qualities of this painting go a long way to explaining its modest value in the eyes of George IV's cataloguer (see above); it is nonetheless surprising that similar works by David Teniers the Younger were so highly prized.[36] At this same time David Wilkie was creating a distinctive style of genre painting out of a fusion of the Flemish and Dutch traditions and seems to have worked out how to create Dutch effects and charge Flemish prices: his *Village Holiday* (fig. 34) was painted for John Julius Angerstein in 1811 at a cost of 800 guineas.[37] The earth colours and soft dappled half-light are especially reminiscent of Isaac van Ostade's work, as is the stuffed-toy rusticity of the figures. George IV acquired his first Wilkie – *Blind Man's Buff* (Royal Collection, RCIN 405537) – in 1812 for 500 guineas.[38]

Fig. 34
Sir David Wilkie,
*The Village Holiday
(The Alehouse Door)*,
1809–11, oil on canvas
(Tate, London)

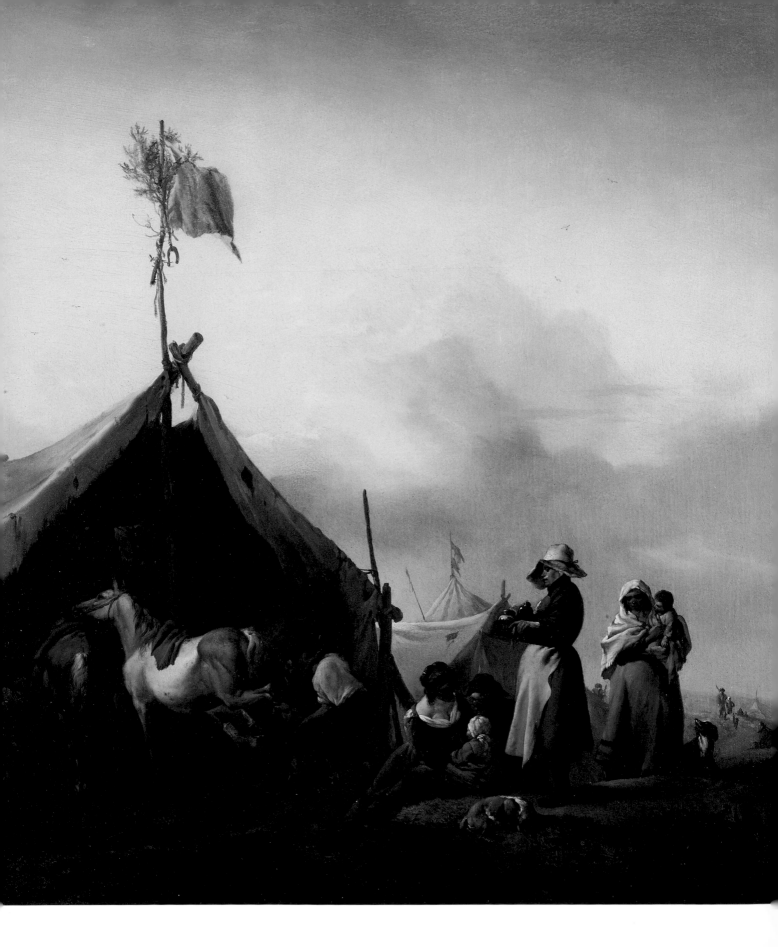

3
PHILIPS WOUWERMANS (1619–1668)
The Farrier of the Camp
Oil on panel
35 × 30.2cm
*c.*1650
Acquired by George IV in 1814 with the Baring collection;
described in 1819 as 'an early but excellent picture of the
Master', and valued at 100 guineas.[39]
RCIN 404809
White 1982, no. 238

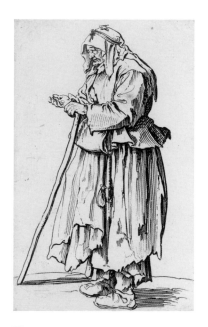

Fig. 35
Jacques Callot,
*Old Woman with Open
Hand* from *Les Gueux*,
1622–3, etching
(British Museum)

Philips Wouwermans spent his life in Haarlem, though briefly visiting Hamburg in 1638 or 1639. Wouwermans's early work is reminiscent of that of Isaac van Ostade (no. 2) and the influence of the Haarlem tonal school persists throughout his career in effects of soft light filtered through misty skies and in the thinly painted areas allowing brown underpaint to show through. His later work has bluer skies, and a more silvery overall tonality as well as including more elegant figures.

This relatively early work shows how Wouwermans departs from the imagery of Isaac van Ostade. In the first place the scene is more remote and threatening: a collection of makeshift tents on a rough dune landscape, set up by camp-followers in order to profit from soldiers billeted nearby. As we have seen (p. 44 above), such opportunistic encampments are visible in the middle ground of Jacques Callot's *Siege of Breda* (fig. 31). The farrier's tent is advertised by a horseshoe on its flagpole; the farrier himself shoes a horse, while a sutler from a neighbouring tent brings a pot of ale. Various women (perhaps soldiers' 'wives') clutch babies. These figures are more individualised and distinctly drawn than in Ostade's work and the heroine stands out against the sky in dramatic silhouette, instead of nestling within the outlines of the landscape as in Ostade's work. These strangely imposing figures – part heroic, part grotesque – derive from Pieter van Laer (1599–1642), a Haarlem artist who worked in Rome and who created the prototypes for the menacing street-loiterers seen in nos 34 and 35, before returning home in 1639. Wouwermans was said to have owned a collection of studies that van Laer had made in Rome.[40] Reynolds clearly noticed the force of van Laer's drawing with the brush, referring to his 'correct, firm, and determined pencil [paintbrush]' which might have been employed on more elevated subjects than he chose.[41] Wouwermans's principal figure is also reminiscent of another monstrous heroine, one of Jacques Callot's beggars (fig. 35), from a series of etchings of 1622–3, especially in the way in which her form seems to be stitched together from rags and driftwood. It is no accident that this redoubtable camp-follower reminds us of 'Mother Courage', a character who first appeared in 1669 in a novel, *Die Lebensbeschreibung der Erzbetrügerin und Landstörtzerin Courasche* (The Life of the Arch-Swindler and Sutler Courage), by Hans Jacob Christoph von Grimmelshausen (1621–1676).

4

PHILIPS WOUWERMANS (1619–1668)
Cavalry at a Sutler's Booth, previously called
Le Coup de Pistolet
Oil on panel
49.3 × 44.2cm
Signed
c.1650–59
Acquired by George IV in 1812; described in 1819 as 'in his
finest manner' and valued at 500 guineas.[42]
RCIN 404615
White 1982, no. 245

This scene is again set on the fringes of a soldier's camp where camp-followers lay out their tented stalls. 'Sutler' comes from the Dutch *zoetelaar* (sweetener) and refers to the manager of the camp's beer tent and convenience store. A tankard here hangs on the side of the tent; a woman draws a measure from a barrel and a girl arrives with another tankard to be filled.

The subject of this painting is not so much the service providers as the soldiers themselves, who seem to conform to a recognisable stereotype – that of the braggart or swaggerer. The most famous example in English literature of the swaggerer is Pistol, a 'captain' (though his right to this title is disputed) and Falstaff's ancient from Shakespeare's *Henry IV*. Swaggerers are usually soldiers or would-be soldiers; they are noisy, bombastic, vainglorious and quarrelsome. They are the very antithesis of respectable folk, as the Hostess of the Boar's Head Tavern in Eastcheap somewhat repetitively explains:

> If he swagger, let him not come here. No, by my faith! I must live among my neighbours; I'll no swaggerers. I am in good name and fame with the very best. Shut the door. There comes no swaggerers here; I have not liv'd all this while to have swaggering now. Shut the door, I pray you (Shakespeare's *Henry IV*, Part II, Act II, scene iv).

Wouwermans's swaggerers are quite as anti-social as Shakespeare's, though kept away from honest folk. One blows on his trumpet; another drinks a noisy toast; a third is accompanied by his woman riding pillion; a final swaggerer discharges a pistol into the air (something that Pistol also threatens to do). An elderly cripple tries in vain to catch their attention, reminding the audience of how the young soldiers' pride will eventually be brought as low. A dog defecates in the foreground as if to underline the point that these are dung-heap champions.

5
PHILIPS WOUWERMANS (1619–1668)
The Hayfield
Oil on canvas
66.9 × 79.1cm
1660–68
RCIN 405334
Acquired by George IV in 1811; described in 1819 as
'one of his Brilliant and Silvery Pictures, finished with the
greatest care throughout' and valued at 800 guineas.[43]
White 1982, no. 249

Though a harvesting scene, the first characters we notice and identify with are the outsiders – the hunters picking their way past a blind beggar on a narrow path, as if about to meet us (the viewer) coming in the opposite direction. They are falconers: one man holds a falcon and a clutch of dogs to retrieve any hunted birds; the other man leans a 'lure-pole' against his shoulder (this is a long pole on the end of which is attached some bait to persuade the bird to return to the arm; one also appears in fig. 21 and no. 12). The mowers are working as long as daylight lasts, piling up the hay, loading it into carts and a barge on the canal to the left. The waterman is bathing to remind us how hot it is to work in the sun, an idea also conveyed by the even warm grey tonality, suggestive of the dusty heat of the harvest. Three women take a break from work and attempt to stuff hay up each other's dresses, watched by a boy with a satchel.

As the compiler of the 1819 inventory of Carlton House pointed out, this is painted in Wouwermans's finished technique and with the 'silvery' tonality characteristic of his later work, features that evidently justified its astonishing valuation. In spite of this precious air, the composition and narrow colour range is still reminiscent of the tonal school and in particular of the work of Isaac van Ostade. Wouwermans has imitated Ostade's tendency to rhyme or homogenise the forms and patterns of the landscape – the thatch of the cottages with the hayricks, the broad backs of the men with the rumps of the horses – as if long habit has made men and their creations seem part of the landscape.

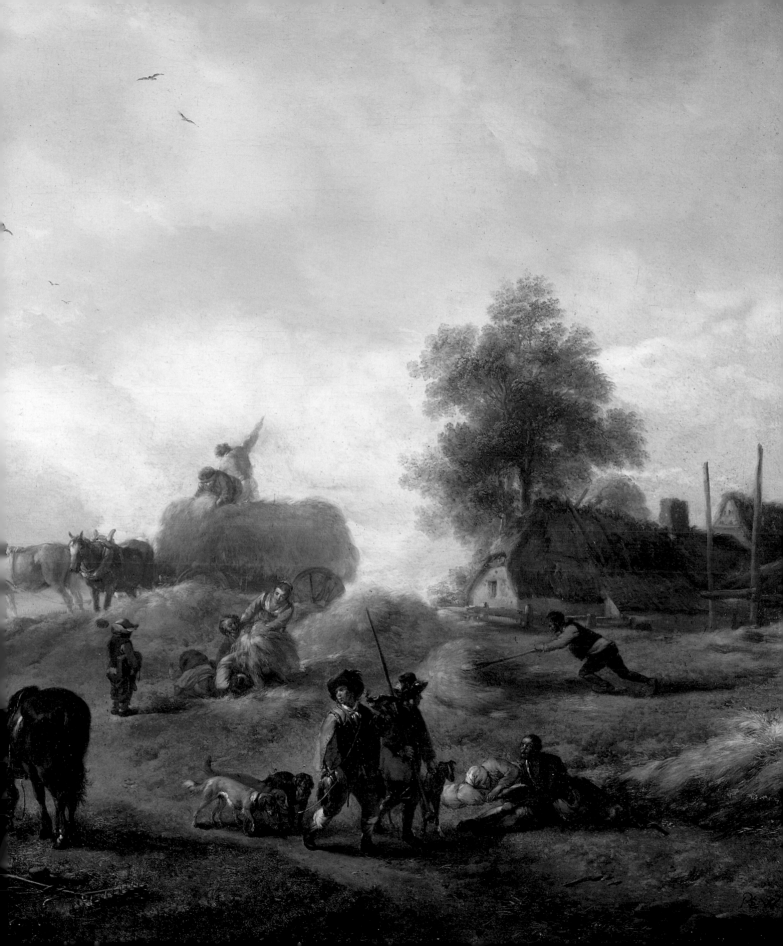

6
PHILIPS WOUWERMANS (1619–1668)
A Horse Fair in Front of a Town
Oil on canvas
69.5 × 82.2cm
*c.*1660–68
RCIN 405330
Acquired by George IV from the Baring collection in 1814;
described in 1819 as 'Most Capital' and valued at £850.[44]
White 1982, no. 239

By the time he painted this late work Wouwermans was a celebrated artist, whose trademark was the depiction of horses; here he sets out a parade of them seen from various different points of view. His principal figures are now cavaliers and bourgeois couples. By this date there is a rich repertoire of images of village and town fairs from throughout Europe, including the Flemish kermis by artists such as Jan Brueghel (fig. 16); and the Italian *fiera*, seen in Jacques Callot's *Fair at Impruneta* of 1620 or Lingelbach's *Village Festival* of *c.*1650 (Castle Museum, Nottingham). Wouwermans's town appears essentially Dutch, but the landscape falls away in a wide dish-shape to allow us to survey the panorama, according to the conventions of landscape painting rather than the topography of the Netherlands.

This painting allows us a fascinating glimpse of a seventeenth-century toy stall, at the left edge (children in the foreground walk off clutching purchases). We also see a high, makeshift stage in the middle distance upon which a theatrical presentation is underway. It is tempting to suggest that William Hogarth (1697–1764) might have seen this painting or others like it when working on his *Southwark Fair* of 1733 (Private Collection).

JAN WOUWERMANS (1629–1666)
A Winter Scene with Figures
Oil on panel
60.2 × 83.1cm
Signed and dated: *J.W./ 1657*
RCIN 407219
Acquired by George IV in 1811; it was commented in
1819 that 'the works of this Master are very rare as he died
young and left but a few Pictures'; this one was valued at
30 guineas.[45]
White 1982, no. 237

Jan Wouwermans was the younger brother of Philips (see nos 3–6) and like him spent his entire career in Haarlem. This scene belongs to a type invented by Hendrick Avercamp (1585–1634) where a frozen river provides a stage upon which a species of spontaneous town fair takes places, with a rich variety of ages, classes and types carefully studied from life (see figs 18–20). When the genre reached Haarlem it was 'toned down' by Esaias van de Velde and Jan van Goyen, with lower horizons, thicker atmosphere and more muted colours. It is this Haarlem style of the skating scene which Jan Wouwermans presents here.

The frozen river scenes of Avercamp (fig. 20) and later artists tend to include a venerable castle to provide a solid and lasting contrast to the impermanent world of the ice fair. In this case a semi-aristocratic country house is contrasted with a temporary beer tent set up by some enterprising profiteer, who advertises his wares with a wreath, a Dutch flag and a jug slung over a pole. Similar temporary outlets are similarly promoted in nos 3, 4 and 10. Around the tent men and children skate, ride in horse-drawn sleighs, push each other on sledges or punt themselves along the ice on wooden blocks.

The rarity of Jan Wouwermans's works, discussed by the compiler of the 1819 inventory of Carlton House (see above), did not seem to increase their value. This is by far the cheapest of George IV's paintings in the exhibition and the only one he thought unworthy to hang in the Picture Gallery at Buckingham House, sending it instead to join the more rustic display of paintings at his newly built 'cottage' in Windsor Park (the present Royal Lodge).

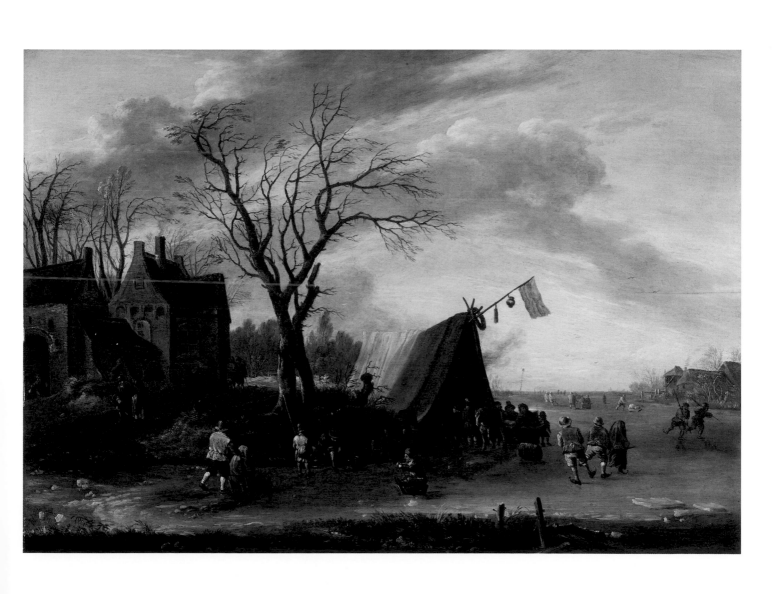

8

PAULUS POTTER (1625–1654)
A Young Bull and Two Cows in a Meadow
Oil on panel
70.2 × 63cm
Signed and dated: *Paulus Potter: f: 1649.*
Acquired by George IV in 1814 with the Baring collection;
described in 1819 as 'painted with great force and with the
utmost delicacy and freedom of pencilling' and valued at
1,000 guineas.[46]
RCIN 404585
White 1982, no. 154

Fig. 36
James Ward,
'Nonpareil', 1824,
oil on canvas
(Royal Collection,
RCIN 405018)

aulus Potter was born in Enkhuizen and studied with his father Pieter Symonsz. Potter (*c.*1597–1652); his brief career was divided between three major Dutch artistic centres: Delft in 1646–9, The Hague in 1649–52 and Amsterdam in 1652–4. His life-sized *Young Bull* (Mauritshuis, The Hague), painted in 1647 when he was only 22, announced two distinctive attributes of his art, which can also be seen in this smaller bull of two years later: his 'extraordinarily exact eye', described by Fromentin; and the suggestion of luminous skies and a sweep of landscape conveyed within a tiny wedge of background.[47] These characteristics mark a decisive departure from the technique of the tonal school: with strong contrasts of colour and tone rather than subtle transitions; with a thicker, drier and more opaque paint layer built up crisply to suggest the varied textures of the subject.

This is a confrontational bull: he is seen from below, his dark form silhouetted against a blaze of light as a storm clears. This animal was painted in an age when resemblance between man and beast was thought to provide serious scientific evidence as to the natures of both. A man's character could then be read by reference to the animal he most resembled: the bovine physiognomy, for example, is illustrated with a comparison of a bull-headed man and an actual bull in Giovanni Battista della Porta's *De humana physiognomonia* of 1586.[48] The same thing worked the other way round: animal behaviour and expression was generally read anthropomorphically. This bull looks very human: the bulging eyes, open mouth and apparent frown suggest that he is telling us to be on our guard. These two *Young Bulls* (this and the one in the Mauritshuis) were painted at the time (1648) that the United Provinces finally won their independence from Spain, after an 80-year struggle. One personification of these United Provinces was 'the Hollandse kuh, the Dutch cow: fat, fecund and peaceable (and symbolizing both rural and commercial prosperity)', which Simon Schama goes on to describe as 'a form of visual self-congratulation'.[49] A famous satire from the early days of the war shows Philip II of Spain trying to ride the Netherlandish Cow.[50] A series of five allegorical prints by Hendrick Hondius was published in 1644 warning the Dutch not to be defrauded by the Spanish in the negotiations leading up to the conclusion of the war; one of them, *Cows by a River*, is inscribed 'Watchmen do your best to see that the Dutch cow is not stolen from us.'[51] Potter's animals are not these fat docile cows, but lean and pugnacious bulls; they would still surely have been read allegorically by his original audience. This is the 'Dutch Bull' defending his family and his meadow from all-comers.

Ten years after acquiring this painting, George IV commissioned James Ward (1769–1859) to paint his 'favourite charger', Nonpareil (fig. 36); this nervous, heroic champion, seen against a clearing storm, has exactly the human character of Potter's bull, as well as his hyper detail and intensely explored textures.[52]

PAULUS POTTER (1625–1654)
The Young Thief
Oil on panel
53.9 × 77.7cm
Signed and dated: *Paulus. Potter. f. 1649.*
Acquired by George IV in 1814 with the Baring collection;
described in 1819 as 'formerly in the celebrated Collection
of M. Gildermeester of Amsterdam and ever considered in
Holland as one of the most Capital productions of the
Master' and valued at 2,000 guineas.[53]
RCIN 400527
White 1982, no. 155

This painting offers a narrative which can be read with more certainty than any other in this selection. It is a beautiful summer's evening; a landowner (or his agent) rides over wide fertile meadows from the country house in the background to visit one of the farms on the estate; the farmer's wife is milking. Suddenly the peace of this rural idyll is shattered: a bitch starts barking and snarling; a boy screams; a cockerel crows in alarm and a sheep bleats. All this because the boy has stolen two newborn puppies, one of which he has already dropped and lies sprawling on the floor; the other he will need to surrender when the bitch gets more of him than the hem of his shirt.

At one level this episode teaches the simple country lore that one should be wary of approaching any animal with young. At another it seems to illustrate a more universal principle – that each species loves its own. Just as the farmer's wife loves her thieving son, so the stallion loves its mare and can be seen nuzzling in the stable; the cows and the sheep similarly pair off two-by-two (though whether bull or ram is present cannot be determined). Let nobody then separate a bitch from her suckling puppies. The supporting cast in this farmyard drama are presented even more anthropomorphically than in no. 8, and seem to look on bemused and indulgently (the bleat of the sheep deliberately appears as laughter).

Though this narrative was described in the 1819 inventory of paintings at Carlton House, this modern Aesop's fable is much less appreciated now. The overstated expressions seem to us more appropriate for children's illustration or even animation than painting.

PAULUS POTTER (1625–1654)
Two Sportsmen outside an Inn
Oil on panel
53.2 × 43.8cm
Signed and dated: *Paulus Potter. f. 1651*
Acquired by George IV in 1811; described in 1819 as
'painted in the best time of the Master' and valued at
800 guineas.⁵⁴
RCIN 400942
White 1982, no. 156

This is a classic 'sportsman's sketch': a rich man is shooting among the dunes, visible in the background, accompanied by a professional hunter, holding a gun and two birds. The wilderness into which they have strayed has thrown them upon the mercy of a remote inn, with a cracked pot announcing the inadequacy of the hospitality on offer. The fine cavalier, colourfully dressed, centrally placed and finely mounted, with a beer pot in his hand, has his stirrup adjusted by a flustered boy, whose mother brings another drink from an interior which she shares with a pig. Farmhouses with separate lodging for humans and livestock had already been introduced in the more advanced provinces of the Netherlands.⁵⁵ Neither mother nor son wears shoes – an infallible sign of poverty rarely seen in Dutch paintings. An old man, presumably the innkeeper, is apparently overcome with the exasperation of dealing with such exalted and exacting customers and dabs his forehead, while no doubt muttering oaths under his breath. The huntsman's spaniel sniffs the innkeeper's mongrel, while a horse urinates.

Reading this image as a comic encounter (it doesn't quite constitute a narrative) is conjectural but reflects what must surely be a universal experience of travel, and moreover follows good literary and visual precedents. Ovid's story of Jupiter and Mercury enjoying the frugal hospitality of the elderly peasant couple, Philemon and Baucis, was similarly painted for laughs by Adam Elsheimer (1578–1610), an image (now in the Gemäldegalerie, Dresden) widely disseminated through Hendrick Goudt's engraving of 1612 (fig. 37).

Fig. 37
Hendrick Goudt, after
Elsheimer, *Jupiter and
Mercury in the House of
Philemon and Baucis*,
1612, engraving
(British Museum)

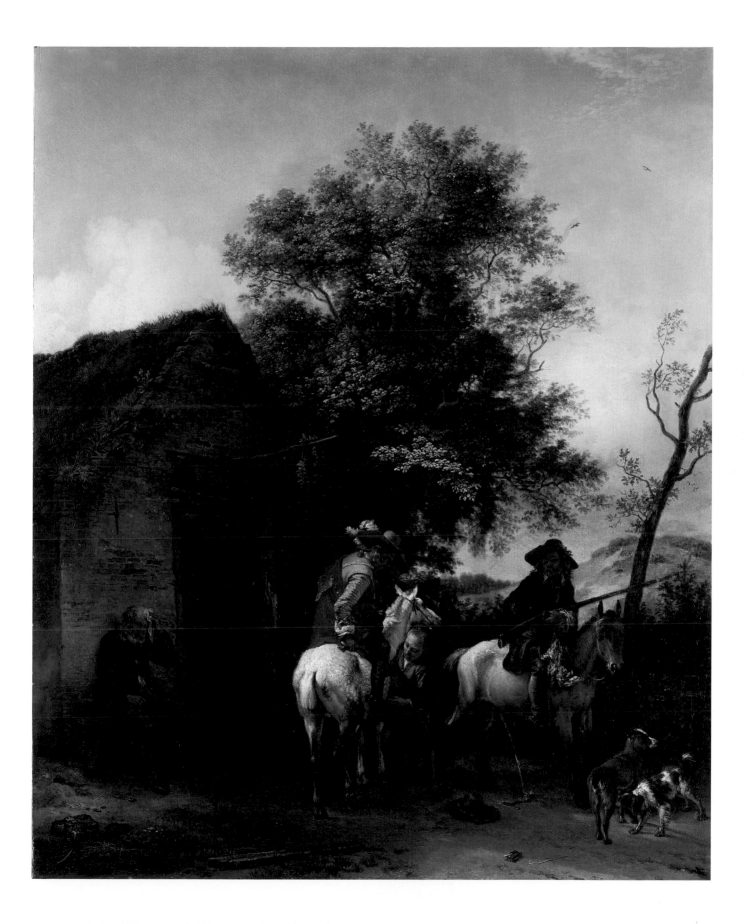

11
JACOB VAN RUISDAEL (1628/9–1682)
Evening Landscape: A Windmill by a Stream
Oil on canvas
79.1 × 102.4cm
Signed: *JvRuisdael*
Mid-to-late 1650s
Acquired by George IV in 1810; seen hanging in the Blue
Velvet Closet (fig. 8); described in 1819 as 'capital' and
valued at 400 guineas.[56]
RCIN 405538
White 1982, no. 172

Jacob van Ruisdael is thought to have trained in Haarlem with his father, Isaack van Ruisdael, and his uncle Salomon van Ruysdael (see no. 22). Ruisdael had moved to Amsterdam by 1657 and stated before an Amsterdam notary in 1661 that he was 32, thereby indicating a birth date of either 1628 or 1629.[57] He is generally regarded as the greatest of the seventeenth-century Dutch landscape painters.

In 1821, when John Constable (1776–1837) saw *Evening Landscape* on display at the Royal Academy, his friend David Lucas (1802–1881), a printmaker, recorded that he particularly admired the 'acres of sky expressed'.[58] This vast expanse of sky dominates the composition, with its ominous clouds rolling over the carefully constructed scene below. Although only in his twenties Ruisdael seems to be honing his skills in this painting by repeating a landscape that he had created when aged 18: *A Windmill near Fields* (fig. 38). The location depicted in both works has not been identified; it may be a specific place, but is more likely to be an idealised landscape constructed out of various sketches and studies which Ruisdael would have made outdoors in the area around Haarlem. Ruisdael appears to have considered such sketches as working drawings, with the result that familiar motifs recur in many of his finished paintings.

The windmills in this painting and in fig. 38 are old-fashioned 'standard-mills' (*standerdmolen*), meaning that the entire body of the mill rotates around a central pole (once the ladder has been raised), which is why it is entirely logical that the Cleveland and Royal Collection paintings show different alignments. Ruisdael has painted out smoke rising (in the wrong direction) from the chimney to the right and added some rising (in the right direction) above the cottage to the left. When comparing the two compositions it is as though the viewer of no. 11 has stepped backwards, in order to gain a clearer, more striking impression of the foreground. The greatest difference between the two paintings occurs in the sky. In the decade between the two works, Ruisdael perfected his ability to create dramatic visual tension, so that the heavy clouds in this painting imbue the scene with character and emotion. The question remains: does such an image have a moral or religious meaning? The scene certainly reflects mankind's dependence upon nature, but the main message lies in the prominence of the windmill – an enduring symbol of the Dutch Republic which played a significant role in the new country's industry and resulting wealth.

Between 1646 and 1657 Ruisdael regularly dated his works, but this painting is undated. It has been placed in the mid-to-late 1650s on the evidence of the sophistication of handling and the unyielding, harsh colours which define the artist's work of this period.

Fig. 38
Jacob van Ruisdael,
*A Windmill near
Fields*, 1646, oil on
panel (The Cleveland
Museum of Art,
Mr and Mrs William
H. Marlatt Fund,
1967.19)

JAN WIJNANTS (*c*.1625–1684)
A Hilly Landscape with a Hawking Party
Oil on panel
45 × 55.4cm
Signed: *J.Wijnants*
c.1665
Acquired by George IV in 1810; thought in 1819 to be a
Wijnants landscape for which Wouwermans supplied
figures, 'a most beautiful work of the two Masters';
valued at 350 guineas.[59]
RCIN 400940
White 1982, no. 263

Wijnants was born in Haarlem, though he had moved to Amsterdam by 1660. His artistic milieu is also suggested by the artists whom he employed to furnish figures for his landscapes: Adriaen van de Velde (nos 14–16), Johannes Lingelbach (nos 27 and 34) and Philips Wouwermans (nos 3–6). The figures in this case appear to be by Adriaen van de Velde, rather than Wouwermans as proposed in 1819. Wijnants's landscape style is formed on that of Jacob van Ruisdael (no. 11), though he lightens Ruisdael's sombre tones, intensifies his colours and makes something more ornamental out of his dramatically gnarled forms. In both the works included here this strong sense of 'crinkled' design informs the patterns of the trees, dunes, tufts of grass, broken branches and even the rutted mud of the track. These conform to Gerard de Lairesse's idea of improper 'painter-like' effects (see p. 31); in his distinctive version of this visual language Wijnants may also have been influenced by oriental landscape forms, which he would have known through the import of porcelain from China by the Dutch East India Company and its imitation in contemporary Delftware.

Wijnants here depicts the remote, infertile and 'unreconstructed' geography of the dunes, with twisting paths, broken fences, and undrained meres. Though only a generic evocation, these look like the inland dunes in Het Gooi and the 'Bad-Lands' beyond, rather than the so-called 'Young Dunes', a strip along the coast of Holland. This land is fit for nothing but shooting and hawking; the mounted huntsman in red has just released a falcon and his assistant rushes over with a 'lure-pole'.

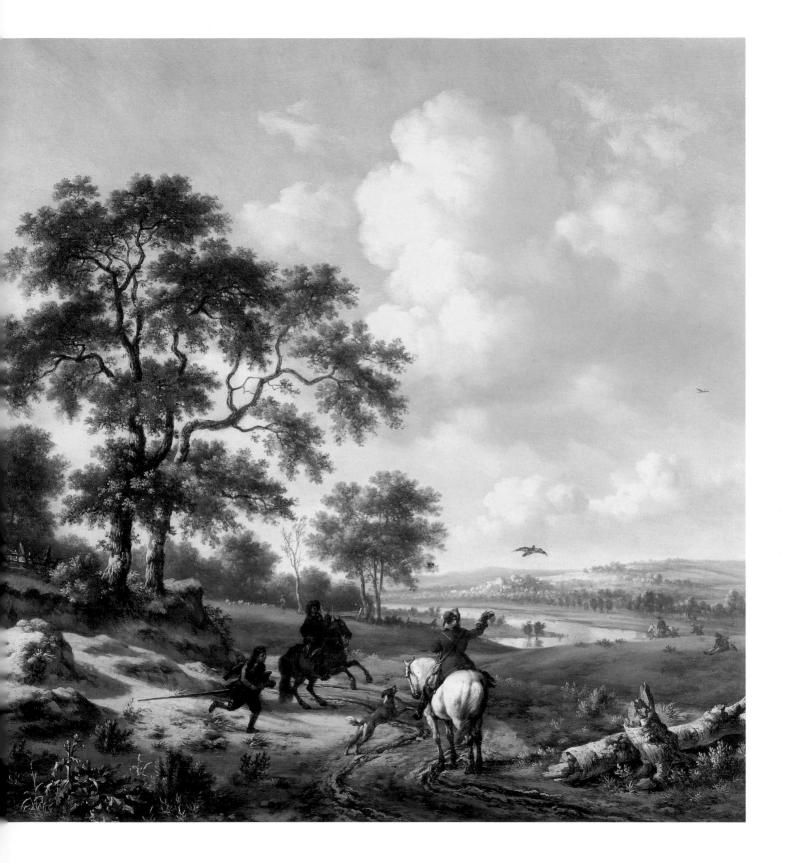

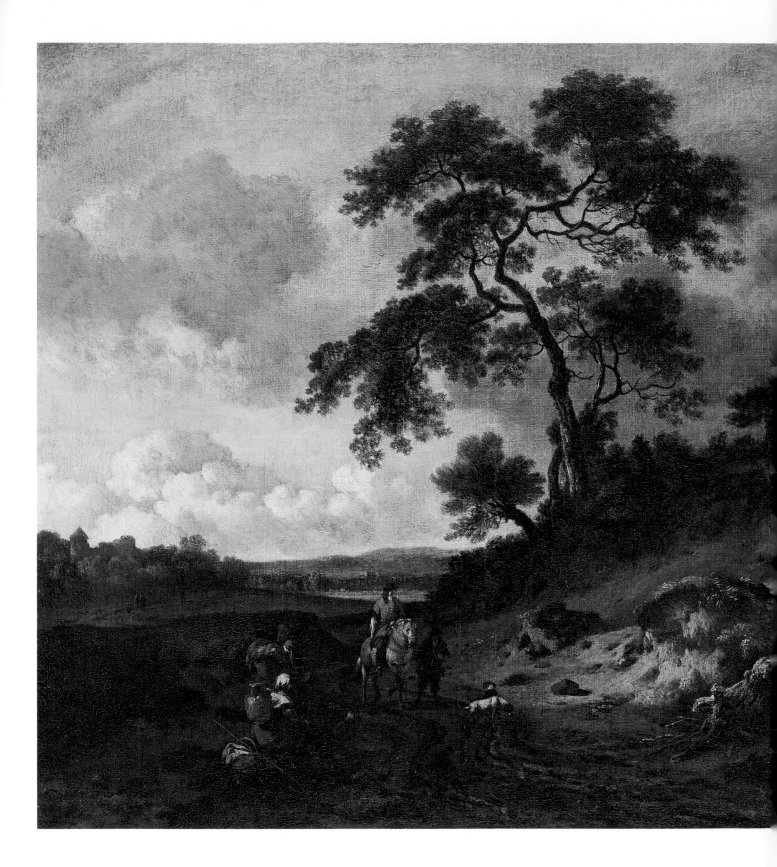

AS THE CITY GATE OPENS

13

JAN WIJNANTS (*c.*1625–1684)
Sportsmen in the Dunes
(Photographed before conservation)
Oil on canvas
38.5 × 47.8cm
Signed and dated: *JWijnants. 1669.*
Acquired by George III in 1762 with the collection
of Consul Joseph Smith.
RCIN 405661
White 1982, no. 264

In *Sportsmen in the Dunes* Wijnants uses the undulation of the terrain to great visual effect. The dominant tree in the centre unites the two distinct elements of the dunes and, accentuated by a stream of sunlight, the lower-level polders (land reclaimed from the sea) beyond. A rider surveys the hilly dunes which rise up alongside the rough, twisting path. His clothes, and the inclusion of a gamekeeper accompanying him on foot, indicate wealth. They may have travelled from the large estate on the left. A figure with a gun is visible on the top of the dunes, shooting a bird with a dog behind him. In peaceful contrast a couple rest with their bundles on the roadside below.

Sand dunes frequently appear in Dutch landscapes of this date and, like the windmill, became a symbol of national pride.[60] The viewpoint displayed here, with the dunes blocking the view of the sea beyond, emphasises their protective nature, as well as their potential as a venue for sport. The barren fallen tree in the foreground serves to guide the viewer's eye up to the top of the dunes while also signifying the potential violence of high winds from the North Sea.

The figures in this landscape could be by Johannes Lingelbach (see no. 27) or Adriaen van de Velde (as in no. 19).

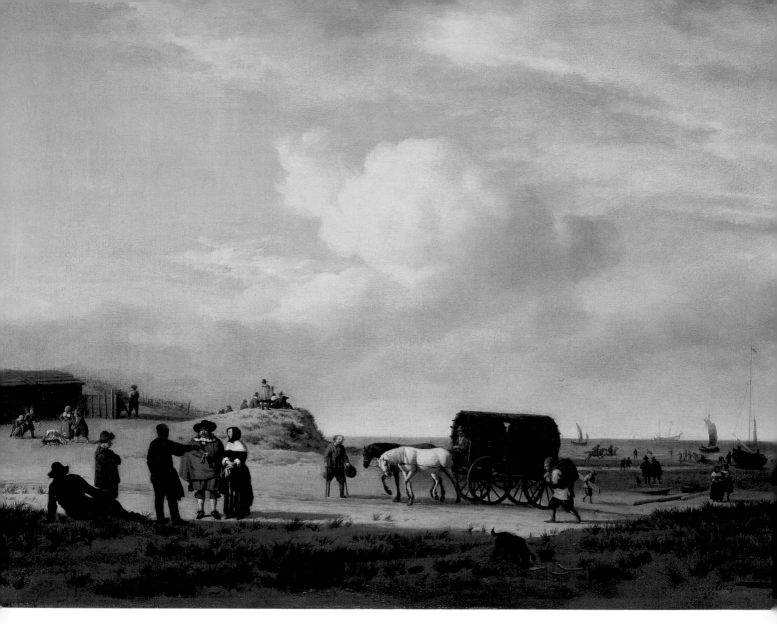

14

ADRIAEN VAN DE VELDE (1636–1672)

Figures on the Beach at Scheveningen

Oil on canvas

38.2 × 50cm

Signed: *A.V.Velde. f. / 1660*

Acquired by George IV in 1814 with the Baring collection; described in 1819 as 'a very singular and beautiful work of the Master' and valued at 300 guineas.[61]

RCIN 404802

White 1982, no. 203

Adriaen van de Velde lived and worked in Amsterdam; he trained with his father, the marine painter Willem van de Velde the Elder (1611–1693), and Jan Wijnants (nos 12 and 13). He was one of the most prolific providers of figures for the landscape paintings of his colleagues, including Jan van der Heyden (nos 17 and 18), Ruisdael (no. 11), Hobbema (nos 19 and 20), Philips Koninck (1619–1688) and Allart van Everdingen (1621–1675).[62] This is one of several Scheveningen beach scenes, the earliest now in Kassel (fig. 39), which demonstrate more clearly than his later work his relationship with his elder brother, Willem van de Velde the Younger (1633–1707), whose *Calm* (no. 23) was painted a few years previously.

The Dutch at this time were the first to think of the 'seaside' in the modern sense; Adriaen van de Velde's group of paintings is the first to show what would become Europe's favourite holiday activity. Previous images of Scheveningen, such as Simon de Vlieger's of 1633 in the National Maritime Museum, London, depict working fishermen. The majority of figures in van de Velde's beach scenes are obviously middle class and enjoying their leisure. On the left a city family sit in one of the huts, which may be intended for bathers or fishermen; another couple ask directions; another are carried past the inevitable beggar in a hired cart with open sides (like that in no. 2 and fig. 39, where it takes its passengers along the sea's edge). Behind a decorously amorous couple can be seen a pair of horsemen riding along the strand and some bathers. There is some industry – a barefooted fisherman carries a basket of fish; others mend boats – but already tourism appears to be a more profitable enterprise.

Fig. 39
Adriaen van de Velde,
*The Beach at
Scheveningen*, 1658,
oil on canvas
(Museumslandschaft
Hessen Kassel,
Gemäldegalerie Alte
Meister)

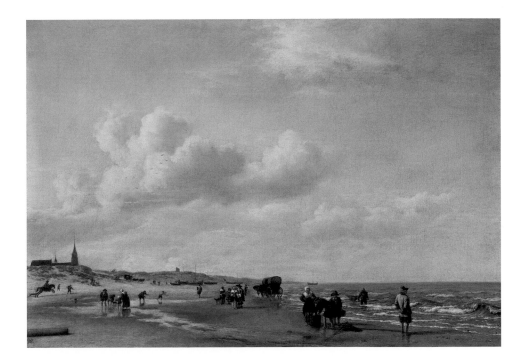

ADRIAEN VAN DE VELDE (1636–1672)
A Woman Milking a Goat outside a Barn
Oil on canvas
33.6 × 27.2cm
Signed and dated: *A.V. Velde. f. / 1666*
Acquired by George IV in 1814 with the Baring collection;
described in 1819 as 'an elegant composition and of the
finest time of his painting' and valued at 300 guineas.[63]
RCIN 404810
White 1982, no. 205

This happy homestead scene seems to derive its imagery as well as its saturated colour and sharp clarity from Paulus Potter (compare especially no. 9). This freshness conveys the essence of light in the north when clear sunshine follows a shower, and can be contrasted with the bleached colours, more searing glare and dustier atmosphere of the Roman Campagna, seen in nos 36 and 37. By the 1660s tonal painting was out of fashion in every species of Dutch art: the inclusion here of the three primary colours – blue, yellow and red – apparently deliberately set out in clear blocks, can be paralleled in the genre paintings of the same period by Johannes Vermeer and Pieter de Hooch.

Van de Velde's landscape does for the country what de Hooch's modest, well-kept courtyards (fig. 40) do for the town, expounding the uncomplicated virtues of daily life. A young mother has just fed her baby who sleeps over her shoulder, while her elder boy pesters her for a bread roll. It is extremely rare for anyone but a beggar to be shown barefoot in Dutch art; the fact that these two women appear thus here, though otherwise well turned-out and with almost classical folds of drapery, suggests that they have a near-allegorical significance rather than that they are destitute. The standing figure certainly reminds us of allegories of Charity. These Raphael-like figures draw attention to the overlap at this date between northern scenes and the idealised Italianate tradition of Cornelis van Poelenburgh (nos 28 and 29). Adriaen van de Velde painted Italianate (fig. 41) as well as northern motifs; the geography is kept quite distinct, but the figure style tends to merge into one generalised image of what Milton might call a 'fair virgin' with 'nymph-like step'.

RIGHT:
Fig. 40
Pieter de Hooch,
A Courtyard in Delft,
1656, oil on canvas
(Royal Collection,
RCIN 405331)

FAR RIGHT:
Fig. 41
Adriaen van der Velde,
A Horseman at a Ford,
1659, oil on canvas
(Royal Collection,
RCIN 400941)

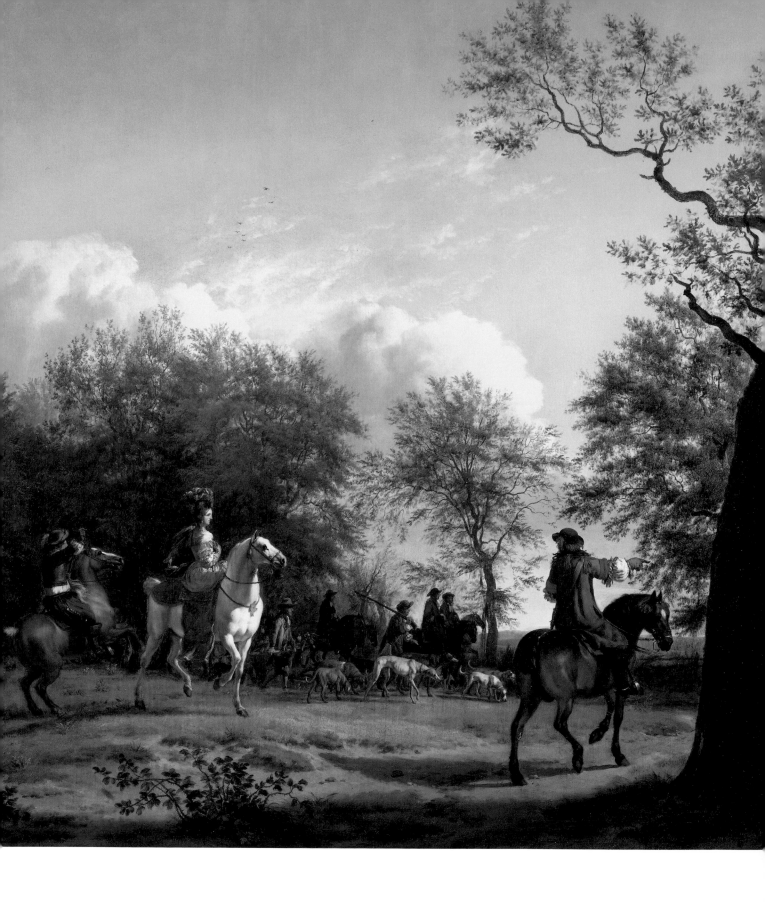

ADRIAEN VAN DE VELDE (1636–1672)
A Hawking Party Setting Out
Oil on canvas
50 × 46.9cm
Signed: *A.V. Velde f/1666*
Acquired by George IV in 1810; described in 1819 as
'a most exquisite work of the Master' and valued at 600
guineas.[64]
RCIN 406966
White 1982, no. 206

If the previous work reminds us of the genre paintings of Pieter de Hooch with classical figures, this one suggests the modern, elegant and somewhat affected gentlemen and ladies of Jacob Ochterveld (1634–1682) and Eglon van der Neer (c.1634–1703). A splendid lady rides side-saddle, with plumed hat, golden dress and sky-blue caparison; huntsmen, with their guns, dogs and loop of hawks, seem to lead her in a triumphal procession. With her attentive husband in the foreground and her page boy in attendance, she appears as if a *châtelaine* from romance, like one of those heading out to hunt in the *Très Riches Heures* of the duc de Berry (fig. 21) of two and a half centuries earlier.

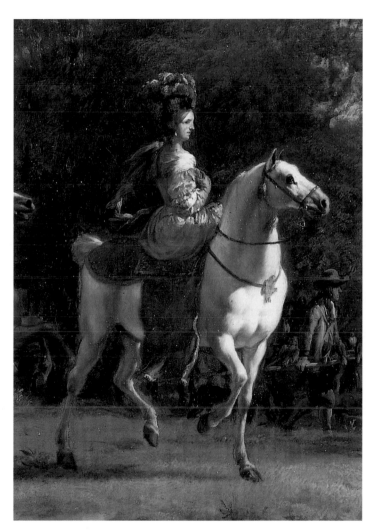

Jan van der Heyden spent his working life in Amsterdam though he travelled extensively. He transformed cities as well as painting them. In 1668 he proposed to the city of Amsterdam a system of street lighting which would prevent burglaries and people falling into the canals in the dark; as a reward he was made 'Overseer and Director of the Lanterns Lit by Night' in 1669.[66] In 1671 Jan and his brother Nicolaas invented a two-handled pump which is the origin of the fire engine; this gained them both in 1673 the position of 'Supervisors of the City Fire Pumps and Fire Equipment'.[67] These prominent and well-remunerated posts meant that Jan van der Heyden did not need to paint for money, yet his works were sought after by international and local collectors.

Veere was a small, walled and moated town in Zeeland on the strait between Walcheren and Noord Beveland. The Zeeland ports – Brielle, Vlissingen and Veere – still have a mythic significance for the Dutch as the first towns captured by the Sea Beggars from the Spanish during the Eighty Years' War, in April and May 1572. However, it is clear from contemporary maps that this is no topographical view of Veere: the Groote Kerk is entirely accurate, as is the general effect of brick fortifications and drawbridges; however, the palace to the right and the circuit of high ground leading from it towards what appears to be a Roman aqueduct are all entirely imaginary.[68] Van der Heyden used monuments from cities lying at some distance from his native Amsterdam – Cologne, Düsseldorf and Veere – more freely than local ones. His patrons, mostly also from Amsterdam, might recognise a far-off church, but would happily accept any urban context the artist chose for it. On the other hand this view has nothing of the caprice about it: it feels like a real Dutch town, whether or not the original owner knew it or thought of it as Veere.

There are untended, and therefore picturesque, elements in this city view – a beggar, some vegetation growing though old brickwork – but the general effect is of neatness, order, security and prosperity. This is a real version of those ideal chessboard cities painted by artists of the Italian Renaissance.[69] To have had such a wide, brick-paved road outside the gates of a city would have seemed especially remarkable and should be compared with contemporary views of Rome (no. 32).

AS THE CITY GATE OPENS

17
JAN VAN DER HEYDEN (1637–1712)
The Town of Veere with the Groote Kerk
Oil on panel
46 × 56.7cm
Signed: *I.V. Heyde*
*c.*1660–65
Acquired by George IV in 1811; thought in 1819 to be a Jan
van der Heyden landscape for which Adriaen van de Velde
supplied figures; valued at 200 guineas.[65]
RCIN 405950
White 1982, no. 65

The country house in the right middle ground has been identified as one which used to lie on the river Vliet, running between Delft and The Hague. Though this is possible, the house does not seem sufficiently distinctive to permit such a specific identification. This scene, however, depicts a fashionable part of Holland in the seventeenth century: a navigable canal or river with a well-kept towpath and a considerable volume of freight traffic (the two boats loading in the foreground are *kaagen*; see p. 99 and figs 57–59). Lining the water are houses with plots of land extending into the flat, low-lying, fertile, reclaimed land. There is an alternation of working farmhouses, like the one with a stepped gable and hayrick, and *buitenplaatsen* (country houses), like the one nearer to us, with its Ionic pilasters and dormer windows with scroll surrounds (as opposed to the more traditional gables). This house has a stone gate and a topiary hedge with *claire-vues* and an avenue of trees. Audrey Lambert reproduces a 1770 map of Rijswijk, between Delft and The Hague, which still shows exactly this alternation of simple plots and formal gardens extending into the polders on either side of the Vliet and nearby roads.[71]

Heyden's image is notable for its restrained depiction of evening light, with more white than gold in the spectrum and just a hint of pink in some of the clouds. But it is the vivid naturalism of the scene, with its matter-of-fact viewpoint, recording a public thoroughfare with no deference to the country house, which so remarkably anticipates the landscapes of the Impressionists. It is also possible that Constable had seen this painting when he painted his *Scene on a Navigable River* in 1816–17 (fig. 42), with its sparkling pointillist touch and scrupulous record of a working inland waterway.

Fig. 42
John Constable, *Scene on a Navigable River (Flatford Mill)*, 1816–17, oil on canvas (Tate, London)

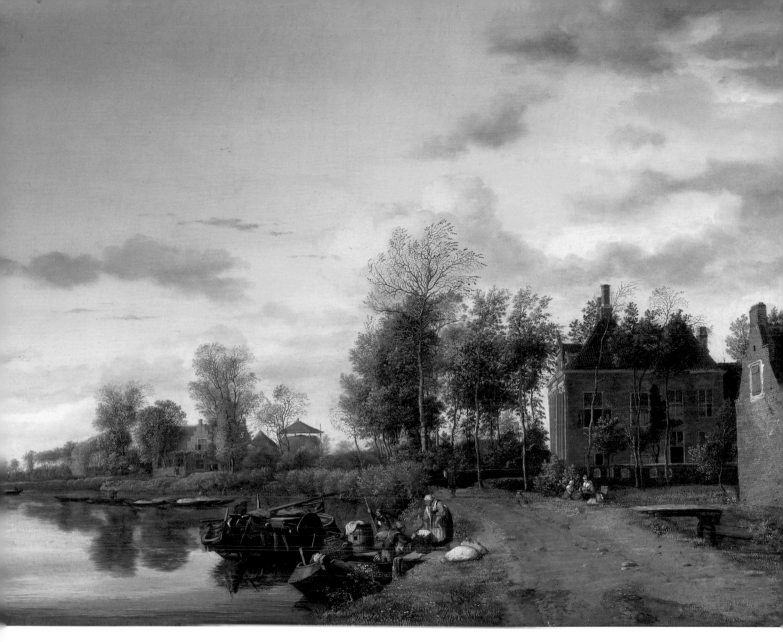

18
JAN VAN DER HEYDEN (1637–1712)
A Country House on the Vliet near Delft
Oil on panel
46.6 × 58.8cm
Signed: *Heyde*
c.1660
Acquired by George IV in 1814 with the Baring collection;
thought in 1819 to be a Jan van der Heyden landscape for
which Adriaen van de Velde supplied figures; described as
'finished with the greatest accuracy throughout' and valued
at 150 guineas.[70]
RCIN 405948
White 1982, no. 66

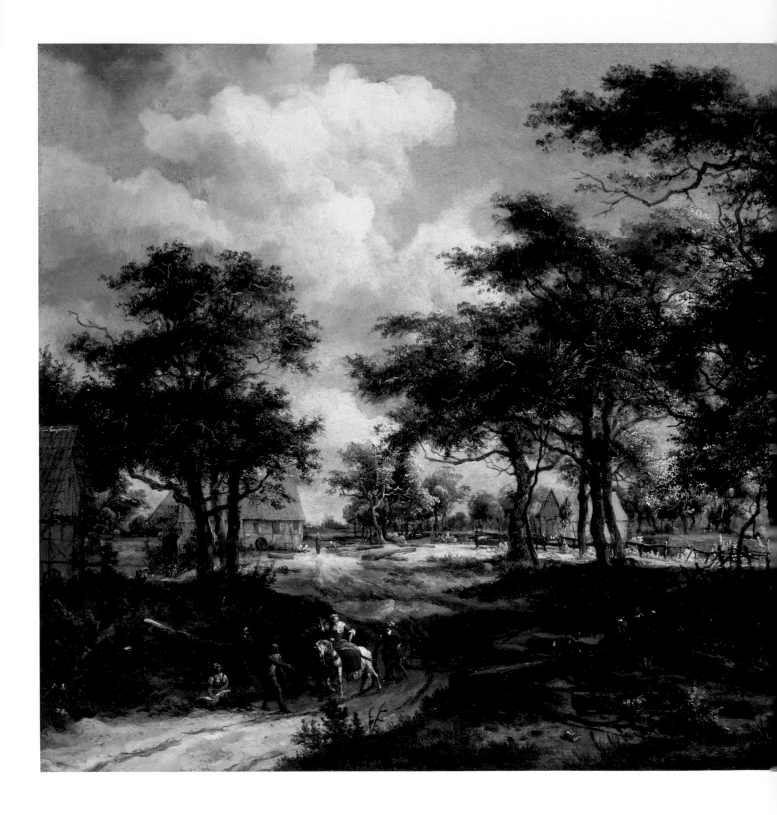

AS THE CITY GATE OPENS

19
MEYNDERT HOBBEMA (1638–1709)
Wooded Landscape with Travellers and
Beggars on a Road
Oil on panel
60.4 × 84.4cm
Signed and dated: *M Hobbema | f 1668*
Acquired by George IV in 1814 with the Baring collection;
described in 1819 as 'painted with great truth and
admirably coloured' and valued at 300 guineas.[72]
RCIN 405210
White 1982, no. 67

Hobbema was born, worked and died in Amsterdam. The name 'Hobbema' was his own invention; his father was called Lubbert Meyndert. On 8 July 1660 Hobbema testified before an Amsterdam notary that he had spent several years 'serving and studying' with Jacob van Ruisdael.[73] He married in 1668 and became a wine gauger for the Amsterdam authorities, after which his artistic output waned.

Hobbema specialised in wooded landscapes, and, like Ruisdael, often repeated motifs in his works. In contrast to Ruisdael's solemn scenes, an element of storytelling animates Hobbema's landscapes. The subject here is one of contrasts: the darkness of the right foreground gives way to bright sunshine beyond; the wildness of the trees is tempered by the appealing homeliness of the houses nestling amongst them. The figure group shows a similarly contrasted encounter between two richly clad riders (she riding side-saddle and followed by a servant on foot) and two roadside beggars, the man reaching out in supplication. Just to the right of centre, two further figures, accompanied by a dog, pause to look through the trees to the area of golden light beyond.

The figures in *Wooded Landscape*, although small, are included for the specific function of directing the viewer's eye through the landscape. It has been suggested that they were painted by Adriaen van de Velde (nos 14–16), who was often engaged to add figures to the landscapes of his contemporaries, including those of Hobbema and Jacob van Ruisdael.

MEYNDERT HOBBEMA (1638–1709)
A Watermill beside a Woody Lane
Oil on panel
52.3 × 68.2cm
Signed and dated: *M. Hobbema / f. 166*[5 or 8]
Acquired by George IV in 1814 with the Baring collection;
described in 1819 as 'of the finest quality' and valued at 350
guineas.[74]
RCIN 404577
White 1982, no. 68

In this engaging landscape the artist transforms a mundane view of everyday life into a charming scene of fairytale innocence. Like no. 19, the composition is constructed to lead the viewer's eye easily through and across it. The winding path on the right curves around away from the watermill, teasing attention away from the main motif.

Watermills appear in about 35 paintings by Hobbema, the majority of which are variations on drawings that he, or other artists such as his teacher Jacob van Ruisdael, made from actual buildings.[75] Despite this repetition of the motif, each depiction of a mill by Hobbema differs in the angle that is presented as well as the mood of the scene. This particular mill, which appears well worn and in need of a new roof, recurs in other works by the artist and may be based on a specific type which, as we know from drawings in the Teylers Museum Haarlem and the Musée du Petit Palais, Paris (Dutuit collection), he had seen and studied in Deventer in the province of Overijssel.[76] The wheel on the side of the mill is in motion, pouring down frothy water which sends ripples across the glossy perfection of the pond beyond.

The predominant use of an orange and brown palette is typical of the artist and also lends the painting an appealing brightness. Figures inhabit this idyllic space; a man walks down the path, a woman and child sit to the side of it, and a man – possibly the mill owner – crosses a bridge to enter the mill. These distinct characters blend seamlessly with their surroundings and, together with the birds which swoop close to the water, harmoniously interact with nature. From the first mentions of landscape painting in the Renaissance it was thought to be the source of a peculiarly simple, restful pleasure.[77] It was for this reason that it was associated with music: Paulus Bril's *Self-Portrait* of *c.*1600 (Rhode Island School of Design, fig. 43) shows the artist playing a lute while a delightful wooded landscape is stretched on the easel in front of him. The fictional world that Hobbema creates similarly seduces the viewer with the imaginary sounds of rustling leaves and splashing water and with images of contentment: houses nestling amongst trees; calm clouds reflected in the surface of the water. Like Jacob van Ruisdael and Salomon van Ruysdael, Hobbema presents a perfect vision of his homeland, but with his distinctive, somewhat eccentric, flavour.

Fig. 43
Paulus Bril, *Self-Portrait*, *c*.1600, oil on canvas (Museum Appropriation Fund, Museum of Art, Rhode Island School of Design)

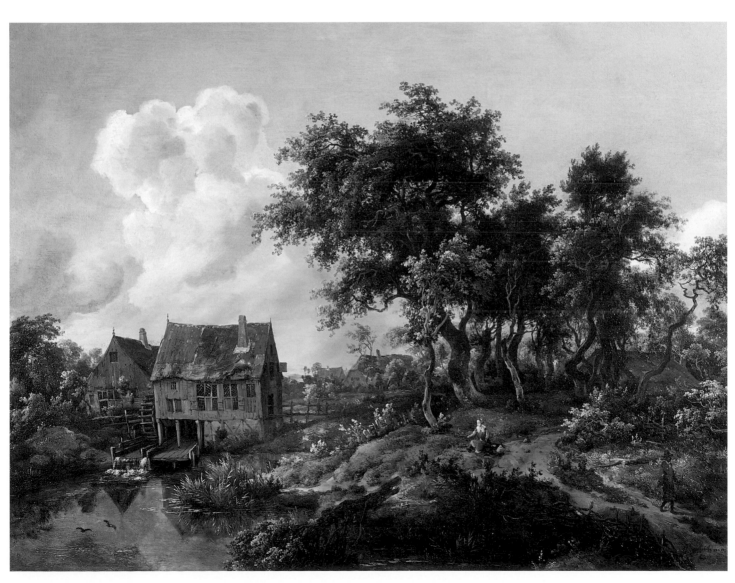

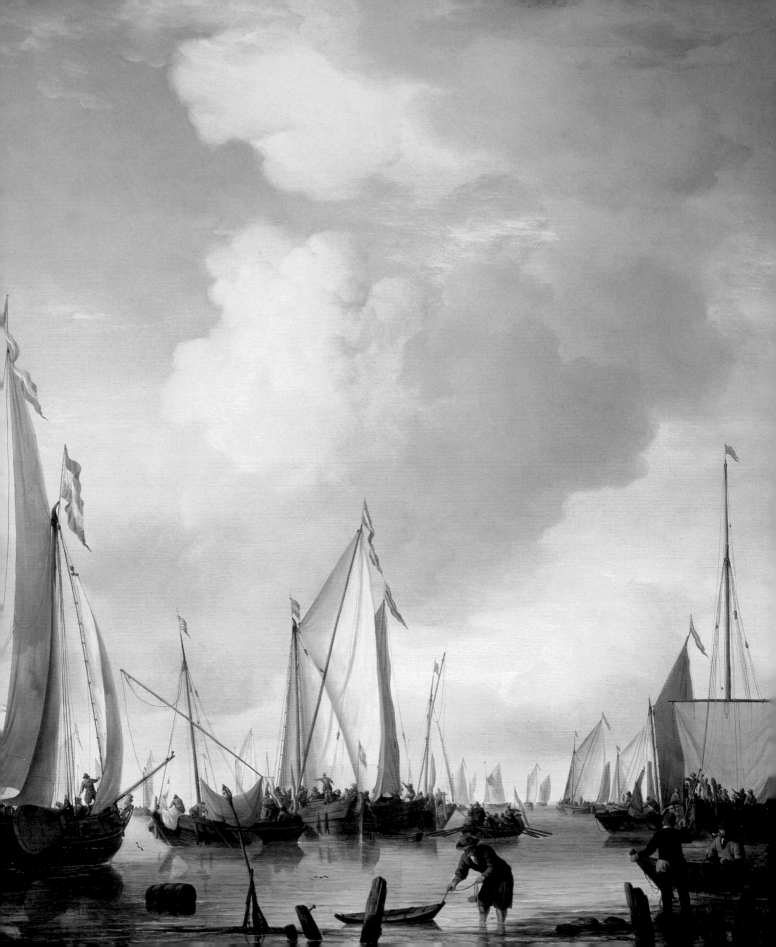

II
ROPES AND RIGGING

Daniel Defoe (c.1659–1731) wrote in the early eighteenth century that the Dutch 'must be understood as they really are, the *Carryers* of the World, the Middle Persons in Trade, the factors and brokers of Europe … that *buy* and *sell* again, *take in* to *send out*; and the greatest part of their vast commerce consists in being supplied from All Parts of the World that they may supply all the World again.'[1] The Dutch especially took over the 'carrying' mantle when, as part of the Eighty Years' War, they blockaded the river Scheldt, removed Antwerp's access to the sea and crippled the maritime trade of their enemies in the Southern Netherlands. The Dutch gained command of the sea which they retained

Fig. 44
Willem van de Velde
the Elder, *Portrait of
the 'Gouden Leeuw'*,
*c.*1667, graphite and
grey wash (National
Maritime Museum,
Greenwich, London)

for at least a century, though they disputed it with Britain in three naval wars: 1652–4; 1665–7 and 1672–4. In 1772 Denis Diderot (1713–84) describes an essentially similar balance of trade: 'The Dutch are human ants; they spread over all the regions of the earth, gather up everything they find that is scarce, useful, or precious, and carry it back to their storehouses.'[2]

This trade required ships, which the Dutch built in unprecedented quantities, perhaps as many as 40,000 seaworthy vessels during the course of the seventeenth century; Sir William Petty (1623–1687) estimated in 1670 that the Dutch owned just under half the total tonnage of European shipping.[3]

Trade requires protection; a survey of Dutch shipping should begin with the navy. Compared to those of their rivals, France and England,

Dutch warships were limited in draught and therefore size by relatively shallow home waters. While an English or French warship might have up to 100 guns on three main decks, the *Gouden Leeuw* (figs 44–46), one of the largest Dutch flagships, mounted a total of 80 guns, with 26 in each broadside on two gun decks, and a further 14 lighter guns a side on her forecastle, quarter-deck and poop. Nonetheless, the Dutch had a well-founded reputation as formidable close-quarter fighters and the Anglo-Dutch sea-battles have been described as 'the greatest concentrations of violence in the world at that time'.[4] During the Four Days Battle, 11–14 June 1666, the Dutch and British deployed over 100 vessels each; there were 30–40,000 men on board and 8,000 cannon; by comparison a land battle of this date might deploy 100 artillery pieces.[5]

Figs 45 and 46
Willem van de Velde
the Younger, *The*
'Gouden Leeuw' at Sea
in Heavy Weather
(no. 25, details)

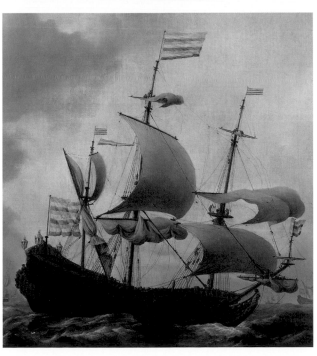

Fig. 47
Willem van de Velde,
the Elder, *Portrait of a
States Yacht*, c.1672,
graphite (National
Maritime Museum,
Greenwich, London)

Fig. 48
A states yacht, from
Willem van de Velde
the Younger, *A Calm*
(no. 24, detail)

All major vessels, for war or deep-water trade, were square-rigged on three masts; that is, with the many (roughly) square principal sails rigged on transverse yards, and in numbers allowing easy handling in many combinations depending on conditions, including replacement after a storm or combat. The small but significant Dutch naval or civic vessel which usually had a fore-and-aft rig (sprit or gaff) was the yacht (figs 47 and 48) – the prestigious 'stretch-limousine' of the period which carried dignitaries of the States and their Admiralties, of City government, the Dutch East India Company (the VOC), or even of the princely house of Orange.

This fast and shallow-draught vessel was originally designed for chasing pirates in coastal waters, which explains its name, *jacht* or 'hunter'. Like most smaller Dutch craft it had distinctive teardrop-shaped lee-boards on each side, of which that to leeward would be lowered as far as the depth of water allowed to act as a keel when going across or up-wind, but raised as necessary in shallow water. The ceremonial yacht could be richly decorated; they were also raced in the Netherlands, a taste which Charles II acquired in exile and imported to England at his restoration, when the Dutch presented him with a yacht called the *Mary*. He was soon building and racing his own, on more English lines, and they became a familiar class of Royal Navy vessel for royal transport and other duties, like their Dutch forerunners.

The long-distance trade of the Dutch East India Company was carried in 'Indiamen' (fig. 49), now easily mistaken for warships in their

bulk and rig, but usually with only a single main tier of guns above a much greater hold capacity, and lighter ones in their upper works. Another merchant vessel which gave the Dutch their unique technological edge, especially in the European carrying trade, was the *fluyt* (in English, the 'flute' or 'fly-boat', fig. 50), which was similarly lightly armed. Their uniquely

De Paerrel een Ooftindis Vaerder, Den Dubbelen Arent een Weftindis Vaerder,

De Liefde een Noorts-Vaerder, t' Geele Fortuyn een Ooster Vaerder,

Fig. 51
Willem van de Velde
the Elder, *Dutch
Herring Busses on
the Fishing Ground*,
1682, oil on canvas
(Royal Collection,
RCIN 400031)

favourable crew-to-cargo ratio was achieved by a relatively deep draught for their size, a bulging hull with narrow decks and sail-handling arrangements designed for a small crew.[6]

Fishing was as important a part of the Dutch maritime economy as trade, especially after the invention of 'gibbing' – a process of cleaning and salting herring which could take place on board ship. According to the Leiden merchant and economist Pieter de la Court (1618–1685), writing in the 1660s, the 'Great Fishery', as the herring trade was called, directly or indirectly employed almost one fifth of the Dutch population.[7] Huge Dutch fleets, with an armed escort, set sail in mid-June for the east coast of Britain; they fished from 24 June to 25 September

and were back with their salted herring by the end of January.[8] The vessel of choice was the *buss* (figs 51 and 53), a 15–20 metre long, three-masted vessel with a pear-shaped hull and high stern. Willem van de Velde the Elder's pen painting of 1682 shows a fleet of busses drawing in their nets, enjoying the protection of at least three Dutch warships (fig. 51). The *hoeker* (figs 52 and 54) was a slightly longer fishing boat, with two masts and a large square-rigged sail used for cod and herring fishing in the same waters.

Passenger and freight transport on inland waters was carried in a variety of vessels. An *aak* (fig. 55) was a heavy barge with flat bow used for transporting wines on the Rhine. A *smalschip* (figs 52 and 56) was slightly shorter and narrow enough

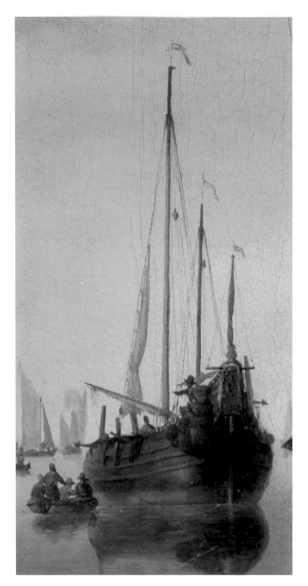

Fig. 53
A herring *buss*, from
Willem van de Velde
the Younger, *A Calm*
(no. 24, detail)

Fig. 54
A *hoeker*, from
Willem van de Velde
the Younger, *A Calm*
(no. 24, detail)

Fig. 55
A Rhine *aak*, from
Willem van de Velde
the Younger, *A Calm*
(no. 23, detail)

to pass through the lock at Gouda (its name means 'narrow-boat'). A *kaag* (figs 57–59) was an even smaller passenger boat and freighter about 13 metres long, called a 'lighter' in English, with a much shallower hull than the *smalschip*. Both *smalschip* and *kaag* (and other similar boats such as the *pleyt*, no. 39) were sprit-rigged, which is to say that a single long spar (sprit), aligned fore and aft, is attached at one end to the top of the sail. The other end of the sprit is pulled down to the foot of the mast to raise the sail and allowed to swing up to lower it (as in figs 56 and 58), in the latter case giving the characteristic appearance of a huge cross with some washing hanging from one end.

A *pont*, as the smaller English 'punt', was more like a pontoon than a vessel and was used for short crossings ferrying horses and carts. As we have seen, the most popular public transport on inland waterways was the horse-drawn barge, called a *trekschuit*, which ran regularly if rather slowly between every major Dutch city (fig. 23).

It is not surprising in view of the value, beauty and prestige of warships and Indiamen that this is what artists were set to paint and that the resulting works were highly prized. Ship painters were awarded important commissions by princes, city councils, trading chambers and wealthy merchants and enjoyed the higher profile of court painters, especially in contrast to the anonymity of 'ordinary' landscapists. Henry VIII employed a painter from the Netherlands (sadly in this case anonymous) to record his newly built navy

Fig. 56
A *smalschip*, from Willem van de Velde the Younger, *Calm* (no. 24, detail)

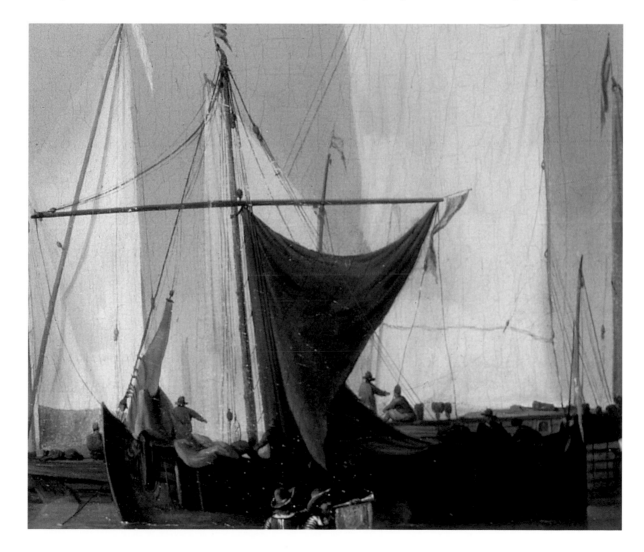

embarking for his summit meeting with Francis I at the Field of the Cloth of Gold in 1520 (fig. 60).[9] Patron and artist were here clearly more interested in the courtiers, coastal fortification and above all ships than they were in the waves or the sky. Ship painting remained a technical speciality for the next hundred years.

The most important exponent at the turn of the century was the Haarlem painter Hendrick Cornelisz. Vroom (1566–1640), who was paid 100 guilders to provide ten designs for the Delft tapestry weaver François Spiering depicting the defeat of the Spanish Armada, for Lord Howard of Effingham, the commander of the English naval defence.[10] These tapestries hung in the House of Lords from 1650 until it was destroyed by fire in 1834 and can be seen in Tillemans's view of Queen Anne's council (fig. 61).[11] Similar tapestries were produced from Vroom's designs

for the council chamber of the Admiralty of Zeeland in Middelburg celebrating the achievement of the Sea Beggars, and survive in the Zeeuws Museum there.[12] Cornelis Claesz. van Wieringen (c.1580–1633) was paid 2,400 guilders in 1622 for his depiction of the 1607 Dutch naval victory over the Spanish off Gibraltar by the Admiralty of Amsterdam in order that they could present the painting (now in the Rijksmuseum) to Prince Maurice; the Admiralty's first choice of artist was Hendrick Vroom, whose asking price of 6,000 guilders was considered excessive.[13] There is much evidence for Alan Chong's observation that 'generally marine painters won the lion's share of landscape commissions'.[14] For their generous remuneration marine painters were expected to record ships and events with great accuracy, which is why the Dutch naval 'war correspondent' Willem van de Velde the Elder (1611–1693,

RIGHT:
Fig. 57
A *kaag*, from Salomon van Ruysdael, *A River Landscape with Sailing Boats* (no. 22, detail)

FAR RIGHT:
Fig. 58
A *kaag*, from Willem van de Velde the Younger, *A Calm* (no. 23, detail)

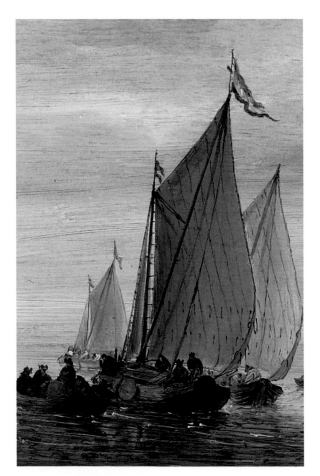

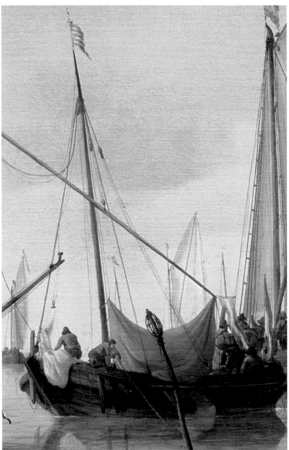

created *Draughtsman of the Fleet* in 1653) was
given a galliot, a small sailing ship seen in no. 25,
with which to accompany the fleet.[15] Van de Velde
sometimes includes himself in his galliot in
depictions of engagements such as the Battle of
Scheveningen of 1653, recorded in a pen painting
of two years later (National Maritime Museum,
Greenwich).[16] It was the demand for such
nationalistic celebrations which prompted
Charles II to poach both Willem van de Veldes
(father and son) from the Dutch in 1672–3.
The King specified the roles of the two artists
precisely in a contract of January 1674: 'The

Salary of One hundred pounds p. Annm unto
William Van de Velde the Elder for taking and
making Draughts of seafights, and the like Salary
of One hundred pounds p. Annm unto William
van de Velde the Younger for putting the said
Draughts into Colours for our particular use.'[17]
We can see how this might work in practice in a set
of 12 naval engagements upon which both artists
collaborated, which were commissioned in 1675–6
by James II when he was Duke of York and Lord
High Admiral (fig. 62).[18]

Painted sea battles were sought after for two
hundred years in order to occupy the same sorts

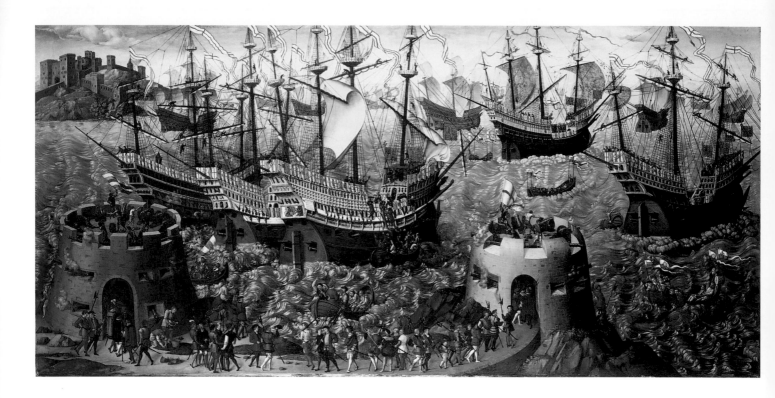

Fig. 60
British School,
*The Embarkation of
Henry VIII*, c.1520–40,
oil on canvas
(Royal Collection,
RCIN 405793)

of spaces which in Florence displayed the battle scenes of Michelangelo and Leonardo. The profit as well as the protection of the Dutch navy was also celebrated in images of ships set in front of city views. A 1611 print by Claes Jansz. Visscher in the Amsterdam Municipal Archives, adapting an earlier 1599 plate of Pieter Bast, depicts Amsterdam across the Ij, the river and harbour presenting a forest of masts.[19] An allegorical figure of Amsterdam is seated in the centre foreground, receiving tributes of merchandise from around the world and holding a model of a ship and a fishing rod. She is surrounded by three tiny wooden walls presumably alluding to the famous advice the Delphic oracle gave to the Athenians

before the battle of Salamis to 'trust to walls of wood', which Themistocles correctly interpreted as meaning ships.[20] An anonymous print of Amsterdam from the same vantage point of *c.*1613 (Royal Library, Brussels) is entitled *'s Lands welvaren* (The Prosperity of the Land) and makes clear that in spite of its name this prosperity depends upon ships at sea.[21] Some of the most interesting early city views are painted in conjunction with ships: the *Departure of a Dignitary from Middelburg* by Adriaen van de Venne (1589–1662) of 1615 (Rijksmuseum, Amsterdam); the view of the city of Hoorn for which Hendrick Vroom was paid 100 guilders by city magistrates on 27 June 1622 (now in Westfries

Museum, Hoorn).[22] Later versions of the idea are more dramatically lit and less documentary: Ludolf Backhuysen's *Shipping before Amsterdam* (Musée du Louvre, Paris) was commissioned on 3 November 1665 for 400 ducats by city magistrates for the marquis de Lionne, Louis XIV's Minister for Foreign Affairs; Willem van de Velde the Younger's *Gouden Leeuw on the Ij at Amsterdam* of 1686 (Amsterdams Historisch Museum) was commissioned by the Chief Commissioners of the Harbour Works for their office on the Schreierstoren.[23]

Ships were not only practical things, they were also emotive and suggestive: images in emblem books and on the walls of genre paintings (fig. 5) suggest that ships in peril provided a rich metaphor for the tribulations of human life. An English-speaking audience will be familiar

with the idea from Shakespeare's images of the ship as the soul guided by love (*Sonnet* No. 116) or as a brave enterprise of state (*Troilus and Cressida*, Act I, scene iii, lines 34–45). Some of the most prestigious commissions given to Netherlandish painters were for religious or symbolic ships, like the frescos painted by Paulus Bril in Rome depicting Jonah and the whale (Scala Santa for Sixtus V) and St Clement being thrown from a ship with an anchor round his neck (Sala Clementina in the Vatican for Clement VIII).[24] A print of 1620 by Frans Schillemans after Jacob Oorloge and Adriaen van de Venne, entitled *Allegory of the Confederated Netherlands Provinces* (Rijksprentenkabinet, Amsterdam; fig. 79) shows a 'ship of state' with Maurice, Prince of Orange, at the tiller, surrounded by a variety of allegorical figures, the entire scene lit by the rays emanating from the aureole of a figure of Truth seated in the clouds.[25] When ships have a heroic or spiritual appearance (as in nos 22 and 39) there is clearly much justification for reading them in this light.

None of this really justifies speaking of 'marine painters' as opposed to ship painters.[26] Even at the time it was understood that there was a difference between the instructive and the artistic. Indeed van Mander concludes his brief life of Hendrick Vroom thus:

> In conclusion, Vroom is a master; as to the drawings of his ships, they show good construction; he has a thorough knowledge of ropes and rigging; the direction of the wind, the sails, and other details, are well rendered. Vroom excels in painting landscapes, rocks,

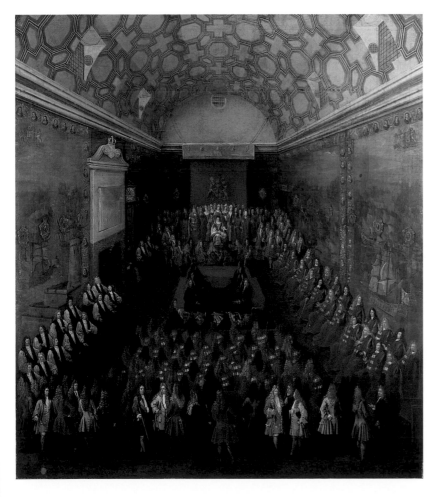

trees, the sky, water, waves, castles, villages, cities, figures, and other subjects, that appear in his marine paintings and make them beautiful.[27]

Whether or not one agrees with van Mander that Vroom excelled in painting 'sky, water and waves', subsequent marine painters certainly did, as a glimpse of nos 22–26 confirms. The defining moment in this was the defining moment for Dutch landscape in general (see above, pp. 9 and 48), namely the inception of the 'tonal' style of landscape painting in Haarlem in the 1620s and 1630s. Writing long afterwards, in 1678, Samuel van Hoogstraten describes how three artists, Jan van Goyen, Jan Porcellis (1584–1632, fig. 63) and François Knibbergen (c.1597–after 1665), had

a competition to paint a landscape in a day in order to devise a way of meeting the demand for paintings which was growing at that time.[28] Hoogstraten explains Jan van Goyen's method:

By 'swaddling' the whole canvas all at once – here light, there dark, more or less like a multicoloured agate or marbled paper – he was able, with barely any effort, to apply with tiny brushstrokes all manner of drolleries, so that over yonder a distant view looms up with peasant hamlets, while elsewhere appears an old fort with a gate and landing-stage, reflected in the rippling water, as well as various kinds of ships and barges, loaded with passengers and freight. In short, his eye – as though in search of the forms that lay hidden in the chaos of

his paint – skilfully guided his hand, so that one saw a perfect painting (Hoogstraten, *Introduction to the Art of Painting*).[29]

Hoogstraten suggests that tonal painting is the artistic equivalent of reading tea-leaves: you let the paint do the work. In the case of Porcellis's *Mussel Fishing* (fig. 63), painted in 1622, the year he arrived in Haarlem, it is possible to imagine that the grain of the wooden panel smeared with brown and grey liquid underpaint might look like the ripples of the wave and the wood of the boats. The artist then devotes a day to realising this potential; dotting some descriptive i's and crossing some t's. The marine painter would appear to be uniquely caught between two extremes of representation: the precision required for 'ropes and rigging' and the painted chaos required to suggest rippling water. The landscape of estuaries especially encourages the other distinctive aspects of tonal landscape painting: the low, thin horizons; the featureless empty spaces; the moist atmosphere and grey indistinct blending of sea and sky. Some prints can also stress an estuary's empty desolation: a series was produced to illustrate the 1665 publication, *Postcaert*, by the Rotterdam postmaster, Jacob Quack, showing how the mail was delivered from Holland to the Indies and back (fig. 64) and designed to help ships' captains find their way up the rivers.[30] Navigation books of the period, such as Willem Jansz. Blaeu's *Le flambeau de la navigation*

Fig. 64
Joost van Geel, *The
Postilion Receives the
Mail from a Small
Rowing Boat*, from
*The Mail Service
between Holland and
the Indies Illustrating
Jacob Quack's
Postcaert*, 1665,
engraving
(British Museum)

(Amsterdam, 1625), include coastal charts, basically thin bumpy horizon lines, to help sailors recognise the near-featureless shore of Holland from far out at sea.[31]

After the tonal marine paintings of Porcellis (fig. 63), Simon de Vlieger and Jan van de Cappelle (fig. 65), it was no longer an option for any artist to paint any part of the 'ropes and rigging' of a ship without thinking at the same time of the weather, the light, the sea and the sky.

Edward Norgate in his *Miniatura* of *c*.1650 mentions the 'sea peeces' of 'John Porcellis', 'who very naturally describes the beauties and terrors of that Element in Calmes and tempests soe lively exprest, as would make you at once in Love with, and for-sweare the Sea for ever'.[32] It is this painterly and atmospheric quality which later prompted Turner to exclaim upon seeing a sea-piece of Willem van de Velde the Younger, 'Ah! That made me a painter.'[33]

ADAM WILLAERTS (1577–1664)
*The Embarkation at Margate of Elector
Palatine and Princess Elizabeth*
Oil on canvas
122 × 197.2cm
Signed and dated: *A Willarts. fe 1623.*
Acquired in 1858 and hung at Windsor Castle.
RCIN 404994
White 1982, no. 235

Adam Willaerts was born in London to Flemish parents; he had moved to the Netherlands by 1585 and by 1597 was settled in Utrecht, where he spent the remainder of his career. He was active in the Utrecht painters' guild and contributed a painting to one of the local hospitals. Willaerts painted religious scenes involving ships as well as ceremonial arrivals and departures, all in a brightly coloured anecdotal style, resembling that of Jan Brueghel the Elder (fig. 16).

Princess Elizabeth, James I's daughter, married Frederick, Elector Palatine, in London in 1613 and sailed from Margate on 25 April 1613 (Julian calendar). The couple were seen off by James I and Anne of Denmark in the foreground; rowed out by bargemen in livery and brought aboard the *Prince Royal*, which lies at anchor in the middle of the composition surrounded by a blaze of natural, but highly suggestive white light. The *Prince Royal* was built in 1610 by Phineas Pett for Henry Prince of Wales (1594–1612), which explains its HP monograms and feathers as well as a figurehead of St George on a horse. After a four-day transit Frederick and Elizabeth were greeted at Flushing (Vlissingen) in Zeeland by Frederick's cousin, Prince Maurice, their arrival depicted in a companion painting by Willaerts dated 1623 (Private Collection).[34] In 1619 Frederick accepted the crown of Bohemia and ruled in Prague for one winter (hence his name the 'Winter King') before being defeated in 1620 by the imperial army. The couple arrived as exiles in the Netherlands in 1622 and were formally deprived of the Palatinate by imperial edict in 1623.

This painting was presumably commissioned in the Netherlands in 1623, at the same time as other representations of the arrival in Flushing by Henrick Cornelisz. Vroom and Cornelis Claesz. van Wieringen (dated 1623 and 1628 respectively and both in the Frans Hals Museum, Haarlem).[35] These glorious naval pageants are clearly inspired by the arrival in the Netherlands of the newly deposed rather than the newly wed monarchs. Why gloat in this way on the contrast of former glory and present misery? The best explanation is that the Dutch audience wished simultaneously to celebrate and to shame the British navy. In 1621 James I summoned parliament to raise money for a European military campaign to restore Frederick V to his throne. Unfortunately nothing came of this commitment and from February to October 1623 the Prince of Wales (the future Charles I) was in Madrid courting the Princess Maria and consorting with the leaders of the Catholic faction. Could the Dutch be suggesting that these British warships, which made such a fine show in 1613, might now, ten years later, be put to the use for which they were designed?

Salomon van Ruysdael (spelt differently so as to differentiate him from his brother Isaack and nephew Jacob) was born in Naarden in Het Gooi, south east of Amsterdam. In 1623 he entered the painters' guild in Haarlem, where he remained for his entire career. The views and landmarks in his paintings indicate that he travelled throughout the Netherlands while also studying topographical engravings to learn the appearance of places that he had never visited.

Salomon van Ruysdael specialised in river views, but also painted landscapes, seascapes and some still-lifes. Despite the frequent recurrence of identifiable motifs in his paintings, they are not repetitive or stylised. Van Ruysdael, along with fellow artists Pieter de Molijn (1595–1661) and Jan van Goyen, sought to experiment with the effects of tone in paintings, where mood is evoked not through action, but through the subtle blending of colour and texture to construct an evocative scene.

A River Landscape with Sailing Boats is typical of the works at the height of van Ruysdael's career. The painting captures a moment at dawn on a broad stretch of river which, bearing in mind the size of the sailing boats depicted, is most likely to be an estuary. The sun is rising, and men are being ferried in rowing boats to their vessels. Carel van Mander in his *Foundation of the Noble, Free Art of Painting* of 1604 had instructed artists how best to approach the demanding task of capturing dawn light. He advised them to be wide awake to observe the beginning of the day, and to keep in mind the imagery and lyrical contours of mythological poetry, likening the clouds and light to the gods and warning artists to '… behold how slowly rosy-rimmed/The purple clouds become…'.[36] In this work van Ruysdael seems to have captured the slow unfurling of such purple-tinged dawn light. Despite the ripples on the water and the inclusion of figures beginning their busy day, it is the sky that is the real focus, the roundly curling clouds dominating the composition with a weighty presence. The daringly low horizon line ensures this domination of sky and water and reminds us that the figures within the painting (whether in boats or in the houses sheltered by trees on the left) spend their working lives trying to read the weather upon which their livelihood depends.

As though to continue this theme of the importance of nature, van Ruysdael uses the tools of his practice – the oil paint and the wood of the panel – to articulate further the homogeneity of the scene. The grain of the wood and even its colour serve as the basis for the pattern of waves in the darker-toned water of the foreground, a technique later employed by Willem van de Velde the Younger (no. 23). This realistic effect is tempered by the poetic reflection of light on water in the middle distance which subtly blends into the sky. In contrast with the crowded noise of Willaerts's colourful opera (no. 21), van Ruysdael's ascetic tonal handling recalls the simplicity of plainsong, and the vastness of nature is hinted at, but not forced.

22
SALOMON VAN RUYSDAEL (1600/3–1670)
A River Landscape with Sailing Boats
Oil on panel
44.5 × 68.2cm
Signed and dated on the rowing boat in the centre:
SvR 1651
First recorded in the Royal Collection in 1849.
RCIN 405517
White 1982, no. 173

WILLEM VAN DE VELDE THE YOUNGER
(1633–1707)
*A Calm: A States Yacht under Sail Close to the
Shore, with many other Vessels*
Oil on panel
59.7 × 71.4cm
*c.*1655
Acquired by George IV in 1814 with the Baring collection;
described in 1819 as 'Very Capital' and valued at £400.[37]
RCIN 405328
White 1982, no. 212

Willem van de Velde was the son of the marine painter of the same name (see above) and brother of Adriaen (see nos 14–16); he studied with his father and with Simon de Vlieger. His earliest paintings, from the early 1650s, include many images like this work and the following (no. 24), depicting perfectly calm seas with a dense arrangement of ships, sometimes now called 'naval parades'.[38] The type was invented by marine painters of the previous generation, in particular Jan van de Cappelle (fig. 65), and would seem to depict the Netherlands' inland sea, the Zuider Zee, which included many of the most important Dutch ports – Amsterdam, Hoorn, Enkhuizen and Kampen – and where large numbers of ships might lie at anchor in relative safety. Though the atmosphere might be studied from the life, the particular variety of shipping in such close proximity looks imaginary. Both these 'calms' have states yachts providing an obvious focus of interest, in this case by its size, in the case of no. 24 by its central position and the fact that a dignitary is being rowed out to it in a barge. It is tempting to read both images as a 'Great Republic of Vessels' with every type, size and function of shipping from the humblest upwards, peaceably coexisting under the protection of the senatorial government yacht.

The ships in question have been identified by Michael Robinson and can be compared with drawings by Willem van de Velde the Elder (figs 47, 52 and 59); in the left foreground is a *pont*; reading across from the yacht is a *kaag*, two *smalschips* and a Rhine *aak* at the extreme right.[39]

The artists already mentioned as Willem van de Velde's inspiration for images such as this – Simon de Vlieger and Jan van de Cappelle (fig. 65) – were both exponents of the 'tonal' style of seascape, initially pioneered by Jan Porcellis (fig. 63). The best way of understanding this painting and the following is to imagine Willem van de Velde setting out to paint a tonal painting and striving not to sacrifice any of its atmospheric unity, while at the same time adding those elements which tonal painting lacks – bright colour and a thick, opaque and smooth paint surface. In the lower part of this painting the boats, ripples and sand are beautifully unified in a close, grey-brown tonal range. This is also a perfect example of 'going with the grain', an effect whereby the paint follows and suggests the grain of the wood panel while at the same time evoking the clinker boats and ripples of water. The sky contains thicker paint, purer white and brighter blue than any tonal painting, and yet colour and tone are controlled in such a way as to retain an effect of atmospheric unity. By this means the viewer is made to feel that there is a veil of moist, sunlit air between their eye and every surface in the painting.

part from rowing boats this parade features (reading from left to right): a herring *buss*; a *hoeker* partly concealed by a *kaag*; a states yacht; two *smalschips*, the second nearer one partly concealing another *hoeker*.[41] Slightly more than in the previous example, van de Velde has used a smooth grey-blue paint layer to suggest a heat haze, an effect reinforced by the artist exploiting the flatness of any marine image rounded off at top and bottom by sky and its reflection.

Constantijn Huygens wrote in his autobiography of *c.*1630 about landscape painters, including Esaias van de Velde, whose work is so natural that 'nothing is lacking except the warmth of the sun and the movement caused by the gentle breeze'.[42] This awareness of what painters can't paint – everything apprehended by smelling, feeling and hearing – is almost a cliché of writers about landscape, which is especially relevant in images such as this where silence and stillness reign. Calms often include a distant cannon's salute, perhaps to suggest sound, perhaps to suggest that silence which in reality accompanies the cannon's smoke before the sound reaches our ears. In this case the artist includes a bargeman in livery blowing a ceremonial trumpet, which certainly shatters the quiet but which also make us think about sound in general and start to imagine the creaking of the sails and lapping of the waves.

WILLEM VAN DE VELDE THE YOUNGER
(1633–1707)
*A Calm: A States Yacht, a Barge and many
other Vessels under Sail*
Oil on canvas
61.7 × 71.7cm
Signed and dated: *W. v. Velde 1659*
Acquired by George IV in 1814 with the Baring collection;
described in 1819 as 'a most beautiful picture and in the
highest preservation' from the Gildermeester collection;
valued at 650 guineas.[40]
RCIN 407275
White 1982, no. 213

25
WILLEM VAN DE VELDE THE YOUNGER
(1633–1707)
The 'Gouden Leeuw' at Sea in Heavy Weather
(Photographed before conservation)
Oil on canvas
66.7 × 82.7cm
Signed: *W. V. Velde*
Probably painted 1671
Acquired by George IV in 1820.
RCIN 405324
White 1982, no. 215

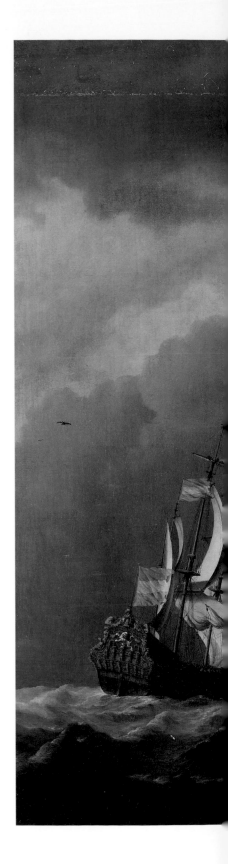

The character of this image derives from 'ship-spotter' prints by such artists as Reinier Nooms, called 'Zeeman' (*c*.1623–1664), whose *Verscheyde schepen en gezichten van Amstelredam* (Various Ships and Views of Amsterdam) (figs 49 and 50) show similar ships in pairs, offering alternative views. The van de Veldes take up this idea but show the same ship twice, from different points of view, which is what Willem van de Velde the Elder does in his 'pen paintings', such as that showing the Dutch warship the *Ster* (Star) in the Rijksmuseum, and Willem van de Velde the Younger does in this case. The *Gouden Leeuw* (Golden Lion) was a Dutch warship built in 1666 and recorded in a drawing by Willem van de Velde the Elder (fig. 44); this painting probably depicts the ship in 1671 when captained by Willem Joseph van Ghent (and before the artist defected to Britain in 1672). Its stern view to the left includes the Golden Lion on its taffrail and the starboard view to the right shows the same emblem as the figurehead. A galliot, the type of ship used by Willem van de Velde the Elder when following the fleet, sails between the 'two' ships.

This image recalls the tradition of the symbolic ship in peril (see above, p. 103): the crews of both ships are mounting the rigging most precariously to take in sail, several of which are flapping dangerously; the left-hand ship sails against grey clouds in the thick of the storm; the right-hand ship seems to be sailing out of the worst of the danger towards blue skies.[43] The flock of gannets fishing in the stormy water adds to the menace. The suggestion that this is about more than one ship is strengthened by the fact that warships generally have symbolic or patriotic names. The Golden Lion is the Dutch national emblem: the rampant heraldic lion which appeared on the arms of many of the Seven Provinces of the Netherlands and became the heraldic emblem of their unity. The 'Dutch Lion' occurs in countless allegories; many maps of the region are manipulated into the shape of a rampant lion. Van de Velde makes the ships stand out against the background, first light against dark (the gold of the heraldic lion singing out against the grey); and then dark against light, the effect of an aureole rather like that seen in no. 21.

WILLEM VAN DE VELDE THE YOUNGER
(1633–1707)
The 'Royal Escape' in a Breeze
Oil on canvas
63.4 × 75.8cm
Signed: *W.V.V.*
Painted for Charles II *c.*1675.
RCIN 405211
White 1982, no. 216

On 15 October 1651 Charles II paid one Nicolas Tettersell £60 to carry him from Shoreham to France in a Brighthelmstone coal-brig called the *Surprise*. After this ignominious flight the King returned in triumph from Scheveningen in 1660 (see no. 27) bringing with him a keen interest in Dutch recreational yachting. He bought the *Surprise*, converted it into a yacht and renamed it the *Royal Escape*.

The *Royal Escape* is shown close-hauled on the starboard tack, which means that the wind is blowing from the direction of the warship in the left distance.[44] Sailing into the wind in this way is an exciting though perfectly possible man-oeuvre and explains why the red ensign streams backwards (unlike the flags in cross-rigged ships with a following wind, as in no. 25). The name of the ship clearly conveys the same message as the previous work: that the boat here in some way represents the heroism of the King's escape from the storm clouds of rebellion towards the blue skies of a safe haven and glorious return. The English warships calmly at anchor in the background is there to reassure us that this is more of a twentieth anniversary re-enactment of a royal escapade than the real thing.

27

JOHANNES LINGELBACH (1622–1674)
The Embarkation of Charles II at Scheveningen
Oil on canvas
96.5 × 147.8cm
*c.*1660–70
Painted for or acquired by Charles II.
RCIN 404975
White 1982, no. 98

Lingelbach was born in Frankfurt; he worked briefly in France and made a six-year sojourn in Rome (1644–50) before settling in Amsterdam.

This scene captures the pomp and ceremony of the departure on 23 May 1660 of Charles II from the Netherlands. The exiled Prince had lived in The Hague since 1648, the home of his sister Mary and (until his death in 1650) her husband William II, Prince of Orange. Lingelbach's scene carefully conveys the vast expanse of beach and the vast number of spectators who came to see the restored English King set sail for his homeland. As one eyewitness recorded, 'Never have more people been seen together in Holland.'[45] The same scene is represented in more pedantic detail by an anonymous painting (fig. 66), copied from a contemporary print.[46] Lingelbach takes a more picturesque and oblique view from the dunes, with the village of Scheveningen to the left. The English fleet, with the recently renamed *Royal Charles* (previously the *Naseby*), is in the distance on the right.

The landscape dramatically undulates, with each step towards the horizon indicating more viewers. Rather than focusing on Charles II with his retinue, the artist purposefully focuses on the spectacle, highlighting the reaction of the people gathered on the beach and dunes. The clouds in the sky are matched by clouds of smoke from a gun salute, the noise of which causes the men in the foreground left to cover their ears in shock at their sudden deafness. The mixture of costumes from expensive high-fashion fabrics to simple garments implies the spectrum of society gathered to witness the event. Some of the figures sit contentedly on high ground, settling down for the show, while others strain, one even using the relatively new technology of a telescope, to gain a better view.

Fig. 66
Dutch School, *The Departure of Charles II at Scheveningen*, *c.*1660–85, oil on canvas (Royal Collection, RCIN 405163)

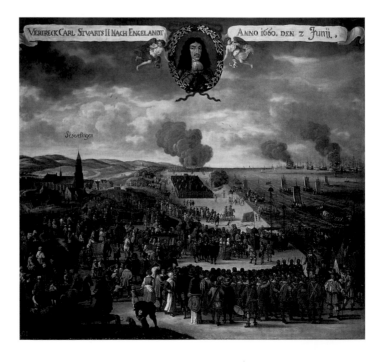

ROPES AND RIGGING

III

THE PAINTING CAPITAL
OF THE WORLD

The title of this section is a modernisation of a phrase in van Mander's description of Rome as 'the city where before all other places the Painter's journey is apt to lead him, since it is the capital of Pictura's Schools; but it is also the right place for spendthrifts and prodigal sons to squander their money' (*Foundation of the Art of Painting*, Chapter I, verse 66). He goes one to say that 'one must fall in love with the beauty of that land and with the Italian people … on the whole they are neither treacherous nor thievish but subtle and very polite, even though they are loud-mouthed and tight-fisted' (Chapter I, verse 68).[1] The Dutch attitude to Rome was evidently ambivalent.

Most northern travellers experienced exactly this mix of wonder and fear when considering Rome and of fascination and disillusionment upon arrival. When Michel de Montaigne first saw Rome in November 1580 he was unimpressed: 'Rome did not make a great show to see it from this road. We had far on our left the Apennines; the country is unpleasant … the land bare, treeless, to a large extent barren; the country very open for more than ten miles around; and almost all of this sort, with very few houses.'[2] The ruins of Rome did not improve upon closer inspection: according to Montaigne, 'those who said that one at least saw the ruins of Rome said too much, for the ruins of so awesome a machine would bring more honor and reverence to its memory: this was nothing but its sepulcher'.[3]

Montaigne's disappointment was widely shared and can be seen reflected in the images of northern artists working in Rome. Antiquarian prints such as Hieronymous Cock's set of Roman ruins of 1561 (fig. 67), show the monumental squalor of Montaigne's inglorious sepulchre, huge areas of brick wilderness where the street plan and the street level of the ancient city has been utterly effaced, and yet no new plan or level has been

Fig. 68
Herman van
Swanevelt, *Campo
Vaccino*, 1631, oil on
copper (Fitzwilliam
Museum)

settled upon to take its place. Instead troglodytes make homes in this baffling, nightmarish, three-dimensional chaos.

There were clearly places in Rome where ruins could seem imperfect glimpses of some past glory, such as the Campo Vaccino, the site of the Roman Forum, seen in Herman van Swanevelt's view of 1631 (fig. 68). But what a contrast: yesterday's Forum, giving orders to the civilised world; in 1589 Sixtus V decided that it should be the site of the Roman cattle-market, hence its name 'field of cows'. A meticulous view of 1824 (fig. 69) allows us to ascend from the position we adopt in Swanavelt's image and to see this forum in the context of the city as a whole. Even after two hundred years of enthusiastic development the panorama from the city's centre, the Capitoline

Hill, reveals gardens and ruins interrupted by the odd church and villa. This is the *disabitato*, the 'rubble-belt', the two-thirds of the area of the ancient city of Rome which was without human habitation. It is difficult to imagine more of a contrast with the tightly packed, walled cities of Holland (see no. 17), which were expanding during the seventeenth century according to careful plans, often reclaiming land from the sea.[4] The Romans at the same time were trying to reclaim their city from itself.

For Montaigne Rome is 'all court and all nobility: every man shares in the ecclesiastical idleness. There are no shop-lined streets, or fewer than in a small town: it is nothing but palaces and gardens.'[5] Most northern artists would seem to have agreed that Romans were certainly idle and

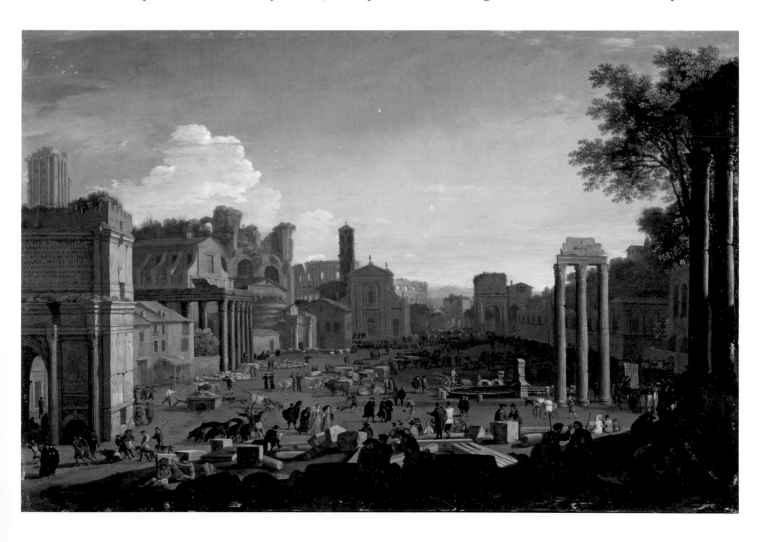

probably dishonest. Their images of the Roman street (see fig. 68 and nos 34 and 35) are unedifying to say the least. On the positive side Montaigne found Rome 'the most universal city in the world, a place where strangeness and differences of nationality are considered least; for by its nature it is a city pieced together out of foreigners; everyone is as if at home'.[6] This does not mean that everyone learned to live with each other: frequent accounts of clashes between the armed retainers of the French and Spanish factions (and rival Italian families) make Rome sound like Shakespeare's Verona.[7] Giacinto Gigli describes one such conflict in 1646 between the Spanish

Ambassador and Cardinal Rinaldo d'Este, the Protector of France.[8] The city was put on alert for a week: papal soldiers were stationed on every corner; the route of the Spanish Ambassador's entry procession on 25 April was altered to avoid passing the Cardinal's palace. In the end a major confrontation was averted and the two men were reconciled by the Pope on 3 May. Only then did they dismiss the private armies they had recruited to protect their palaces and their carriages while in the street; that of Cardinal d'Este was said to have numbered 3,000, many of them bandits. The peace did not prevent seven Frenchmen, on 25 June 1646, from following a Spaniard who had

Nord Westliche Uebersicht von Rom, genommen von dem Thurme des Capitols 1 *Vue du Nord Ouest de Rome, prise de la Tour du Capitole 1*

provoked them into the *casa* of the church of S. Giacomo degli Spagnuoli, where they were cornered by the Spanish retainers lodged there and slaughtered even though they had surrendered their arms.[9]

For the more peaceably minded this cosmopolitanism was an altogether positive thing, which artists took advantage of as much as antiquarians, priests and pilgrims. Northern artists flocked to a small quarter immediately inside the Porta del Popolo, the gate into Rome from the north, a handful of streets lying between the Piazza del Popolo and the Piazza di Spagna.[10] This is the quarter of Rome shown in many street scenes, including Lingelbach's (no. 34). There had been a northern colony here at least since the 1550s; during the first half of the seventeenth century this area of Rome was frequented by artists from France (Nicolas Poussin (1594–1665) lived here from 1624 until his death); from Germany (Adam Elsheimer (1578–1610) lived here from 1600 until his death; Joachim von Sandrart (1606–1688) visited in 1630–36, befriended Poussin and Claude and subsequently wrote their lives); Lorraine (Claude arrived here in 1627 and remained until his death); the Southern Netherlands (Paulus Bril (1553/4–1626) settled here in the 1570s), as well as the Dutch Republic. All these separate groups seem to have known each other, bought their paints from the same shops and met in the same taverns. This association provides the justification for including artists from Lorraine and Germany (nos 30 and 34) in an exhibition entitled *Dutch Landscapes*.

The most tangible expression of this pre-Romantic artists' colony, was the *Bentvueghels* ('Club-Birds'), a group of artists mostly from the Netherlands who in 1623 created a semi-formal club, with disreputable initiation rituals and club names, and regular meetings at the Osteria della Fontana in the via Condotti (then called via Trinitatis).[11] The *Bentvueghels* fell out with the Roman artistic establishment over their refusal to pay dues to the Accademia di San Luca. The only members whose work appears in this exhibition were Cornelis van Poelenburgh (nos 28 and 29), whose nickname, *Satyr*, perhaps derives from the satyrs in his paintings (see no. 29), and Karel du Jardin (nos 35–7), called *Bokkebaart* (Goatee-Beard). The most famous member of the *Bent* was Pieter van Laer (1599–1642, in Rome from 1625 to 1639), whose nickname, *Il Bamboccio* (The Ragdoll), referred to his hunchback. The name *Bamboccianti* was also used by northerners and Italians alike to describe all artists painting the Roman street in the manner of van Laer (fig. 68 and no. 34 for example).

There was a considerable market for *Bamboccianti* painting in Rome in the period, but not surprisingly there was much hostility to this art which so insulted the city and its inhabitants. The painter Salvator Rosa (1615–1673) devoted a section of his satirical poem, *La Pittura*, of c.1645 to attacking those who 'paint swindlers and wretchedness and urchins and pick-pockets' and such like debased subjects.[12] Francesco Albani (1578–1660) wrote on 28 October 1651 to his pupil Andrea Sacchi (1599–1661) attacking 'Monsù Bamboccio' and his ilk who show scenes of wretchedness and

squalor which sell for six to eight scudi; he wishes for a 'voice of thunder' to execrate these people 'who have dragged that worthy Queen, Painting, to lead a life so unsuited to her nobility in taverns, brothels and pig-sties'.[13]

Though probably not unduly stung by such attacks, Dutch artists chose not to settle in Rome. Some northern painters spent their entire careers there during the seventeenth century: Paulus Bril and Jan Miel (1599–1663) from Flanders; Nicolas Poussin and Gaspar Dughet (1615–1675) from France and Claude from Lorraine. None of the famous 'Dutch Italianates' by contrast were in Italy for more than a decade (with the exception of the thirteen-year stays of Pieter van Laer and Herman van Swanevelt); two of the most influential, Adam Pynacker and Nicolas Berchem,

spent only three years there at most. Of the group of artists sometimes bracketed with the Italianates because of their decorative handling, golden light or occasionally Mediterranean-looking motifs – Philips Wouwermans, Adriaen van de Velde, Jan Wijnants and Aelbert Cuyp – not one set foot in Italy.

If artists were so disillusioned with Rome and behaved so disreputably there, why then did they go in the first place? In fact of course it is possible to present a completely different picture of Rome in this period, one that celebrates the achievements of the great 'town-planning' popes – Sixtus V (1585–90), Paul V (1605–21), Urban VIII (1623–44), Innocent X (1644–55) and Alexander VII (1655–67) – and the creation of the Roman Baroque. This transformation was already remarked upon in a letter soon after the death of Sixtus V:

> Here am I in Rome and yet I cannot find the Rome I know: so great are the changes in the buildings, the streets, the piazzas, the fountains, the aqueducts, the obelisks, and the other marvels with which the glorious memory of Sixtus has beautified this old and ruinous city, that I cannot recognise or find, so to speak, any trace of that old Rome which I left ten years ago. (Angelo Grillo writing in *c*.1590 to Alessandro Spinola)[14]

As the century progressed so did this transformation, beginning with the grandest 'buildings, streets and piazzas' and over time adding smaller and often more creatively designed

churches, palaces and fountains. Two views of the Piazza del Popolo, entrance to the city and part of the 'artists' quarter' (mentioned above), demonstrate this transformation: Israel Silvestre's view of *c.*1650 (fig. 70) records the fountain and obelisk erected by Domenico Fontana for Sixtus V in 1589 within an otherwise dilapidated space; 16 years later Lieven Cruyl shows a magnificent Baroque urban arena (fig. 71), with the embellishments added to the designs of Gianlorenzo Bernini: a new gate erected in 1655 in preparation for the triumphal entry into Rome of the recently converted Queen Christina of Sweden, and the pair of matching churches marking the 'spines' separating the three famously long, straight roads – Babuina, Corso and Ripetta – two of which were ancient.[15] The churches (S. Maria di Montesanto and S. Maria dei Miracoli) are shown in optimistic anticipation of their completion in the 1670s. It is a question of attitude: for the picturesque painter the piazza is half-ruined; for the town planner it is half-rebuilt.

It was not just the ancient and newly built city and its art which attracted artistic visitors, it was also the landscape. It was barren and under-populated, and often appears so in paintings, but it was also open, mountainous and exotic, and warm enough to enable artists to make long expeditions to draw and paint out of doors.[16] This was also the landscape described by Virgil in his *Eclogues* and *Georgics*; this was where Horace had his Sabine farm from which he saw the snow on Mount Soracte. There is no depiction of Roman squalor which does not have some hint of this glory. As Montaigne again put it, 'one saw nothing of Rome but the sky under which it had stood'.[17]

Fig. 71
Lievin Cruyl,
*Prospectus Portae
Flaminiae vulgo Populi*
from *Prospectus
locorum urbis Romae*,
1666, etching
(British Museum)

Poelenburgh was a Roman Catholic and (like many Italianate painters) a native of Utrecht, the most Catholic of Dutch cities. He studied there with Abraham Bloemaert (1564–1651) before travelling to Rome in 1617, where he remained until 1627. Poelenburgh enjoyed an international reputation during his lifetime: working for Cosimo II de' Medici in Florence in 1620–21 and for Charles I in London off and on from 1637 to 1641.[19] The rest of his career was spent in Utrecht, where he received important commissions from local aristocrats and from Prince Fredrick Henry of Orange.[20]

The early date of this work is suggested by comparison with the similar work in the Louvre, which is signed and dated 1620. It gives an excellent idea of the sort of painting for which Poelenburgh was famous. The market for small-scale Roman landscapes with a figure narrative was created by two artists of exceptional international fame, Adam Elsheimer and Paulus Bril; their death within a few years (in 1610 and 1626) created a gap in the market which Poelenburgh effectively filled.[21] All three artists mentioned above set out their landscapes like a stage, with every element seeming to lie parallel or perpendicular to the picture plane. The alternation of episodes from one side to the other as the eye 'zig-zags' into the distance enlivens what is essentially a vista towards a central vanishing point. The handling of these conventions has been transformed in the 20 years between Bril's landscape (fig. 72) and Poelenburgh's: the later horizon is lower, the perspective more strictly observed, the outlines of the landscape less pronounced and decoratively contrived, the colours more blended. Elsheimer contributed greatly to these developments, but Poelenburgh's smooth, almost enamel surfaces and neat shaping of the elements is utterly unlike his work.

Though a brightly coloured and light-filled scene, Poelenburgh's imagery draws heavily on the sinister and sepulchral aspect of the Roman rubble-scape (see above, pp. 126–7, and compare fig. 67). The houses to the left grow out of the ruined Roman arches which themselves rest on monstrous rock formations. Similar human termite hills appear in the distance; the boy in the left foreground appears to have emerged from an open grave. The consistent brown colour of the middle distance and imprecise form suggests that all human architecture is destined to melt into the sands of a giant hourglass.

This is certainly an imaginary view, but the fountain to the left was designed by Giacomo della Porta and installed in the Campo Vaccino in 1593 to serve the cattle market (compare fig. 68). The figures similarly have one foot in reality: some recognisable Roman nobles and shepherds in the background, and a couple in the foreground resembling Mary and Joseph preparing to flee to Egypt.

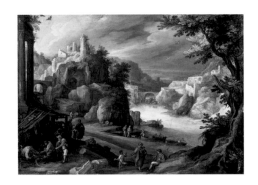

Fig. 72
Paulus Bril, *Fantastic Landscape*, 1598, oil on copper (National Gallery of Scotland, Edinburgh)

THE PAINTING CAPITAL OF THE WORLD

28
CORNELIS VAN POELENBURGH
(1586–1667)
Shepherds with their Flocks in a Landscape
with Roman Ruins
Oil on copper
31.7 × 40cm
Signed: *C.P.*
*c.*1620
Acquired by George IV in 1814 with the Baring collection;
attributed to Bartholomeus Breenberg (*c.*1598–1657) in
1819, described as 'a fine specimen of the Master' and
valued at 100 guineas.[18]
RCIN 404819
White 1982, no. 141

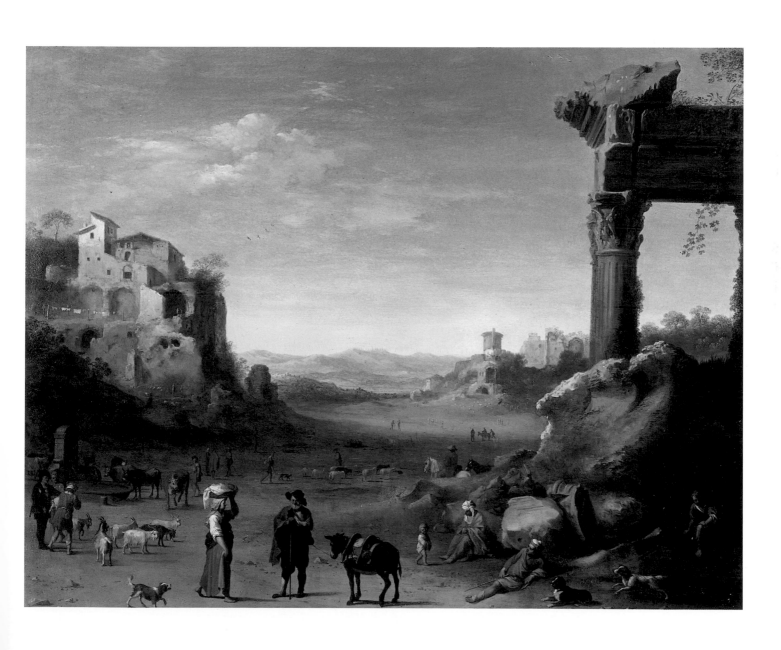

CORNELIS VAN POELENBURGH
(1586–1667)
Nymphs and Satyrs in a Hilly Landscape
Oil on panel
39.2 × 63cm
Signed and dated: *C.P.F 1627* [?]
Recorded in the collection in the early eighteenth century.
RCIN 405629
White 1982, no. 142

The date on this panel is difficult to read, making it impossible to decide whether the work was painted in Rome or immediately after the artist's return to Utrecht. The particular imagery here – disporting nymphs and satyrs against a sun-baked landscape – may also reflect the impact of Titian's 'Este Bacchanals', the *Andrians* and *Putti in Front of a Statue of Venus* (both Prado, Madrid, fig. 73) and *Bacchus and Ariadne* (National Gallery, London), which were brought to Rome by Cardinal Aldobrandini in 1598.[22] There is a close relationship, perhaps disguised by the artists' subsequent careers, between this work and the early mythologies of Nicolas Poussin, who arrived in Rome in 1624 and was similarly impressed by Titian's Bacchanals.[23]

This sort of idealised mythological landscape remained in fashion for at least a hundred years, with an artist such as Gerard Hoet (1648–1733) creating similar imagery throughout his career. In the chapter on landscape in his *Inleyding* of 1678, Hoogstraten endorses this species of landscape, urging artists to show him the enchanted wood penetrated by Tasso's Rinaldo, the home of the blessed in the Elysian Fields, as sung by the poets, the Vale of Tempe in Thessaly and the hunting grounds of Arcadia.[24]

Poelenburgh retains his love of fantastical forms in the rocky outcrop to the left-hand side and enjoys the rhyme in colour and shape between these and the suntanned torsos of the satyrs. Is he suggesting that seeing mythology might be the result of a trick of the light exacerbated by sun-stroke on a hot Roman hillside?

Fig. 73
Titian, *Bacchanal of the Andrians*, 1523–6, oil on canvas (Prado, Madrid)

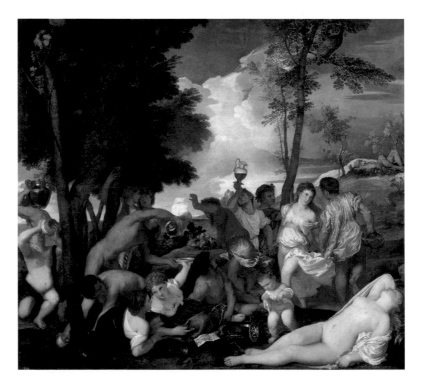

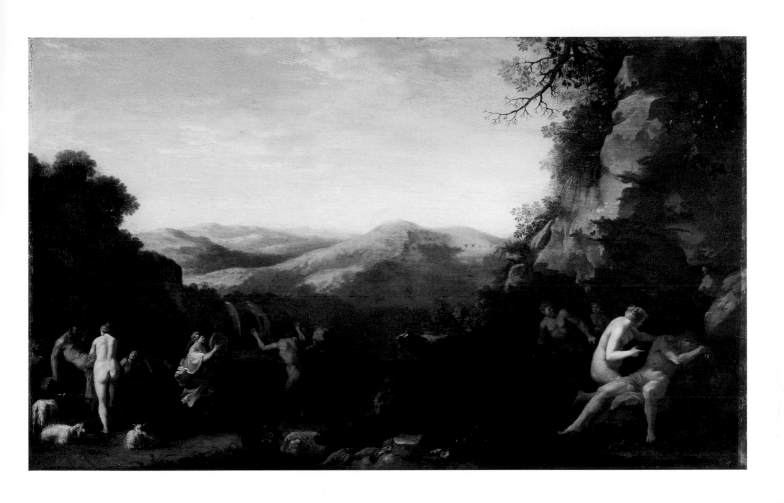

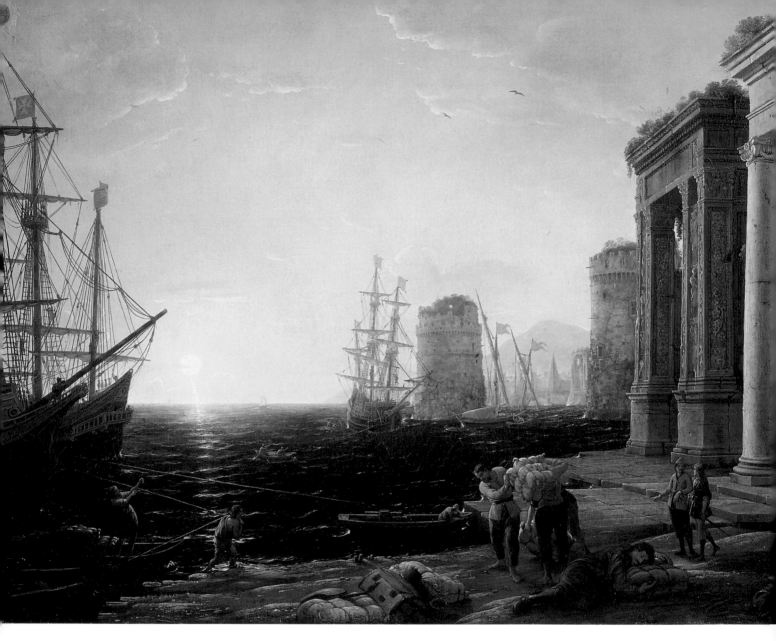

30
**CLAUDE GELLEE, CALLED
'LE LORRAIN'** (1604/5–1682)
Harbour Scene at Sunset
Oil on canvas
74.3 × 99.4cm
1643
Probably acquired by Frederick, Prince of Wales.
RCIN 401382

Fig. 74
Claude Gellée, called
'Le Lorrain', *Pastoral
Landscape*, 1638, oil on
canvas (Minneapolis
Institute of Arts, The
John R. Van Derlip
Fund, and Gift of
funds from Ruth and
Bruce Dayton, SIT
Investment Associates,
Darwin and Geri
Reedy, and Alfred and
Ingrid Lenz Harrison)

Claude was born in the Duchy of Lorraine, which was then an independent state within the Holy Roman Empire. He travelled to Italy in 1613 and studied with the Italian perspective specialist and landscape painter, Agostino Tassi (*c*.1579–1644). By 1627 he had settled in Rome in the 'artists' quarter' (see above, p. 129), where he remained for the rest of his life.

Claude's first mature works, like his landscape of 1638 in Minneapolis (fig. 74) take as their point of departure the landscape of Poelenburgh, especially in their 'stage management'. However, Claude's Campagna is a fertile paradise with ruins rather than a scorched earth, his observation of light so subtle that it is as if he paints the vapour hanging over every surface rather than the surface itself. Scenes such as this struck Claude's contemporaries as miracles of naturalism, not idealisation: the Florentine, Filippo Baldinucci (1624–1696), asserted in his *Notizie de' Professori del Disegno* (published 1681–1728) 'that the great quality of this artist was a marvellous and still unsurpassed imitation of nature in those of its various aspects which condition the views of the sun, particularly on the sea and the rivers at dawn and evening'.[25]

This harbour scene approaches Roman ruins with the same wonderment that Claude approached the Campagna (fig. 74): in reality the Arco degli Argentieri (Arch of the Money-Changers) was in a squalid corner of Rome, but here it is the glorious frame of an idealised harbour with a walled port in the background, protected by two venerable towers. The activities of the figures similarly seem to be calculated to create a mood rather than describe the Italian street: two noble figures contemplate a voyage, while bales of cloth and caskets of treasure are unloaded and a man sleeps (associating the setting sun with well-earned repose).

Claude's other strength, acknowledged by his biographers, was his command of perspective: here a strict vanishing point dictates the perspective of the comfortably solid architecture and pavement.[26] The sun also sets on the vanishing point and every part of the tone and colour of the painting is dictated by its distance from this point. The sky describes a spectrum of yellow to blue and light to dark, but the transitions are so imperceptible and the range so remarkably close that it appears to be no more than an inflection within a single white glow. Claude suggests that his painting covers but a small part of the larger hemisphere of the sky. The air at evening also appears mistier as one looks into the sun and clearer as one looks away, an effect which Claude also records with great fidelity, making his lit surfaces at the margins sparkle sharply against the blue sky behind while at the same time veiling the central areas surrounding the sun with a glowing mist. The only part of the scene out of step with this tonal shift is the intensely dark sea, which accurately records the appearance of deep water seen at twilight, but which also suggests the Homeric epithet 'the wine-dark sea'.

Fig. 75
Giovanni di Paolo,
*Saint John the Baptist
Retiring to the Desert*,
1454, egg tempera
on wood (National
Gallery, London:
Bought with a
contribution from
The Art Fund, 1944)

31
JAN BOTH (c.1615–1652)
Landscape with St Philip Baptising
the Eunuch
Oil on canvas
128.6 × 161.8cm
Signed: *Jboth*
1640s
Acquired by George IV in 1811; in the Blue Velvet Room
(fig. 7); described in 1819 as 'the Chef D'Oeuvre of the
Master. From the collection of M. de Schmidt of
Amsterdam' and valued at 1,500 guineas.[27]
RCIN 405544
White 1982, no. 30

Andries and Jan Both were the sons of the Utrecht glass painter Dirck Both (or Boot); they both studied there with Abraham Bloemaert before travelling to Rome by 1638; Andries drowned in Venice in 1642 and soon afterward Jan returned to Utrecht. Andries Both's work is inspired by that of Pieter van Laer; Jan's work is close to that of Cornelis van Poelenburgh, who sometimes provided figures for his landscapes (the two artists would have known each other in Utrecht). While in Rome Jan Both was acquainted with Claude and Herman van Swanevelt; all three artists worked on a set of large religious and secular landscapes commissioned by Philip IV of Spain in 1640 to decorate his recently built palace, the Buen Retiro, in Madrid (all now in the Prado).[28] The scale of this commission – most landscapes are roughly 2 × 1.5 metres – and the obvious importance attached to the religious subject matter make it something of a turning point in the status and ambition of Roman landscapists. One of Jan Both's landscapes for Philip IV depicts St Philip baptising the eunuch; the artist clearly saw the potential of providing other clients with something as grand and improving as a religious landscape destined for the 'Most Christian King'.

The subject comes from the Acts of the Apostles (VIII, 26–39), and tells of St Philip on the road meeting a man of Ethiopia, 'an eunuch of great authority under Candace queen of the Ethiopians', whose chariot he shares while discussing Isaiah. Having established that Jesus is the one foretold by the prophet, Philip stops at some water to baptise the eunuch in His name. This is an ideal subject for a landscape because it concerns a journey; Jan Both plays with this idea by showing the other finely dressed Ethiopians adrift and directionless, with expressions of aimless consternation as if their chariot has broken down. The path to the left, which the eunuch will resume, is the 'true path', a steep and stony one leading to a hermitage, contrasting with the extensive fertile plain to the right. The same contrast can be seen in Giovanni di Paolo's depiction of the young St John the Baptist choosing the steep and stony path into his mountainous wilderness rather than the fertile patchwork of the plain (fig. 75). Few seventeenth-century artists would have known much of Giovanni di Paolo, but the contrast of wild places as a home for hermits and the plain as the place of sin can be found throughout the story of landscape painting in Europe, and in many of those provided for Philip IV's Buen Retiro.

An even more powerful metaphor for spirituality in this landscape is the light which impregnates every part of the scene and streams over the central figures like a river. Jan Both (and his contemporaries) may have thought of the dark-skinned Ethiopians as metaphors for 'those that live in darkness'. In his depiction of light, especially in the spectrum in the sky and in the extraordinary translucency of the foliage, Jan Both has clearly been influenced by the example of Claude, as can be seen by comparison with the landscape painted in the year of his arrival in Rome (fig. 74).

32
NICOLAES BERCHEM (1620–1683)
Italian Landscape with Figures and Animals:
A Village on a Mountain Plateau
Oil on panel
32.5 × 44cm
Signed and dated: *Berghem / 1655*
Acquired by George IV in 1814 with the Baring collection
and valued in 1819 at 400 guineas.[29]
RCIN 404818
White 1982, no. 20

Berchem was the son and presumably pupil of Pieter Claesz (1597/8–1660), a Haarlem painter of down-to-earth still lifes. He also studied with a variety of artists, including Jan van Goyen (1596–1656), and became a prominent member of the Haarlem artistic community, on one occasion travelling to Germany with fellow townsman, Jacob van Ruisdael. The last decade of his life was spent in Amsterdam. Berchem painted some northern forest landscapes (like the one of the later 1640s in Dulwich Picture Gallery) of a type which this training and milieu might lead one to expect. The majority of his work however is Italianate, either inspired by an undocumented visit to Italy, which can only have occurred between 1651 and 1653, or by exposure to the work of returning Italianates such as Poelenburgh, Jan Both and Jan Asselyn (*c.*1615–1652), all of whom were back home by the late 1640s.

This work and two of the Du Jardins in this exhibition (nos 36 and 37) belong to a popular type – the small, jewel-like evocation of a hot Italian hillside – which ultimately derives from the work of Cornelis van Poelenburgh (see nos 28 and 29). The comparison perhaps makes Poelenburgh's landscapes appear contrived in composition and mechanical in lighting. Berchem's panorama has a daring openness which derives from a famous work by Asselyn of *c.*1650 (Akademie der Bildenden Künste, Vienna); his sky has Claude's effect of white luminosity through minimal transitions of colour and tone.

The most striking effect of Berchem's work however is the way that he has allowed the texture of the paint and the patterns of the brushstrokes to appear so strongly even in a work of such small scale. A few years later Samuel van Hoogstraten describes the advantages of this procedure:

> It is above all desirable that you should accustom yourself to a lively mode of handling so as to smartly express different planes and surfaces; giving the drawing due emphasis and the colouring, when it admits of it, a playful freedom, without ever proceeding to polishing or blending … it is better to aim at softness with a well-nourished brush … for, paint as thickly as you please, smoothness will, by subsequent operations, creep in of itself (*Introduction to the Art of Painting*, 1678).[30]

33
NICOLAES BERCHEM (1620–1683)
*Mountainous Landscape with Herdsmen
Driving Cattle down a Road*
Oil on canvas
71.9 × 91.6cm
Signed and dated: *NBerchem / 1673*
Acquired by George IV in 1814 with the Baring collection;
described in 1819 as 'Very Fine' and valued at 300 guineas.[31]
RCIN 405345
White 1982, no. 16

This landscape (as to a lesser extent the previous one) shows how the Italy of the imagination is as important as the Italy which can be visited and observed. In imagination Italy is a garden protected by a mountain wall: this is suggested by Giovanni di Paolo's predella scene (fig. 75) as much as by Goethe's famous poem, *Kennst du das Land?*, where Italy is a land of lemon groves, marble houses and a mountain pass, and where 'Das Maultier sucht im Nebel seinen Weg' ('The mule seeks its way in the mist'). According to van Mander, Pieter Bruegel the Elder's Italian visit resulted in 'many pictures from life on his journey, so that it was said of him, that while he visited the Alps, he had swallowed all the mountains and cliffs, and, upon coming home, he had spit them forth upon his canvas and panels; so remarkably was he able to follow these and other works of nature'.[32] Berchem's subject in both these paintings is similarly the journey, the herdsman and muleteer leading their beasts over mountain passes (in this painting) and onto scorched plateaus in time to arrive at an inn by sunset (in no. 32). This romantic idea of Italy predates the nineteenth century: Jacques Callot's *La Petite Treille* was published in 1635, an image of earthly pleasure, depicting a meal under the trellis of a picturesque Italian *locanda*, very like the plastered houses visible in the middle distance of no. 32.

34

JOHANNES LINGELBACH (1622–1674)
Figures before a Locanda, with a View of the Piazza del Popolo, Rome
Oil on canvas
63.2 × 72.6cm
*c.*1645–50
Acquired by George IV in 1811.
RCIN 404534
White 1982, no. 97

This is a classic *Bamboccianti* scene depicting Romans at their least prepossessing. During his first years in Rome Lingelbach lodged in this very street; had he chosen the *locanda* (hostel) depicted here, with its cheap paper windows and extraordinary projecting hatch, he would have had to pick his way through a variety of street traders: a *ciambella* (ring-shaped cake) seller, who also runs a *girella* (a species of roulette wheel banned in Rome at the time) and an old man mending a boy's shoe while its owner sits in the dirt.[33] Even the hostel door is barred by a blind musician playing a guitar while a boy sings and a suspicious young woman loiters. The armed man with his hat drawn over his eyes is even more sinister; he is certainly no mountebank, as has been suggested. Some context may be provided for this menacing presence and the couple in Spanish dress in the background by accounts of clashes between armed retainers of the kind which took place in 1646, at exactly the time Lingelbach was in Rome (see above, pp. 128–9). Could this man be a retainer, the 'hired gun' of Baroque Rome? The lawless feudal warlord – the subject of Alessandro Manzoni's historical novel, *I Promessi Sposi*, of 1824–7 – was a real phenomenon in the seventeenth century (see above, pp. 128–9), as suggested by the fact that the Italian word *barone* meant at once a 'baron' and a 'rogue'.

The setting here can be recognised from contemporary topographical sketches (fig. 70), and shows a road, square, walls and gate, all of which date from Roman times. As in views of the Forum (fig. 68), we meditate upon the contrast of former glory and present ignominy, except that during the Renaissance and Baroque periods (1500–1700), successive popes turned the Piazza del Popolo into one of Europe's most spectacular urban spaces (see above, p. 131). Lingelbach does not seem anxious to celebrate this achievement: he omits Sixtus V's obelisk and shows the Roman Via Paolina obstructed by a stone platform and street vendors. The urban planning of Rome was policed by a functionary ascribed to each parish (*rione*) called the 'Master of the Streets' (*Magister viarum*); this image depicts everything that he sought to eliminate.

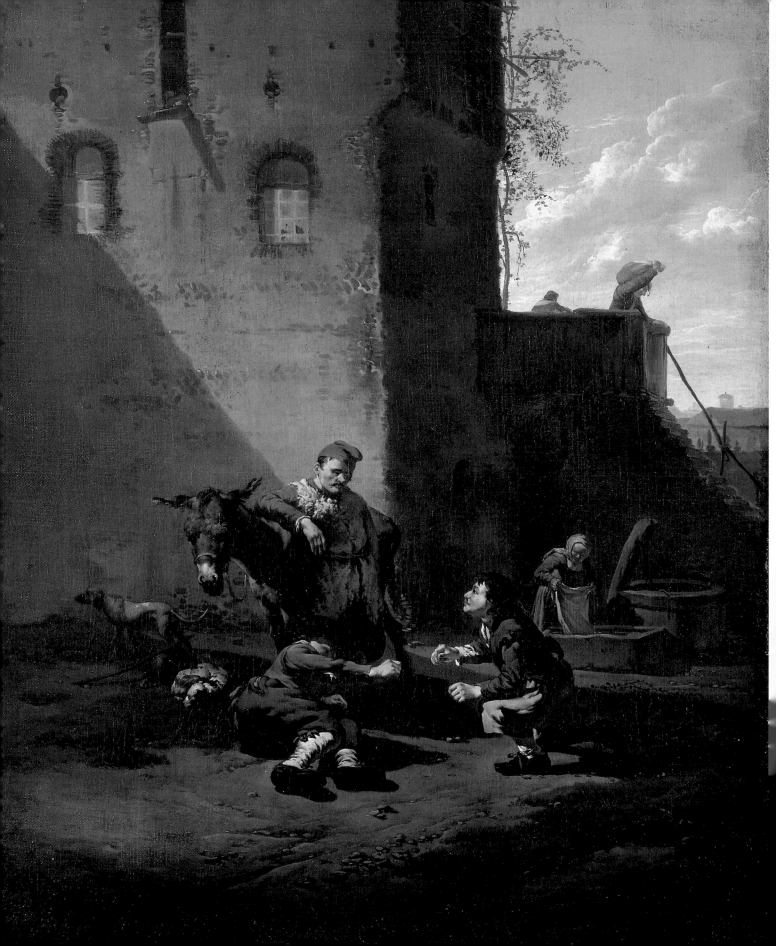

35
KAREL DU JARDIN (1626–1678)
A Muleteer and Two Men Playing the Game of Morra
Oil on canvas
52 × 42cm
Signed: *C. du Jardin.*
*c.*1650–52
Acquired by George IV in 1818; valued in 1819 at 250 guineas.[34]
RCIN 406208
White 1982, no. 93

Born in Amsterdam, du Jardin is thought to have studied with Nicolaes Berchem and, although there is no documentation to prove it, he probably first went to Rome during the late 1640s. In 1650 he was in Paris but returned to Amsterdam in 1652 where he settled for a while, although he spent a few years from 1655 to 1658 in The Hague. In 1675 he returned to Italy in the company of Jan Reynst, the son of the famous Dutch merchant and art collector of the same name.

This work, although created in Paris, is reminiscent of the low-life works created by the irreverent Dutch and Flemish artists in Rome (*Bamboccianti*), mixed with the style of Sébastien Bourdon (1616–1671). This French artist had a major influence on du Jardin. Bourdon had spent time in Rome and his works combined elements of genre painting with the serious classicism of Nicolas Poussin. Such a studied amalgamation of influences is typical of du Jardin, although at its core the artist's style remained distinctively Dutch.

A run-down tower dominates the scene, perhaps alluding to the disintegration of classical Rome. In the foreground two men, watched by a mule-driver, play Morra. The game dates back to ancient Greece and slightly resembles our 'paper, scissors, stone': two players simultaneously display from one to five fingers while shouting out what they guess to be the sum of both hands. While often used to settle disputes (much as tossing a coin), it also suggests time-wasting. In the baking heat of the afternoon sun, the languid attitude of the muleteer, leaning against his weary mule, indicates the idleness of the group. In contrast du Jardin fills the rest of the image with activity; a woman washes clothes, two men are caught up in carrying heavy sacks of grain down a steep staircase, and a dog looks off to the left in eager anticipation.

Despite his frequent travelling and ability to amalgamate various influences and styles, du Jardin retained a Dutch flavour in his paintings. In this example the mountainous background is clearly a reference to the Roman Campagna rather than the artist's homeland, and the scene is suffused with southern brightness, but his muted palette and careful observation remain typically Dutch. The stillness of this scene is conveyed through the straightforward presentation of the sky, with the strong evening light picking out details such as the individual wooden spikes of the fence and the white fleece of the foreground sheep.

This landscape is arid; the ground is rough and dry, with a few thin patches of grass, and the trees beyond the fence are sparse. The young herdsman and his dog cut two solitary figures with their backs turned away from the ox, ass and sheep. The boy is absorbed in the task of fixing his boot, his left hand pinching the leather. Du Jardin reworked this detail to ensure that the angle of the boot was in correct perspective, but the original positioning of the foot slightly lower down is clear to the naked eye.[36] The overall pose of the herdsman recalls the figure of 'Spinario', a boy with a thorn in his foot, portrayed in classical sculpture.[37]

36
KAREL DU JARDIN (1626–1678)
A Herdsman with an Ox, an Ass and Sheep in the Campagna
Oil on panel
30.8 × 38.5cm
Signed: *K. DV. JARDIN. fe.*
early 1660s
Acquired by George IV in 1814 with the Baring collection; valued in 1819 at 250 guineas.[35]
RCIN 404808
White 1982, no. 89

37
KAREL DU JARDIN (1626–1678)
A Shepherd Boy Asleep with a Cow and its Calf
(Photographed before conservation)
Oil on panel
25.9 × 34cm
Signed: *K. DV. Iardin.*
early 1660s
Acquired by George IV in 1814 with the Baring collection
and valued in 1819 at 200 guineas.[38]
RCIN 404811
White 1982, no. 90

In contrast to the sunshine of no. 36, the sky in *A Shepherd Boy Asleep with a Cow and its Calf* is stormy, the claustrophobic darkness setting a threatening tone. Du Jardin compositionally balances the sleeping boy with the resting cow. The wakefulness of the standing calf is intended to be eye-catching so that realisation dawns on the viewer, along with this animal, that the weather has altered and the shepherd should awaken and move to shelter.

This is drama of a rhythmical kind. There is no serious threat, and no sudden action. Instead the artist records the reality of nature, where changes in the weather can creep up steadily. The light in this painting is decidedly northern, with saturated greens and browns dominating and adding to the overall intensity of the atmosphere.

The similarity of du Jardin's works to those of Paulus Potter (nos 8–10) is striking, and their paintings have often been confused.

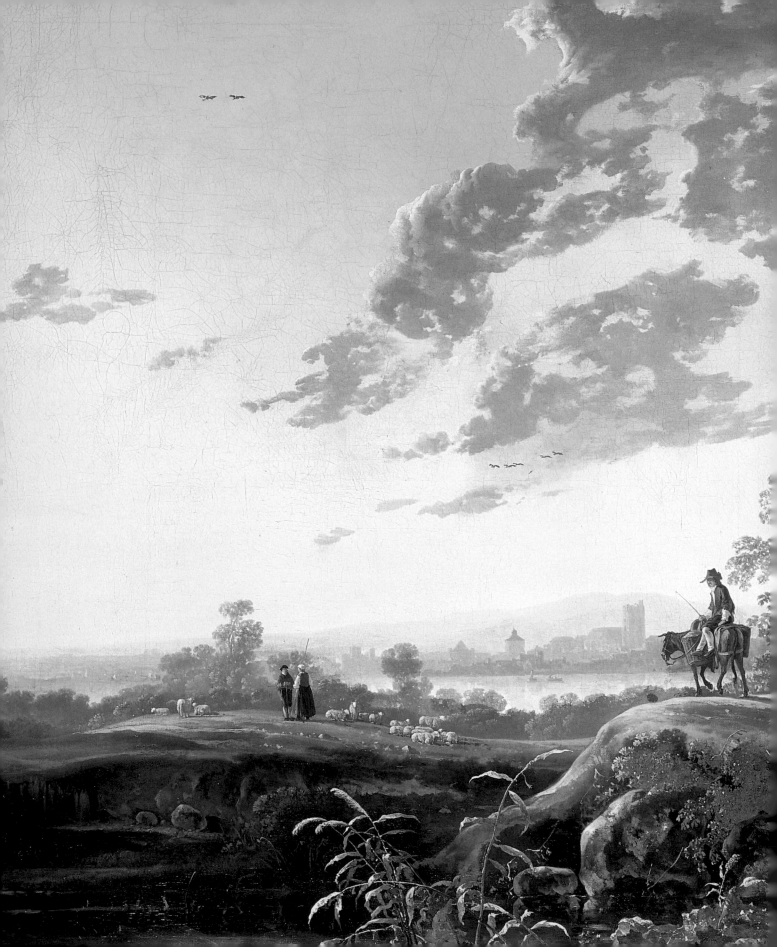

IV
AELBERT CUYP

The group of landscapes in the Royal Collection by Aelbert Cuyp are of such range and quality (though all produced between 1645 and 1660) as to justify this final section being devoted exclusively to the master. This is partly because of the special enthusiasm for Cuyp in England in the Regency period, witnessed by the pride of place offered to his work in the interiors at Carlton House: the *Passage Boat* (no. 39) hung in the Blue Velvet Room (fig. 7) and the *Cavalry Trooper* (Royal Collection, RCIN 405321) in the Blue Velvet Closet (fig. 8).[1] Turner especially admired Cuyp, commenting in his 1811 lecture on 'Backgrounds' to the students of the Royal Academy that Cuyp had 'a judgement so truly qualified,

knew where to blend minutiae in all the golden colour of ambient vapour'.[2] It is clear that *Calm* from the *Liber Studiorum* (fig. 11) is a particular tribute to Cuyp (compare no. 39), as well as acknowledging the Dutch marine tradition in general.[3] The other reason for singling out Cuyp is that his landscapes have a greater range than those of other masters, something which Fromentin recognised:

> In the first place he has the merit of being universal. His work is such a complete repertoire of Dutch life, especially in its rural environment, that his scope and variety would suffice to give him considerable interest. Landscapes, sea-pictures, horses, cattle, people of all conditions, from men of fortune and leisure to shepherds, great and small figures, portraits, and pictures of farmyards, such is the curiosity and aptitude of his talent that he must have contributed more than anyone to enlarge the basis of local observation upon which his country's art unfolded.[4]

Cuyp worked throughout his life in Dordrecht; he probably studied with his father, the portrait painter Jacob Gerritsz. Cuyp (1594–1652), and was strongly influenced at the outset of his career (during the early 1640s) by Jan van Goyen. At some stage in the mid-1640s Cuyp must have seen landscapes by Jan Both (no. 31), who had returned from Rome to Utrecht in *c.*1642, when Cuyp visited Utrecht on family business (the journey from Dordrecht is less than 40 miles).[5] Cuyp produced a series of drawings which testify to a trip down the Rhine to Nijmegen and Cleves (only a 60-mile venture); topographical details reveal that this must have taken place some time between late 1651 and November 1652.[6]

Cuyp's landscape motifs arise from these circumstances. He painted many estuaries and polders, some with recognisable landmarks, which seem accurately to record the landscape around Dordrecht (as in nos 38 and 39). He also created a more imaginary terrain (see nos 40–42) with rolling hills and elemental architectural forms. These perfectly cylindrical towers and cubic blocks, with plain window openings (fig. 76), suggest Italianate architecture but may be inspired by the dramatic Romanesque monuments of the Rhine valley – the Valkhof in Nijmegen and the Schwanenburg in Cleves. By removing obviously medieval details, like machicolations, Cuyp could be trying to evoke the ancient character of this region: Nijmegen being the site of the *oppidum Batavorum*, the most important Roman city in the Netherlands.[7] These later imaginative landscapes certainly do not look obviously Mediterranean and have none of the tricks – shepherds in skins, bare hillsides, ruins and so on – by which other artists suggest Italy.

Cuyp appears to have been something of a celebrity in his home town, though not well known beyond until the eighteenth century. He rose to the rank of Regent of the city of Dordrecht and worked for a close network of the city's elite, described by Alan Chong as 'well-to-do Dordrecht burghers who identified themselves with the aristocratic values suggested by Cuyp's pictures'.[8] Cuyp's career therefore followed a pattern nearer

to the court model of patronage than the anonymity of most Dutch landscape painters (described above on pp. 20–22). A court artist is known personally by most of his patrons who are also familiar with a substantial proportion of his works. Such an artist needs to be more ambitious, more varied and perhaps more 'poetical' than one working for art fairs.

Though the range of terrain is much wider, the character of the human interaction in these five landscapes follows the pattern of the 'city-dweller's excursion' covered in the first section of this exhibition. The *Cows in a Pasture* (no. 38) resembles a Potter homestead, though in this case lacking a sense of encounter found in the latter's

work. The *Passage Boat* (no. 39) on the other hand is a unique marine painting in depicting an ordinary ferry, which appears to be docking in order that we, the viewer, may climb aboard. The three Rhineland views (nos 40–42) are classic wayfarer scenes where travelling noblemen encounter strange people and places on their journey south.

One aspect of the poetry of the city excursion is significant here: its tendency to see in landscape some sign of divine benevolence. It is as if the God who turned the year in the *Très Riches Heures* and whose worship consisted in seasonal labour is now apprehended subjectively by the poet inspired by some mood or element in the

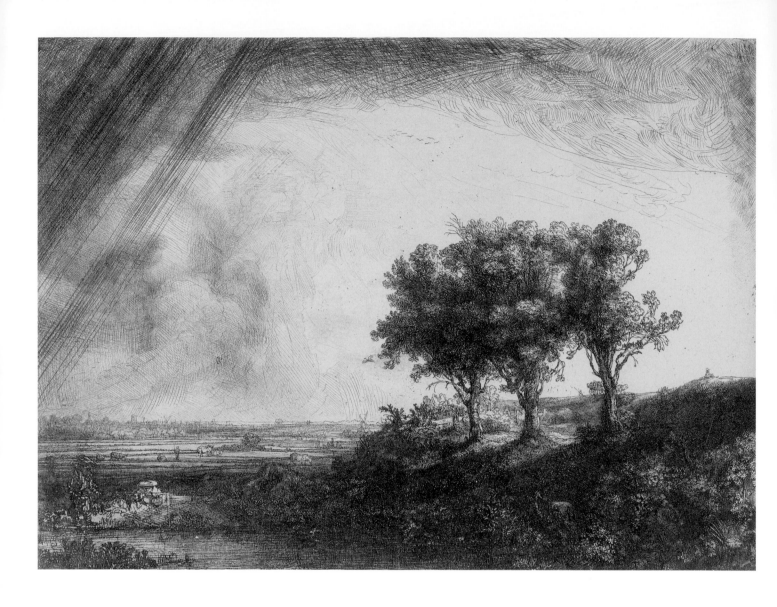

AELBERT CUYP

Fig. 77
Rembrandt, *Three
Trees*, 1643, etching
(British Museum)

landscape. The worship now lies in a way of seeing the world or rather seeing *through* the world to a truth beyond. A passage from Vondel's *Bespiegelingen van Godt en godtsdienst* (Reflections on God and Religion) has a margin description, 'God's Providence apparent from the beauty of creation'.[9] Constantijn Huygens in his *Oogentroost* (Comfort for the Eyes) of 1647 criticises those who go for a walk 'in woods, hills and vales' and describe a scene as 'picturesque' because they imply that God should be congratulated on His ability to imitate man's art, rather than vice versa.[10] Those looking in nature for God's truth rather than man's taste (the 'picturesque') might see something like Rembrandt's print of 1643 (fig. 77), where three trees seen against the light of the clearing storm are clearly intended to suggest the three crosses at the Crucifixion.[11] Cuyp painted explicitly religious images of roadside conversions and, according to Houbraken, was a fervent Calvinist.[12] Might some of his landscapes without specific religious themes (no. 39, for example) involve viewing Nature in the way recommended by Huygens?

Of all landscape painters of the Dutch Golden Age, Cuyp is the least naturalistic in intention: he has much more in common with the more artificial and decorative Flemish tradition.

Flemish landscape has a high, 'floating' viewpoint, seen especially in Bril (fig. 72) and Jan Brueghel (fig. 16), but still a feature of Rubens's landscapes (fig.17). By contrast Cuyp adopts an exaggeratedly low viewpoint, which forces almost every form through the horizon line to be silhouetted against the sky. This seems like that realistic recording of human vision, which gives such thin horizons and high skies to van Goyen and Salomon van Ruysdael's work (no. 22). Only Cuyp takes the effect further, giving us a rabbit's eye view and thus creating a strange, detached effect, especially when he adds extra planes in the foreground (like the jetty and reeds in no. 38) to 'alienate' the viewer from the scene. His landscapes have that flat 'out-of-reach' effect which can be observed when viewing the world through a telescope. His use of overlapping planes moving step-wise into the background is an updating of Brueghel and Bril (figs 16 and 72), as is his tendency to suggest distance by vaporising these planes in mist. Most of all, however, it is the idea of landscape as an imaginative and poetic expression – seen expressed in Bril's 'musical' self-portrait (fig. 43) – which inspired Cuyp and which ensured the very high reputation enjoyed by the Flemish tradition, especially in aristocratic circles within the Netherlands and elsewhere.[13]

Cuyp's earliest paintings such as his 1640–42 *River Scene with Distant Windmills* (National Gallery, London, fig. 78) are in the tonal style of Jan van Goyen, except that his paint layer is thicker and much more sensually applied. This work of a few years later exhibits many of the same features: earth colours; areas of paint applied thickly in a variety of mannered patterns like mould growing on a dish; a mundane, flat fens-and-fields motif. In this later example, however, the extra-low viewpoint takes the figures away from any possible encounter, an effect heightened by the fact that they turn away from us. The colour in the sky also has a luminosity and spectrum of light quite unlike that of tonal painting, as is the way in which the mist swallows up the ruins: this is like the *Herdsmen with Cows* of *c*.1645 (Dulwich Picture Gallery, London), admired by William Hazlitt for being 'woven of ethereal hues'.[15]

The ruin in the background has been identified as that of the Abbey of Rijnsburg near Leiden; the absence of any distinctive and legible architectural features makes this difficult to sustain with any certainty.[16] Ruins appear in many prints of the period and are usually castles, like Brederode and Huis te Kleef, destroyed by the Spanish in the 1570s and 1580s.[17] The fact that the ruin is here combined with the emblematic 'Dutch Cow' discussed above (p. 62), as well as copper milk vessels to convey their great productivity, suggests that this may be intended (like no. 8) as a celebration of the conclusion of the war (an outcome realistically expected at this time) and the anticipated benefits of peace.

Fig. 78
Aelbert Cuyp, *A River Scene with Distant Windmills*, *c*.1640–42, oil on oak (National Gallery, London: Salting Bequest, 1910)

AELBERT CUYP

38
AELBERT CUYP (1620–1691)
Cows in a Pasture beside a River, before Ruins,
possibly of the Abbey of Rijnsburg
(Photographed before conservation)
Oil on canvas
95.4 × 134.7cm
Signed: *A:.cuÿp.*
*c.*1645
Acquired by George IV in 1814 with the Baring collection;
valued in 1819 at 300 guineas.[14]
RCIN 405351
White 1982, no. 34

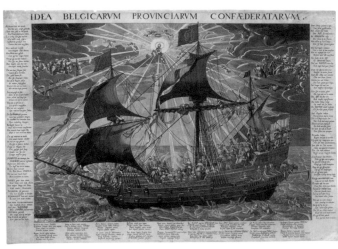

AELBERT CUYP (1620–1691)
The Passage Boat
Oil on canvas
124.4 × 145cm
Signed: *A.cüyp.*
1650s
Acquired by George IV in 1814 with the Baring collection;
in the Blue Velvet Room (fig. 7); described in 1819 as 'in his
finest manner' and valued at 1,200 guineas.[18]
RCIN 405344
White 1982, no. 39

A 'passage boat' is an old-fashioned word for a ferry: this one is probably the regular passenger service between Dordrecht and Rotterdam, part of the network of waterborne public transport which was such a remarkable feature of life in seventeenth-century Holland (see above, p. 39). This vessel is a *pleyt* – a single-mast, sprit-rigged, shallow-draught, broad-hulled tub, very similar to a *smalschip* – adapted to carry large numbers of passengers slowly in calm inland waters. The two *pleyts* here are made to look as if successive views of the same vessel and show how the sail is lowered as the boat drifts towards the jetty. A bugler and drummer announce the arrival of the service and a man fends off with a bargepole. This is a remarkably large scale image of a boat, but there is nothing remarkable about the boat itself or the function it is performing. There are some burghers aboard the *pleyt* and the rowing-boat but no obvious dignitary; there are many ships in the background but nothing to suggest that this is a review of the Dutch fleet.[19] What we see here is literally a daily occurrence.

The drama of presentation here does not just depend upon the isolation of the ferry and its scale. The water-skimming viewpoint means that the hull stands out against the horizon, which glows like a halo as the setting sun catches the mist coming off the sea; it also pushes the mast up into the clouds. These clouds are shaped rather like those in Rembrandt's *Three Trees* (fig. 77) to suggest the forms of angels or zephyrs surrounding the light of the sky. Hoogstraten later advises artists to 'Observe the lovely gliding of the clouds, and how their drift and shapes are related to one another, because the eye of the artist must always recognise things by their essence while the common folk see only weird shapes.'[20]

'Peopled clouds' were familiar from allegorical prints, like that depicting the Dutch 'ship of state' (fig. 79), produced in 1620 to celebrate the Synod of Dordrecht (1618–19) and showing the Stadholder, Prince Maurice of Orange, at the tiller, surrounded by the Seven Provinces, lit from the sky by a figure of Truth holding the States Bible, while the Pope drowns.[21] The *Passage Boat* appears too ordinary to be a 'ship of state', yet the image carries the same visionary enthusiasm. This is probably intended to be a more private allegory of salvation of the type which a spiritual person reads in the ordinary fabric of the world. It would certainly be unlikely for a contemporary viewer to look at this boat without noticing that the mast and sprit make a cross.

Fig. 79
Frans Schillemans
after Jacob Oorloge
and Adriaen van de
Venne, *Allegory of the
Confederated Provinces
of the Netherlands*,
from *Idea belgicarum
provinciarum
confaederatarum*,
1620, engraving
(Rijksprentenkabinet,
Amsterdam)

AELBERT CUYP (1620–1691)
Two Cavalry Troopers Talking to a Peasant
Oil on panel
36 × 46cm
Signed: *A. cuÿp.*
1650s
Acquired by George IV in 1814 with the Baring collection;
described in 1819 as 'of the finest quality' and valued at 250
guineas.[22]
RCIN 404801
White 1982, no. 36

This is an early example of an 'Italianate' Cuyp landscape and demonstrates the influence of Jan Both's work (see no. 31). Cuyp uses the same orange-brown colour range for earth and foliage; the same yellow-to-blue spectrum of light spread across a glassy-smooth evening sky, with clouds painted in such a way as to be obviously sitting in front of this heavenly dome. There is also something of the exoticism of the eunuch's conversion in this roadside encounter: the riders both wear fancy-dress costume, the mounted figure has old-fashioned slashed sleeves and the standing figure wears a *dolman*, a Hungarian garment associated with hunting in the Netherlands.[23] These riders have also travelled beyond the familiar terrain of Cuyp's Dordrecht patrons into a region which might be called the 'gateway to the south' (see above, pp. 154–5). However, they have ventured into a delightful and romantic terrain, unlike the threatening wilderness visible in Wouwermans's contemporary dune scenes (nos 3 and 4). Like Wouwermans, however, Cuyp makes much of the effect of figures seen from below and silhouetted against the sky.

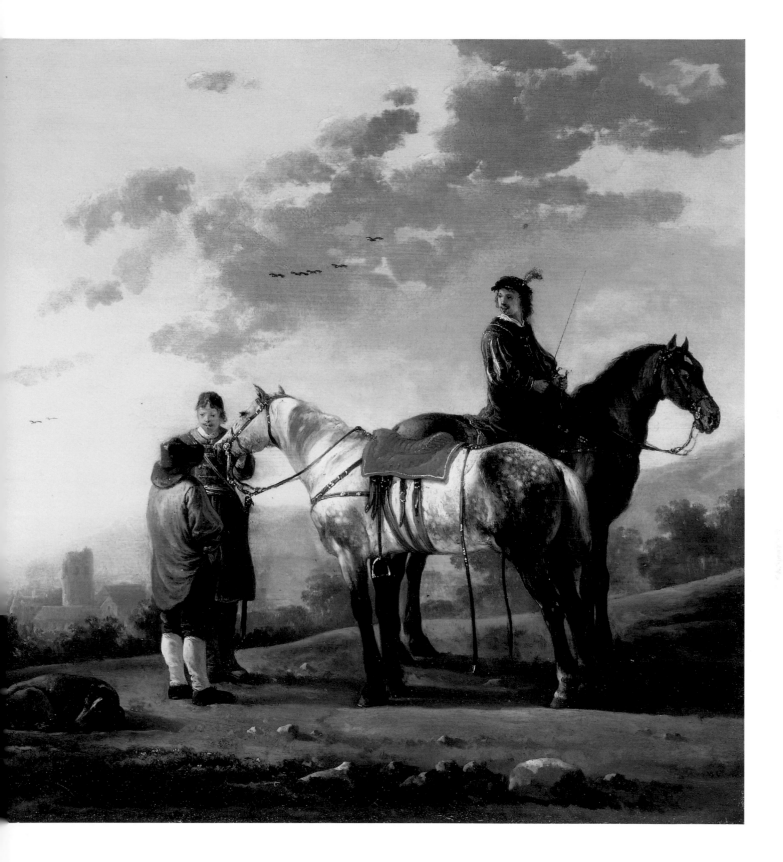

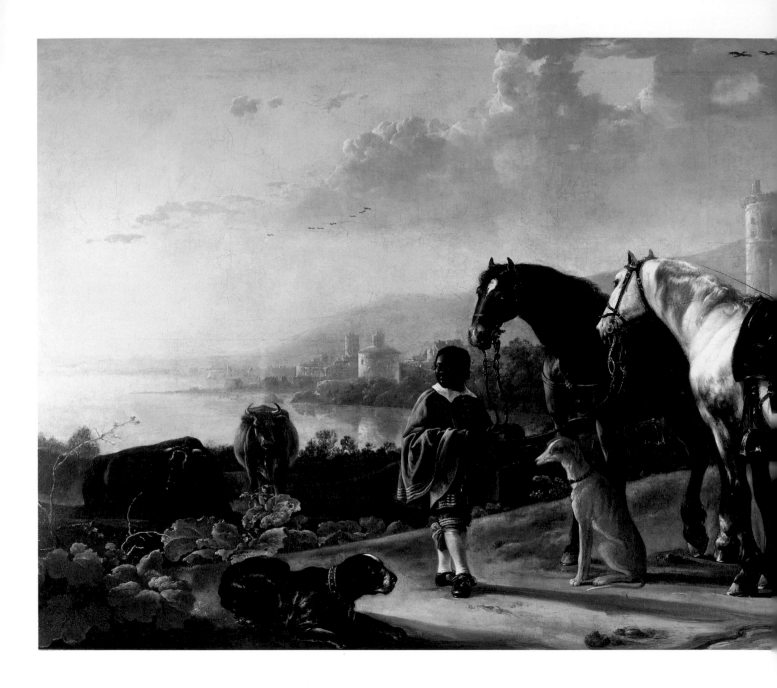

41
AELBERT CUYP (1620–1691)
A Page with Two Horses
Oil on canvas
143.2 × 228.1cm
late 1650s
Acquired by George IV in 1809; the 1819 inventory
remarks, 'the Horses admirable', and values the picture at
400 guineas.[24]
RCIN 405319
White 1982, no. 37

The real or would-be aristocratic character of Cuyp's clientele (discussed above, pp. 154–5) explains the popularity in his oeuvre of riding and hunting portraits, such as *Michiel and Cornelis Pompe van Meerdervoort with their Tutor* (Metropolitan Museum, New York) and *Lady and Gentleman* (National Gallery of Art, Washington).[25] It has been suggested that the nobleman here, wearing black and attended by his groom and page, is a portrait and may be identified as Willem van Beveren (born 1624), son of Cornelis van Beveren, who was knighted by Louis XIII in 1635.[26] The background architecture is certainly of exactly the type used in the equestrian portraits mentioned above; however the man in black is half hidden by his horse and upstaged by his page, neither of which suggests the prominence one might expect from a portrait. The alternative is that this is another general evocation of journeying south (see no. 40). The scale of this painting may seem rather grand for an equestrian caprice rather than an equestrian portrait, but in fact the decorative schemes which became a feature of Dutch painting in the later years of the seventeenth century (see pp. 10–13 and fig. 6) are almost always grand in scale and imaginary in subject.

There are many examples in Dutch art of literal-minded episodes, where the actions match the setting, like most of the inns and stalls in the first section (nos 2–4, 6, 7 and 10). This is rather more allusive and open-ended: to make sense of the scene we are to imagine that the horsemen have ridden all day and arrived at a strange town where their horses are tended by their own or their host's page – in other words the event we see here should be taking place in the courtyard of one of the castles or inns in the background. Instead it has been improbably transposed to a place outside the city gates to convey the journeying as well as the arriving.

42

AELBERT CUYP (1620–1691)
An Evening Landscape with Figures and Sheep
Oil on canvas
101.6 × 153.6 cm
Signed: *A cuÿp.*
late 1650s
Acquired by George IV in 1814 with the Baring collection;
described in 1819 as 'a brilliant and fine Picture' and valued
at 900 guineas.[27]
RCIN 405827
White 1982, no. 35

This is a characteristic imaginary landscape of Cuyp's maturity, again depicting a terrain reminiscent of the Rhine between Nijmegen and Cleves. The most direct source for his style here is unquestionably the work of Jan Both; Cuyp's *Baptism of the Eunuch* at Anglesey Abbey (The National Trust) is close enough to Jan Both's treatment of the same subject (no. 31) to imply that he was familiar with this particular painting.[28] The pattern of trees against the sky in Cuyp exactly follows Both's model except in being more simplified in design and more freely handled in the application of paint.

It is more surprising to note how much this painting has in common with Rubens's *Summer* (fig. 17) with its mannered clouds, use of multiple layers stacked behind each other to suggest depth, light pouring over the crests of the forms, and in its highly emotive theme of a path leading towards the light. It certainly has remarkably little in common with Jan van der Heyden's canal scene of exactly the same date (no. 18). This latter comparison reveals the mannerism of Cuyp's landscapes (if one can use that word without implied criticism): the decorative touch, the low but far-off perspective suggestive of a distant dream, and the contrived additive composition.

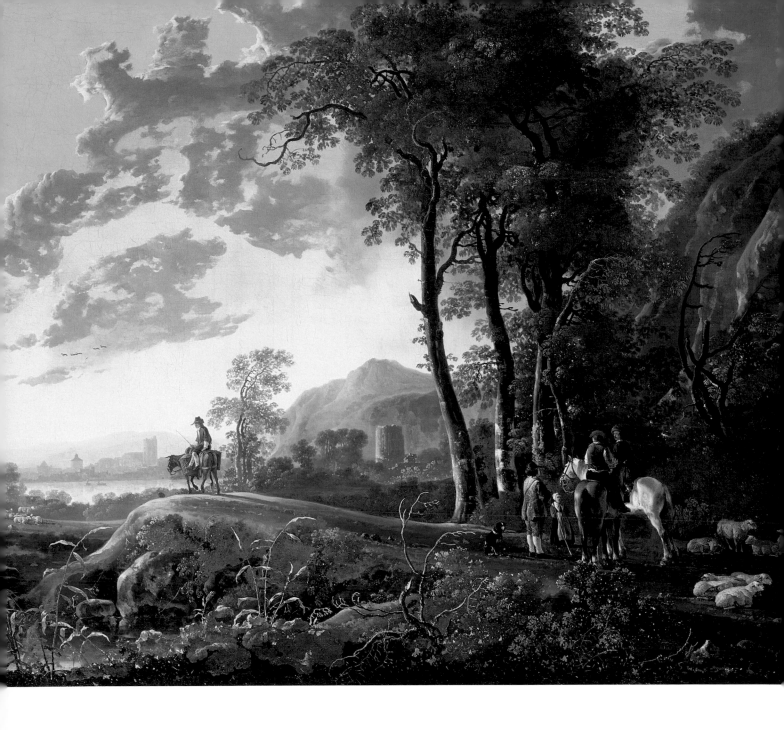

NOTES

INTRODUCTION

1 Comments and valuations from the 1819 inventory of Carlton House are quoted with each catalogue entry below.
2 The majority of George IV's Dutch and Flemish paintings were destined to be hung in the Picture Gallery at Buckingham Palace which was completed after the King's death; White 1982, pp. lxx–lxxi.
3 White 1982, p. lxx
4 White 1982, p. lxx
5 Vegelin van Claerbergen 2007, pp. 11ff
6 See Van der Ploeg 1997
7 For the display of Dutch landscapes, see Welu 1990, pp. 51–9
8 Sutton 1987, p. 399; Harwood 2002, p. 174, no. 45
9 For the decorative schemes of Melchior de Hondecoeter and Jan Weenix (1640–1719) see Kiers 2000, pp. 288–90; see also Sutton 1987, p. 56
10 Millar 1963, pp. 153–5, nos 403–11
11 Sir Francis Baring letter to Shelburne, 9 October 1802, Baring archives DEP 193.17.1
12 See Reitlinger 1961, pp. 13–14 and Bailey 2003, pp. 18–19
13 Bailey 2003, p. 334, no. 105
14 Reitlinger 1961, pp. 28–9; White 1982, lvi–ii; Potter's *Young Bull* (no. 8) came from the Calonne collection; see Carlton House 1819, no. 87
15 Reitlinger 1961, p. 291, 338–9, 446–7; Hayes 1966, pp. 190–97
16 Carlton House 1819
17 Carlton House 1819, nos 24, 35 and 549
18 Fromentin 1981, p. xvi
19 Walpole 1752, p. xi
20 Horace Walpole letter to Horace Mann, 12 November 1779, Walpole 1844, p. 189
21 White 1982, p. lxxi.
22 Kiers 2000, p. 151; see also Sutton 1987, p. 416
23 Kiers 2000, p. 261
24 Forrester 1996, pp. 31–2 and pp. 48–9, 53–4 and 105–6 for the examples cited below
25 De Piles 1743, pp. 201–2
26 From *Discourse IV* of 1771; Reynolds 1997, pp. 69–70
27 Walpole 1752, p. xxvii
28 Reynolds 1997, p. 69
29 Reynolds 1996, p. 110
30 Reynolds 1996, p. 107, quoted in Alpers 1983, p. xviii
31 Ruskin 1903, VII, p. 364
32 Montias 1982, pp. 220, 259 and 169
33 Chong 1987, pp. 115, 117–18 and 119, n. 3; see also Montias 1982, p. 259; Sutton 1987, pp. 3–5
34 Montias 1982, pp. 71–2 and 194
35 Evelyn 1935, p. 39, quoted in Chong 1987, p. 104
36 Montias 1982, pp. 218–19
37 'Pullenburgs vernünftige kleine Figuren, die auf Rafaels Weise mit zierlichen Landschaften, Ruinen, Thieren und dergleichen vergesellschaftet', Sandrart 1925, p. 157; Sutton 1987, pp. 402–3
38 White 1982, pp. xxxiii–iv and xliv–xlviii
39 Sutton 1987, p. 416; Kiers 2000, p. 151
40 Kiers 2000, p. 295; Keyes 1990, p. 155
41 Houbraken 1753, II, pp. 73–4

42 Passeri 1934, p. 141 writing of Giovanni Lanfranco (1582–1647), quoted in the context of Italian artists seeking *servitù particolare* by Haskell 1980, pp. 6–7
43 Sutton 1987, p. 390
44 Ramsay's *Dialogue on Taste* of 1755 contains this idea; see Smart 1992, p. 143
45 Montias 1982, pp. 71–2
46 See, for example, the story of Zeuxis and Parrhasius in Pliny 1976, pp. 108–11 (*Natural History*, XXXV, 65)
47 See, for example, Schama 1987b, p. 71
48 Descriptions by Sir Henry Wotton in 1620 and Constantijn Huygens in 1622 are quoted in Alpers 1983, pp. 12 and 50–51.
49 Reynolds 1996, p. 97, quoted in Alpers 1983, p. xvii
50 See Bruyn 1987, pp. 92–3
51 Fromentin 1981, p. 108
52 Fromentin 1981, p. 112
53 Landscapes are sometimes given more specific descriptions in inventories – 'a little sea', 'a little winter', 'an ice scene', 'a beach scene', 'an animal piece', 'a little Haarlem view', etc. – but the word 'landscape' is more commonly used than any of these; see Montias 1982, pp. 209, 214, 221, 230–31, 238 and 245; Sutton 1987, pp. 8–9.
54 See Gombrich 1966
55 Norgate 1997, p. 82
56 Norgate 1997, p. 83
57 The translation used here is published in Brown 1986, pp. 35–43.
58 Scholars have referred to a 'Bruegel revival' in Dutch art of this period; see Sutton 1987, p. 290 and Brown 1986, pp. 110–11.
59 See Pliny 1976, pp. 146–7 (*Natural History*, XXXV, 116–17) who calls the painter 'Studius'
60 Alpers 1983, p. 148, makes the point that during the period half of all land in the Northern Netherlands was peasant-owned and that, unlike other countries, 'seigneurial power was weak to nonexistent'.
61 Lairesse 1707, I, pp. 418–34, passages translated and discussed by Alan Chong in Sutton 1987, pp. 444–5

I AS THE CITY GATE OPENS

1 Translated in Brown 1986, p. 36
2 Hoogstraten's chapter on landscape (Book IV, chapter V, 1678, pp. 135–40) is profoundly dependent upon van Mander.
3 Quoted in Freedberg 1980, p. 12
4 See Sutton 1987, p. 12
5 See Freedberg 1980, pp. 12 and 19 for Dutch translations of Virgil
6 Freedberg 1980, p. 12
7 Schenkeveld-van der Dussen 1986, p. 75
8 Schenkeveld-van der Dussen 1986, pp. 72–8; Freedberg 1980, p. 15; Sutton 1987, pp. 12–13
9 See Mody 1978
10 Freedberg 1980, pp. 11, 21 and 28
11 British Museum no. 1987, 1003.11, inscription translated in Freedberg 1980, p. 30
12 Brown 1986, p. 174, no. 73a
13 Sixty per cent of the population lived in cities in the seventeenth century, of which these were the most populous; Sutton 1987, p. 3.
14 De Vries 1986, pp. 79–84
15 De Vries 1986, p. 79

16 De Vries 1986, p. 80
17 Ray, *Observations*, 1673, quoted in Wheelock 2001, p. 15
18 Sutton 2006, pp. 22–3; Meyer's *L'arte di restituire a Roma la tralasciata navigazione del suo Tevere* was published in 1683; see Harwood 2002, p. 204
19 Lambert 1985, p. 151
20 Lambert 1985, p. 154
21 Lambert 1985, p. 203; De Vries 1986, pp. 82–3
22 De Vries 1986, p. 82; Lambert 1985, p. 205
23 Lambert 1985, p. 202
24 De Vries 1986, pp. 80–2
25 Keyes 1990, p. 49
26 Lambert 1985, p. 182
27 Lambert 1985, p. 185
28 For timber demand see Lambert 1985, p. 209
29 Lambert 1985, p. 67, fig. 23
30 Lambert 1985, p. 76
31 De Vries 1986, p. 84; this wild dune landscape was much celebrated in Dutch poetry of the period; see Sutton 1987, p. 440
32 De Vries 1986, p. 85
33 For the contrast of *buitenplaats* and *ridderhofstad*, see Sutton 2006, p. 52
34 Sutton 1987, p. 419, n. 10
35 Carlton House 1819, no. 152, in the Ante Room, Attic Floor (here and elsewhere in this catalogue values are expressed in guineas when this yields a round number)
36 Teniers, *Kermis of St George's Day* (RCIN 405952) was valued at 1,500 guineas; Carlton House 1819, no. 580
37 Tromans 2002, p. 60, no. 7
38 Millar 1969, no. 1175; Tromans 2002, p. 64, no. 9
39 Carlton House 1819, no. 82, in the Ante Room to the Dining Room, Ground Floor
40 Houbraken, quoted in Harwood 2002, p. 186
41 *Discourse VI* of 1774, Reynolds 1997, pp. 108–9
42 Carlton House 1819, no. 30, in the Bow Room, 'State Floor'
43 Carlton House 1819, no. 24, in the Bow Room, 'State Floor'
44 Carlton House 1819, no. 144, in the Colonnade Room, Ground Floor
45 Carlton House 1819, no. 157, in the Middle Room, Attic Floor; in 1824 sent to Royal Lodge in Windsor Park
46 Carlton House 1819, no. 87, in the Ante Room to the Dining Room, Ground Floor
47 Fromentin 1981, pp. 121–2.
48 Montagu 1994, p. 20, fig. 19
49 Schama 1987a, p. 71; see also Sutton 1987, pp. 294–5
50 Hearn 1995, p. 87, no. 42
51 Sutton 1987, pp. 294–5, fig. 3
52 Millar 1969, no. 1136
53 Carlton House 1819, no. 35, in the Bow Room, 'State Floor'; the inventory also describes the puppy-stealing incident depicted.
54 Carlton House 1819, no. 28, in the Bow Room, 'State Floor'
55 Lambert 1985, p. 195
56 Carlton House 1819, no. 224, in the Store Room
57 Slive 2005, Chronology
58 Slive 2005, p. 32
59 Carlton House 1819, no. 81, in the Ante Room to the Dining Room, Ground Floor

60 Walford 1991, pp. 62–3
61 Carlton House 1819, no. 88, in the Ante Room to the Dining Room, Ground Floor
62 Kiers 2000, p. 265
63 Carlton House 1819, no. 108, in the Ante Room to the Dining Room, Ground Floor
64 Carlton House 1819, no. 26, in the Bow Room, 'State Floor'
65 Carlton House 1819, no. 102, in the Ante Room to the Dining Room, Ground Floor
66 Sutton 2006, pp. 22–3
67 Sutton 2006, p. 23
68 Compare the map of Veere from the *Toonneel der Steden* of Willem and Johannes Blaeu, 1652.
69 A famous example by an unknown artist is in the Palazzo Ducale in Urbino.
70 Carlton House 1819, no. 104, in the Ante Room to the Dining Room, Ground Floor
71 Lambert 1985, p. 198, fig. 68
72 Carlton House 1819, no. 137, in the Ante Room, Ground Floor
73 Slive 2005, Chronology
74 Carlton House 1819, no. 142, in the Ante Room, Ground Floor
75 Slive 1995, p. 206
76 Lloyd 2004, p. 78
77 Gombrich 1966, p. 111; see also Sutton 1987, pp. 13–14

II ROPES AND RIGGING

1 Wilson 1990, p. 40
2 Diderot, *Voyage en Hollande*, 1772, translated in Alpers 1983, p. 111
3 Wilson 1990, p. 45
4 Daalder 2008, p. 17
5 Daalder 2008, p. 17
6 Wilson 1990, pp. 41–2
7 Wilson 1990, pp. 45–6
8 Wilson 1990, pp. 45–6; for the threat to this trade and its seamen, see Schama 1987b, p. 76
9 Millar 1963, no. 24; Keyes 1990, p. 5 suggests two Netherlandish artists in connection with this painting: Cornelis Anthonisz. Theunissen (c.1499–1553) and Jan Vermeyen (1500–1559).
10 Van Mander 1936, p. 378; Keyes 1990, pp. 7–8 and 426
11 Millar 1963, no. 489; Quarm 2008, p. 60
12 Keyes 1990, pp. 8–10
13 Keyes 1990, pp. 11 and 427
14 Chong 1987, pp. 106–9; see also Montias 1982, pp. 82 and 187–8
15 Keyes 1990, p. 22; see also Kiers 2000, pp. 233–4
16 Gaschke 2008, p. 140, no. 46
17 Keyes 1990, p. 22
18 White 1982, nos 218–29
19 Keyes 1990, pp. 284–5, no. 101
20 Plutarch 1998, p. 14
21 Goedde 2008, pp. 24–5
22 Keyes 1990, pp. 199–201, no. 52; Kiers 2000, pp. 401–2
23 Keyes 1990, pp. 90–1, no. 5; Kiers 2000, pp. 236–7, no. 161
24 Baglione 1649, p. 296
25 Goedde 2008, pp. 23–4
26 See Russell 1986, pp. 67–71
27 Van Mander 1936, p. 379

28 Kiers 2000, p. 134; see also Brown 1986, pp. 31–3
29 Kiers 2000, p. 133
30 Freedberg 1980, p. 65
31 Alpers 1983, pp. 142–3
32 Norgate 1997, p. 84
33 Solkin 2009, p. 118
34 The companion piece is slightly larger (123.5 × 236.5cm); Keyes 1990, pp. 204–6, no. 54
35 Keyes 1990, pp. 201–3, no. 53
36 Schenkeveld-van der Dussen 1986, p. 72
37 Carlton House 1819, no. 75, in the Dining Room, Ground Floor
38 Russell 1975, p. 36
39 Robinson 1990, pp. 338–40, no. 32
40 Carlton House 1819, no. 71, in the Dining Room, Ground Floor
41 Robinson 1990, pp. 337–8, no. 31
42 Brown 1986, p. 44
43 Robinson 1990, pp. 742–4, no. 34, who describes the wind as a 'strong breeze' rather than a gale.
44 Robinson 1990, pp. 985–6, no. 33
45 White 1982, p. 69
46 Pieter Hendricksz. Schut, *Caroli II Regis magnae Britanniae ex Hollandia in Angliam discessus*, 1660, etching and engraving, British Museum

III THE PAINTING CAPITAL OF THE WORLD

1 Both passages translated in Stechow 1966b, p. 58
2 Montaigne 2003, p. 1141
3 Montaigne 2003, p. 1150
4 For the dramatic and yet planned expansion of Amsterdam in the seventeenth century, see Lambert 1985, pp. 215–19.
5 Montaigne 2003, p. 1164
6 Montaigne 2003, p. 1173
7 Petrocchio 1970, pp. 84–6
8 Gigli 1994, II, pp. 466–73
9 Gigli 1994, II, pp. 474–5
10 Brown 2002, pp. 34–5
11 Brown 2002, p. 34
12 Rosa 1810, p. 122
13 'nelle taverne dunque, ne' postriboli, ne' porcili vedremo strascinata così degna Reina à menar vita tanto diversa da quella nobiltà'; Malvasia 1678, vol. II, pp. 267–8
14 Pastor 1932, p. 305
15 The print is based on a drawing dated 1664 in the Cleveland Museum of Art; see Jatta 1992, pp. 121–2, no. 69 and pp. 157–8, no. 95.
16 Sandrart claimed that he, Claude, Poussin and Pieter van Laer painted landscapes from life; Jan Asselijn's drawing inscribed 'Bent-Vueghels' shows artists painting out of doors; see Sutton 1987, p. 59, n. 65 and p. 280, fig. 2.
17 Montaigne 2003, p. 1150
18 Carlton House 1819, no. 123, in the Bow Room, Ground Floor
19 White 1982, pp. xxxiii–xxxiv
20 Harwood 2002, p. 75
21 Great enthusiasm for Bril is expressed by Constantijn Huygens in c.1630 (Brown 1986, p. 44) and Edward Norgate in c.1650, who also praises Elsheimer as a 'Diavolo per gli cose picole' (Norgate 1997, p. 82).

22 Haskell 1980, p. 25
23 Sandrart describes inspecting one of Titian's Bacchanals with François Duquesnoy (1597–1643), Pietro da Cortona (1596–1669), Nicolas Poussin and Claude Lorrain; Langdon 1989, p. 40.
24 Hoogstraten 1678, p. 138
25 Quoted in Langdon 1989, pp. 17 and 35
26 Baldinucci commented upon Claude's 'wonderful perspectives'; Langdon 1989, p. 44.
27 Carlton House 1819, no. 49, in the Audience Room, 'State Floor' (also called 'Blue Velvet Room')
28 See Úbeda de los Cobos 2005
29 Carlton House 1819, no. 109, in the Ante Room to the Dining Room, Ground Floor
30 Hoogstraten 1678, p. 233, quoted in Alpers 1983, p. 47
31 Carlton House 1819, no. 143, in the Colonnade Room, Ground Floor
32 Van Mander 1936, p. 153
33 See White 1982, p. 68
34 Carlton House 1819, no. 136, in the Ante Room, Ground Floor
35 Carlton House 1819, no. 113, in the Bow Room, Ground Floor
36 Infrared examination of this detail confirms the change in the positioning of the boy's left foot (the author is grateful to Rosanna de Sancha and Nicola Swash-Hardie for investigating this).
37 The 'Spinario' is an antique bronze statue in the Palazzo dei Conservatori, Rome. The motif was often copied in Renaissance sculpture.
38 Carlton House 1819, no. 116, in the Bow Room, Ground Floor

IV AELBERT CUYP

1 For the Cuyp vogue in England in the eighteenth century, see Chong 2001, pp. 42–6
2 Solkin 2009, p. 152
3 Forrester 1996, pp. 105–6, no. 44
4 Fromentin 1981, pp. 146–7
5 Cuyp drawings of Utrecht confirm that such a visit occurred; see Reiss 1975, p. 8.
6 Wheelock 2001, p. 200, n. 2 and pp. 255–61, nos 87–93
7 Lambert 1985, pp. 53–4
8 Chong 2001, p. 36; Schama 1987b, p. 82
9 Schenkeveld-van der Dussen 1986, p. 77
10 Schenkeveld-van der Dussen 1986, p. 74
11 See Brown 1986, p. 226, no. 112
12 Reiss 1975, p. 7; for depictions of *The Road to Damascus* and *The Baptism of the Eunuch*, see Wheelock 2001, nos 9, 16 and 30
13 Huygens writing in c.1630 (Brown 1986, p. 44) and Norgate in c.1650 (Norgate 1997, p. 82) both regard Paulus Bril as the 'benchmark' in landscape painting.
14 Carlton House 1819, no. 25, in the Bow Room, 'State Floor'
15 Reiss 1975, p. 77
16 See White 1982, p. 32
17 See Freedberg 1980, p. 32; Brown 1986, pp. 28–9; Sutton 1987, p. 24
18 Carlton House 1819, no. 48, in the Audience Room, 'State Floor' (also called 'Blue Velvet Room')

19. Margarita Russell has suggested that Cuyp's *Maas at Dordrecht* (National Gallery of Art, Washington) depicts the review of the fleet at Dordrecht in 1646; see White 1982, p. 35.
20. Hoogstraten 1678, p. 140, translated in Sutton 1987, p. 10
21. Goedde 2008, pp. 23–4
22. Carlton House 1819, no. 86, in the Ante Room to the Dining Room, Ground Floor
23. Gordenker 2001, pp. 53–4
24. Carlton House 1819, no. 33, in the Bow Room, 'State Floor' (also called Rose Satin Drawing Room)
25. See Wheelock 2001, pp. 150–1, no. 29 and pp. 172–4, no. 40
26. Reiss 1975, pp. 9–10; discussed in White 1982, pp. 33–4
27. Carlton House 1819, no. 29, in the Bow Room, 'State Floor'; also visible hanging in the Picture Gallery, Buckingham Palace (top left of fig. 1)
28. See Wheelock 2001, pp. 152–3, no. 30

BIBLIOGRAPHY

ALPERS 1983: S. Alpers, *The Art of Describing*, Chicago

BAGLIONE 1649: G. Baglione, *Le vite de' pittori, scultori et architetti; dal pontificato di Gregorio XIII fino à tutto quello d'Urbano VIII*, Rome

BAILEY 2003: C.B. Bailey, *et al.*, *The Age of Watteau, Chardin, and Fragonard: Masterpieces of French Genre Painting*, Ottawa

BALDINUCCI 1845–7: *Notizie dei professori del disegno da Cimabue in qua*, 5 vols, Florence

BEAL 1984: M. Beal, 'Richard Symonds in Italy: his meeting with Nicolas Poussin', *Burlington Magazine*, CXXVI, No. 972, pp. 141–4

BROWN 1986: C. Brown, *Dutch Landscape: The Early Years, Haarlem and Amsterdam 1590–1650*, London

BROWN 2002: C. Brown, 'The birds of a feather', in Harwood 2002, pp. 34–41

BRUYN 1987: J. Bruyn, 'Towards a scriptural reading of seventeenth-century Dutch Landscape', in Sutton 1987, pp. 84–103

BUCHANAN 1824: W. Buchanan, *Memoirs of Painting*, London

CARLTON HOUSE 1819: 'Catalogue of the Prince Regent's Pictures, in Carlton House, June 1819', manuscript held in the office of the Surveyor of The Queen's Pictures, St James's Palace (Inventory no. 47)

CHONG 1987: A. Chong, 'The market for landscape painting in seventeenth-century Holland', in Sutton 1987, pp. 104–20

CHONG 2001: A. Chong, 'Aristocratic imaginings: Aelbert Cuyp's patrons and collectors', in Wheelock 2001, pp. 35–51

DAALDER 2008: R. Daalder, 'Naval battles to order: Dutch history in marine paintings', in Gaschke 2008, London, pp. 11–21

DE PILES 1743: R. de Piles, *The Principles of Painting*, London

DE VRIES 1986: J. De Vries, 'The Dutch rural economy and the landscape: 1590–1650', in Brown 1986, pp. 79–86

EVELYN 1935: J. Evelyn, *Diary*, E. S. de Boer (ed.), Oxford

FORRESTER 1996: G. Forrester, *Turner's 'Drawing Book': The Liber Studiorum*, London

FREEDBERG 1980: D. Freedberg, *Dutch Landscape Prints of the Seventeenth Century*, London

FREEDBERG 1988: D. Freedberg, *Iconoclasm and Painting in the Revolt of the Netherlands 1566–1609*, New York and London

FROMENTIN 1981: E. Fromentin, *The Masters of Past Time: Dutch and Flemish Painting from Van Eyck to Rembrandt*, H. Gerson (ed.), Oxford

GASCHKE 2008: J. Gaschke *et al.*, *Turmoil and Tranquility: The Sea through the Eyes of Dutch and Flemish Masters 1550–1700*, London

GIGLI 1994: G. Gigli, *Diario di Roma*, M. Barberito (ed.), 2 vols, Rome

GOEDDE 2008: L.O. Goedde, 'Natural metaphors and naturalism in Netherlandish marine painting', in Gaschke 2008, pp. 23–31

GOMBRICH 1966: E.H. Gombrich, 'The Renaissance theory of art and the rise of landscape', in *Norm and Form: Studies in the Art of the Renaissance*, London, pp. 107–21.

GORDENKER 2001: E.E.S. Gordenker, 'Cuyp's horsemen: what do costumes tell us?', in Wheelock 2001, pp. 53–63

HARWOOD 2002: L.B. Harwood, *et al.*, *Inspired by Italy: Dutch Landscape Painting 1600–1700*, London

HASKELL 1980: F. Haskell, *Patrons and Painters: A Study in the Relations between Italian Art and Society in the Age of the Baroque*, New Haven and London

HAYES 1966: J. Hayes, 'British patrons and landscape painting: eighteenth-century collecting', *Apollo*, March 1966, pp. 188–97

HEARN 1995: K. Hearn (ed.), *Dynasties; Painting in Tudor and Jacobean England 1530–1630*, London

HOOGSTRATEN 1678: S. van Hoogstraten, *Inleyding tot de hooge schoole der schilderkonst; anders de zichtbaere werelt*, Rotterdam

HOUBRAKEN 1753: A. Houbraken, *De groote schouburgh der Nederlandsche konstschilders en schilderessen*, 2 vols

JATTA 1992: B. Jatta, *Lieven Cruyl e la opera grafica: un artista fiammingo nell'Italia del Seicento*, Brussels and Rome

KEYES 1990: G. Keyes, *Mirror of Empire: Dutch Marine Art of the Seventeenth Century*, Cambridge

KIERS 2000: J. Kiers *et al.*, *The Glory of the Golden Age. Dutch Art of the Seventeenth Century: Painting, Sculpture and Decorative Art*, Amsterdam

LAIRESSE 1707: G. de Lairesse, *Groot Schilderboek*, Amsterdam

LAMBERT 1985: A.M. Lambert, *The Making of the Dutch Landscape: An Historical Geography of the Netherlands*, London

LANGDON 1989: H. Langdon, *Claude Lorrain*, Oxford

LEVESQUE 1994: C. Levesque, *Journey through Landscape in Seventeenth-Century Holland. The Haarlem Print Series and Dutch Identity*, Pennsylvania

LLOYD 2004: C. Lloyd, *Enchanting the Eye: Dutch Paintings of the Golden Age*, London

MALVASIA 1678: C.C. Malvasia, *Felsina Pittrice*, 2 vols, Bologna

MILLAR 1963: O. Millar, *The Tudor, Stuart and Early Georgian Pictures in the Collection of Her Majesty The Queen*, London

MILLAR 1969: O. Millar, *The Later Georgian Pictures in the Collection of Her Majesty The Queen*, London

MODY 1978: J.R.P. Mody, *Vondel and Milton*, Philadelphia

MONTAGU 1994: J. Montagu, *The Expression of the Passions*, New Haven and London

MONTAIGNE 2003: M. de Montaigne, 'Travel Journal', from *The Complete Works*, trans. D.M. Frame, New York

MONTIAS 1982: J.M. Montias, *Artists and Artisans in Delft: A Socio-Economic Study of the Seventeenth Century*, Princeton

NORGATE 1997: E. Norgate, *Miniatura or the Art of Limning*, J.M. Muller and J. Murrell (eds), New Haven and London

PASSERI 1934: G. Passeri, *Vite de' pittori, scultori ed architetti che hanno lavorato in Roma dall'anno 1641 sino all'anno 1673*, J. Hess (ed.), Leipzig and Vienna

PASTOR 1932: L. F. von Pastor, *History of the Popes from the Close of the Middle Ages*, R. F. Kerr (ed.), vol. XXII, London

PETROCCHIO 1970: M. Petrocchio, *Roma nel Seicento*, Bologna

PLINY 1976: Pliny the Elder, *The Elder Pliny's Chapters on the History of Art*, R.V. Schoder (ed.), Chicago

PLUTARCH 1998: Plutarch, *Life of Themistocles*, trans. J.L. Marr, Warminster

QUARM 2008: R. Quarm, 'The Willem van de Veldes Dutch Marine Art in England', in Gaschke 2008, pp. 55–64

RADEMAKER 1720: A. Rademaker, *Kabinet van Nederlandsche en Kleefsche utheden*, Amsterdam

REISS 1975: S. Reiss, *Aelbert Cuyp*, London and Boston

REITLINGER 1961: G. Reitlinger, *The Economics of Taste: The Rise and Fall of Picture Prices 1760–1960*, 2 vols, London

REYNOLDS 1996: J. Reynolds, *A Journey to Flanders and Holland*, H. Mount (ed.), Cambridge

REYNOLDS 1997: J. Reynolds, *Discourses on Art*, R.R. Wark (ed.), New Haven and London

ROBINSON 1990: M. S. Robinson, *The Paintings of the Willem van de Veldes*, 2 vols, London

ROSA 1810: S. Rosa, *Satire di Salvator Rosa*, Amsterdam

RUSKIN 1903: J. Ruskin, 'Modern Painters', in E.T. Cook et al. (eds), *The Works of John Ruskin*, vol. VII, Edinburgh

RUSSELL 1975: M. Russell, *Jan van de Cappelle 1624/6–1679*, Leigh-on-Sea

RUSSELL 1986: M. Russell, 'Seascape into Landscape', in Brown 1986, pp. 63–71

SANDRART 1925: J. von Sandrart, *Academie der Bau-, Bild- und Mahlerey-Künste von 1675*, ed. A. R. Peltzer, Munich

SCHAMA 1987a: S. Schama, *The Embarrassment of Riches. An Interpretation of Dutch Culture in the Golden Age*, London

SCHAMA 1987b: S. Schama, 'Dutch landscapes: culture as foreground', in Sutton 1987, pp. 64–83

SCHENKEVELD-VAN DER DUSSEN 1986: M.A. Schenkeveld-van der Dussen, 'Nature and landscape in Dutch literature of the Golden Age', in Brown 1986, pp. 72–8

SLIVE 1991: S. Slive, 'Additions to Jacob van Ruisdael', *Burlington Magazine*, CXXXIII, no. 1062, pp. 598–606

SLIVE 1995: S. Slive, *Dutch Painting 1600–1800*, New Haven and London

SLIVE 2005: S. Slive, *Jacob van Ruisdael: Master of Landscape*, London

SMART 1992: A. Smart, *Allan Ramsay; Painter, Essayist and Man of the Enlightenment*, New Haven and London

SOLKIN 2009: D. Solkin (ed.), *Turner and the Masters*, London

STECHOW 1966a: W. Stechow, *Dutch Landscape Painting of the Seventeenth Century*, London

STECHOW 1966b: W. Stechow, *Northern Renaissance Art, 1400–1600, Sources and Documents*, Englewood Cliffs, NJ

STERCK 1936: J.F.M. Sterck et al. (eds), *De werken van Vondel*, vol. IX, Amsterdam

SUTTON 1987: P.C. Sutton, *Masters of Seventeenth-Century Dutch Landscape Painting*, Boston

SUTTON 2006: P.C. Sutton, *Jan van der Heyden (1637–1712)*, New Haven and London

TROMANS 2002: N. Tromans, *David Wilkie: Painter of Everyday Life*, London

ÚBEDA DE LOS COBOS 2005: A. Úbeda de los Cobos, et al., *Paintings for the Planet King: The Decoration of the Buen Retiro Palace*, Madrid

VAN DER PLOEG 1997: P. Van der Ploeg, et al., *Princely Patrons: The Collection of Frederick Henry of Orange and Amalia of Solms in The Hague*, Zwolle

VAN MANDER 1936: C. van Mander, *Dutch and Flemish Painters, Translation from the Schilderboeck*, trans. C. Van de Wall, New York

VEGELIN VAN CLAERBERGEN 2007: E. Vegelin Van Claerbergen (ed.), *David Teniers and the Theatre of Painting*, London

WALFORD 1991: E.J. Walford, *Jacob van Ruisdael and the Perception of Landscape*, New Haven and London

WALPOLE 1752: H. Walpole, *Aedes Walpolianae*, London

WALPOLE 1844: Lord Dover (ed.), *Letters of Horace Walpole to Sir Horace Mann*, vol. III, London

WELU 1990: J.A. Welu, 'Seventeenth-century Dutch seascapes, an inside view', in Keyes 1990, pp. 51–9

WHEELOCK 2001: A Wheelock, et al., *Aelbert Cuyp*, Washington

WHITE 1982: C. White, *The Dutch Pictures in the Collection of Her Majesty The Queen*, Cambridge

WILSON 1990: C.K. Wilson, 'A new republic', in Keyes 1990, pp. 37–50

INDEX

Note: page numbers in *italics* refer to illustrations;
emboldened page numbers as part of a sequence
of numbers are for main references to a topic

PICTURE CREDITS

Bibliothèque nationale de France: fig. 70

© The Trustees of the British Museum: figs 11, 12, 13, 23, 31, 35, 37, 64, 67, 69, 71, 77

© RMN (Domaine de Chantilly)/René-Gabriel Ojéda: fig. 21

© The Cleveland Museum of Art: fig. 38

Currier Museum of Art, Manchester, New Hampshire: fig. 29

Fitzwilliam Museum Cambridge: fig. 68

Museumslandschaft Hessen Kassel, Gemäldegalerie Alte Meister: fig. 39

© 2009 Kunsthaus Zürich: fig. 30

Minneapolis Institute of Arts: fig. 74

© National Gallery of Ireland: figs 4, 5

© The National Gallery, London: figs 9, 20, 65, 75, 78

National Gallery of Scotland: fig. 72

© National Maritime Museum, Greenwich, London: figs 44, 47, 49, 50, 52, 59, 63

© Museo Nacional del Prado, Madrid, Spain: fig. 73

Photo by Erik Gould, Courtesy of the Museum of Art, Rhode Island School of Design, Providence, Rhode Island 5: fig. 43

Rijksmuseum Amsterdam: fig. 79

© Tate, London 2009: figs. 34, 42

ACKNOWLEDGEMENTS

This catalogue would not have been possible without the wealth of scholarly research undertaken into the paintings in the Royal Collection; in particular Sir Christopher White's catalogue of the Dutch paintings, published in 1982, has proved a constant and reliable resource. *Enchanting the Eye*, an exhibition held in 2004 and 2005 at the Queen's Galleries in Edinburgh and London, and Christopher Lloyd's superb accompanying catalogue served as a model for us to follow in this catalogue and the exhibition which accompanies it. We have greatly benefited from the advice and specialist knowledge of colleagues in other institutions; we are especially grateful to Robert J. Blyth, Roger Quarm, and Dr Pieter van der Merwe of the National Maritime Museum in Greenwich for unpicking countless errors and confusions in the section dealing with marine painting. For those which remain we take full responsibility. We have also benefited from expert knowledge generously shared by Kim Smit, Bob Gowland, Clara Harrow and Remmelt Daalder.

We are grateful for the assistance of our Royal Collection colleagues. Special thanks are due to Janice Sacher for carrying out image research and for obtaining copyright. We would also like to thank Nicola Christie, Karen Ashworth, Al Brewer, Claire Chorley, Adelaide Izat, Rosanna de Sancha and Tabitha Teuma for conserving the paintings and for providing advice on technical matters and Alex Buck and Charlotte Bolland for checking the manuscript for errors. We are grateful to Michael Field, Stephanie Carlton, Nicola Swash Hardie and Christopher Stevens for preparing the paintings for photography and display and to the exhibitions team and the photographic services department.

We are indebted to Oliver Craske and the team at Scala for their unfailing enthusiasm and hard work in producing this book and to Jacky Colliss Harvey and Nina Chang in Royal Collection Publications. We would also like to thank Adam Hooper for designing the book so beautifully and Isambard Thomas for creating the excellent map.

Desmond Shawe-Taylor and Jennifer Scott